DEVELOPING ANIMALS

D1125240

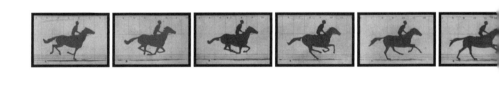

Developing Animals

WILDLIFE *and* EARLY AMERICAN PHOTOGRAPHY

———

Matthew Brower

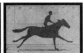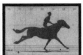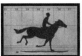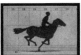

UNIVERSITY OF MINNESOTA PRESS

Minneapolis · London

An earlier version of chapter 1 was previously published online as "'Take Only Photographs': Animal Photography's Production of Nature Love," *Invisible Culture* 9 (2005), http://www.rochester.edu/in_visible_culture/; reprinted online in *Antennae: The Journal of Nature in Visual Culture* 5, no. 2 (July 2008), www .antennae.org.uk. Portions of chapter 2 appeared previously in "Trophy Shots: Early North American Non-Human Animal Photography and the Display of Masculine Prowess," *Society and Animals* 13, no. 1 (2005): 13–32 (published by Brill Academic Publishers), and in "George Shiras and the Circulation of Wildlife Photography," *History of Photography* 32, no. 2 (Summer 2008): 169–75 (published by Taylor and Francis).

Published by the University of Minnesota Press
111 Third Avenue South, Suite 290, Minneapolis, MN 55401-2520

http://www.upress.umn.edu

Library of Congress Cataloging-in-Publication Data

Brower, Matthew, 1971–
Developing animals : wildlife and early American photography /
Matthew Brower.
 p. cm.
Includes bibliographical references and index.
ISBN 978-0-8166-5478-9 (hc : alk. paper) — ISBN 978-0-8166-5479-6
(pb : alk. paper)
1. Wildlife photography—United States. 2. Human–animal relationships—
United States—History—19th century. I. Title.
TR729.W54B76 2010
778.9'32--dc22
2010036228

Design and production by Mighty Media, Inc.
Text design by Chris Long

Printed in the United States of America on acid-free paper

The University of Minnesota is an equal-opportunity educator and employer.

17 16 15 14 13 12 11 10 9 8 7 6 5 4 3 2 1

CONTENTS

PREFACE

When I began this project in the fall of 1998 at the University of Rochester, I was often asked why I wanted to study animals. The topic struck some of my instructors and fellow students as a strange obsession, as the stakes of an inquiry into the representation of animals were not immediately obvious. In fact, the graduate program director at the time took me aside during my second year and suggested that it might be better for my academic development if I spent a semester not writing about animals. The problem was that animals did not figure as a topic in the humanities and social sciences then; animal studies was not yet a recognized area of research and publishing and was only beginning to be discussed as a possible term to describe the scholarship of individuals scattered across a number of disciplines. The animal-themed conferences I attended in 2000 and 2002 were marked by a palpable sense of relief among the participants at not having to begin the discussion by justifying the scholarly significance of animals.[1] Since then, the question of animals has arisen with par-

ticular force and has been increasingly central to conversations around the posthumanities.[2]

This project had its conceptual beginning in a footnote to a paper I published in 1998 on the Canadian wildlife painter Robert Bateman. "Robert Bateman's Natural Worlds" analyzed the visual economy of Bateman's images, arguing that their close-ups of animals in nature left no space for the viewer to occupy.[3] The vantage point of the images situated the viewer in proximity to the animals depicted and implied that the viewer was present with the animals in nature; at the same time, the behavior of the animals, their nonreaction to the viewer's proximity, denied the viewer's presence. In a footnote, I compared this erasure of human presence from the image to the photo blinds shown at the beginnings of the wildlife films I saw in school in order to authenticate the images of animal behavior that followed.

I wrote the paper on Bateman in part to try and think through the hostility toward him that was (and still is) prevalent in the Canadian art world. Liking Bateman was seen as evidence of Philistinism, and disparaging him was a marker of allegiance to serious art. His well-painted images of wild animals, which he used to raise awareness of environmental issues, were anathema to anyone with pretensions to an artistic sensibility.[4] His popularity was taken as evidence of the vulgarity of mass taste. His animals were seen as a cheap and sentimental subject addressed to petit bourgeois sensibilities on par with Thomas Kinkade's nostalgic fantasies.[5] This dynamic played out on a smaller scale in a philosophy of art class I took as an undergraduate. The class decided as a group to use Bateman as our counterexample to test the theories of art we were exploring. We were certain Bateman was not art and applied this certainty to test the theories; if a theory couldn't distinguish between wildlife painting and art, then it was flawed. My paper thus had an undercurrent of exploring the question of animal representation that I had not been able to explicitly formulate.

Developing Animals: Wildlife and Early American Photography
formally began when, for Douglas Crimp's introductory methods
class in visual culture studies at Rochester, I started to trace the
origins of the photographic blind. Investigating the origins and
function of the blind led me to the strangeness of nineteenth-
century animal photography and the practice of camera hunt-
ing. This work formed the core of my dissertation in visual and
cultural studies, supervised by Lisa Cartwright and Paul Duro.
I developed key pieces of the project working with Joan Shel-
ley Rubin at Rochester and Margaretta Lovell at University of
California, Berkeley. After much revision and important feedback
from my writing group and outside readers, that dissertation has
become this book.

The project has broader roots than simply exploring the
implications of a footnote. It is grounded in my own history of
engagement with animals. I spent my summers during my under-
graduate years planting trees in Northern Ontario, Alberta, and
British Columbia. The job involved reforesting clear-cuts with
saplings and a shovel, and it brought me and my coworkers into
proximity to the complex borders between nature and culture.
The difficulties of these borders were brought home for me in
numerous ways. When one coworker complained that another
hadn't picked up after his lunch, the curt response was "look
around, we're in the middle of a fucking clear-cut." In the face
of the industrial consumption of nature, it was difficult to main-
tain that one Coke can was significant. It was hard to maintain
a belief in the ideology of wilderness while planting a tree farm
for the production of toilet paper. Yet the easy cynicism of this
answer suggested that the disappointment with the disruption of
that illusion threatened to undermine any sense of responsibility
for one's actions in nature. This temptation was deftly identified
by the locals who would wink at us in town and say, "Green side
up, eh?"[6] Being directly involved in the industrial production of
nature made it hard to maintain "normal" cultural standards of

behavior.[7] The breakdown in cultural standards was not simply based in our proximity to nature but rather to the exigencies of capitalism; doing backbreaking labor for piecework undermined our connection to social mores.[8]

I spent six summers working in the bush, and during that time my coworkers and I had a number of encounters with wild animals that helped shape the questions this book addresses. In my first summer planting, I spent time working outside Red Lake in Northwestern Ontario. Red Lake is an end-of-the-road gold-mining town 175 kilometers north of the Trans-Canada Highway. We were staying in a firefighting campsite owned by the Ministry of Natural Resources. After we arrived at the campsite, we were visited by the apologetic owner of a hunting lodge down the road. He hadn't expected the camp to be in use and so had been baiting bears across the road from the campsite. We were advised to keep all our food in our cars and to make sure that the kitchen was always clean. Although we never saw any bears, most mornings we would find paw prints on our vehicles. The lodge owner was baiting bears so that wealthy tourists could pay 1,500 dollars a week to sit in a blind across from a piece of rotting meat so that they could get a shot at a bear. On a day off in town, I saw two bear hunters from Ohio driving down the main street in a camouflage pickup with a bear head for a hood ornament. They were cruising slowly, arms hanging out of the open windows, showing off.

My second summer planting was spent in a camp outside Longlac in Northern Ontario. Toward the end of the season a young black bear began watching the camp. The bear would sit for hours in the brush one hundred feet out, watching the life of the camp. It was too small to be threatening and was just old enough to be separated from its mother. The bear's watching us became an important part of camp life, giving us a constant sense of being on display. We used to speculate that the bear was lonely and wanted to come hang out with us. While we were anthropo-

morphizing the bear, the worry was that the bear was becoming accustomed to humans and would need to be relocated before it became dangerous and needed to be shot. Rather than being a spectacle, the bear watched us. In this case, we felt responsible to the bear, not wanting to encourage its interest in humans in case that interest destroyed it.

I spent my fifth summer planting outside Swan Hills in Northern Alberta. One of my coworkers, clearly shaken, got in the truck at the end of the day and described to us the experience of coming face to face with a grizzly. She had been wearing her Walkman and was planting close to the tree line when she looked up and saw a bear standing six feet away and looking right at her. She told us that she slowly shrank down into a ball on the ground and spent half an hour huddled on the ground repeating to herself that she was invisible and trying not to move. When she gathered the courage to look up, the bear was gone.

These incidents, and others, left me with a series of unformulated questions around animals, display, and looking. These questions seemed to find resolution when I discovered John Berger's essay "Why Look at Animals?"[9] Berger's argument provided a framework with which I began to explore my interest in representations of animals. A conversation with Jonathan Burt at the annual conference of the Association of Art Historians in 1999 reoriented my thinking.[10] Burt's healthy skepticism to Berger's assertion that it was no longer possible to meaningfully look at animals enabled me to rethink my experiences with animals. I began to compare Berger's largely theoretical account of the history of animal representation to the material I was finding in my investigations of nineteenth-century American animal photography. This reassessment of Berger's thought reoriented my investigations back to the questions my encounters with wildlife had raised. While these questions are not explicitly framed as part of the book's argument, *Developing Animals* does help resolve them for me.

This project received financial support from the Social Sciences and Humanities Research Council of Canada, the Susan B. Anthony Institute for Gender and Women's Studies at the University of Rochester, and the Faculty of Fine Arts at York University. I acknowledge the important intellectual contribution to the development of this work made by Lisa Cartwright, Paul Duro, and Joan Shelley Rubin. Margaretta Lovell was very helpful during my stay at Berkeley, and I thank Kaja Silverman for sponsoring my fellowship there. I would particularly like to thank Linda Steer, Sarah Parsons, and Sarah Basnett for their patient revisiting of multiple drafts of this work. Finally, I thank Esther, Simone, and Nelson for their emotional support through this process.

INTRODUCTION

Capturing Animals

Contemporary American woodlore suggests that to properly respect nature we should "take only photographs and leave only footprints" when we enter the wilderness. In this schema photography appears as a nonintrusive, environmentally friendly activity that shows proper respect for the fragility of nature; taking photographs takes nothing from nature, leaving it undisturbezd. This rhetoric positions nature photography as maintaining a separation between human and nature.[1] It assures us that photography keeps us at an appropriate distance from nature. Within this conception of nature, photography stands as the figure of an ideal relation to nature; it provides access to nature while leaving it untouched. Ultimately, nature photography offers us an image of nature that it at the same time forbids us to occupy. This expression presents photography as a model of noninterventionist right practice. The conception of nature as a space from which humans must be excluded echoes the deep Western myth of the Garden

of Eden. The myth positions nature as innocent, and humans as guilty and fallen.[2] Thus, their entry into nature is corrupting. Ideal nature resembles the garden on the fifth day of creation.[3]

It is this conception of nature that is at work in wildlife photography. In his essay "Why Look at Animals?" John Berger argues that wildlife photography presents an image of the animal as fundamentally separate from the human.[4] He further suggests that nature photography is not simply a convenient rhetorical figure for humanity's separation from nature but is central to the operation of this ideology. Wildlife photographs are marked by their "normal invisibility," positioning the animals depicted in a realm outside the human (14). The photographs show us animals we could not "normally" see. Wildlife photographs erase their taking, offering their viewers transparent access to nature. But by erasing their taking, wildlife photographs leave no space within their visual economies for viewers to occupy.[5] Thus, the images provide their viewers with access to a deep nature from which they are fundamentally excluded.

The "invisibility" in these images functions as evidence for Berger's argument that late-capitalist Westerners can no longer really be in nature. It is no longer possible for us to have an "authentic" encounter with an animal. Because of our alienation, we can no longer engage with animals except as figures of nostalgia. For Berger, "the image of a wild animal becomes the starting-point of a daydream: a point from which the day-dreamer departs with his back turned" (15). Wildlife photographs function as a substitute for a real nature that the images themselves assert is impossible for modern humans to occupy.[6] We find delight in images of wild animals as compensation for our complete domestication. Berger argues that capitalism's reorganization of society has separated humans from the animals with whom we used to live and offers us instead images of animals that compensate for this disconnection by functioning as an ideal figure of freedom.

Akira Lippit has extended Berger's argument for the compen-

satory function of animal imagery to technology in general. Lippit argues that "modernity can be defined by the disappearance of wildlife from humanity's habitat and by the reappearance of the same in humanity's reflections on itself: in philosophy, psychoanalysis, and technological media such as the telephone, film, and radio."[7] Thus, for Lippit, like Berger, modern human beings are fundamentally separated from animals who no longer appear in our daily lives. These vanished animals reappear in representations. For Lippit, however, these representations are not simply compensatory but instead mourn the animals that haunt humanity. Within Western onto-theology, animals are unable to have the properly human experience of death and thus cannot truly die. Because animals cannot really die, we have no way of coming to terms with their disappearance and so must continually mourn their loss in representation. Thus, Lippit says, technological representation determines "a vast mausoleum for animal being" (187). This means the animals in wildlife photography only appear to be alive but are instead spectral presences perpetually vanishing but unable to completely disappear. Because nature recedes from the encroachment of modernity, the modern animal becomes according to Lippit "a memory of the present" (3).

Both Lippit and Berger argue that it is no longer possible to have a direct relation to animals and so we encounter them in images and technological representations instead. While this image of wildlife photography is seductive (like the images it describes), it too is a compensatory fantasy haunted by a desire for an unmediated relation with animals. As Donna Haraway has shown, the desire for an innocent relation to nature does not provide us with a secure ground for politics but rather leaves us in a double bind between an innocence that must remain passive and victimized and a guilty teleology culminating in apocalypse.[8] This logic leaves us longing for an unrealizable relation with animals and denying the possibility of any appropriate relation with animals. It is for this reason that Jonathan Burt insists that Berger's

and Lippit's positions represent a "flight from the animal."[9] As Burt notes, "The idea that the animal as a natural non-human object is always automatically corrupted or falsified as soon as it is visually troped" denies the possibility of any appropriate human-animal relation (188). More importantly, he notes that this logic "*reinforces* at a conceptual level the effacement of the animal that is perceived to have taken place at the level of reality even whilst criticizing that process" (29). Thus, the analysis of animal imagery offered by Berger and Lippit retains the conception of nature as fundamentally separate from humanity at work in the wildlife image.

It should also be noted, however, that this separation only occurs within the logic of the images, not in their production. As Bill McKibben has argued, the production of wildlife photography can be enormously disruptive to the lives of animals.[10] McKibben describes wildlife photographers chasing animals with helicopters to photograph them. Similarly, James Elkins observed "a man with a camera" in Yellowstone Park "running full-tilt after a bison."[11] More seriously, Elkins notes "some national parks have problems with tourists who lure bears with food in order to take their pictures" (33). This behavior not only endangers the tourists but also ultimately threatens the life of the bears.[12] While these behaviors may stem from a love of animals, they do not maintain an ideal distance from the animal, as suggested by the "take only photographs" slogan.[13] These examples highlight the human-animal relation involved in the production of the animal image that the rhetoric of the wildlife photograph obscures. McKibben's and Elkins's allegations suggest that in seeing nature photography as a model for being in nature, we fail to understand animal photography and in particular that we fail to appreciate its mode of production. Correcting this misunderstanding calls for an analysis that denaturalizes wildlife photography. What needs to be clarified is that animal photography has a history. The images of animals in photography are produced in relation to their social

conditions and are not simply found in or extracted from nature. Analyzing the history of animal photography foregrounds the social production of the wild animal in wildlife photography and shows that we must understand wildlife photography as producing a social relation with animals.

PHOTOGRAPHY FROM ANIMALS TO WILDLIFE

By 1890 the portability and instantaneity of photographic technology were sufficiently developed to allow the photographing of live animals in nature to become a regular accomplishment. Before this point, photographing live animals was difficult, and most earlier animal photographs were pictures of captive, tame, or dead animals.[14] *Developing Animals* examines the intersections of animals and cameras in late-nineteenth- and early-twentieth-century America. The book traces the emergence of the photographing of animals in nature as a social practice within visual culture. It concentrates on the historical moment when photographic technology allowed photographing animals in nature to become a practice.[15]

Although the photographs under consideration here are photographs of live animals in nature, they are not wildlife photographs. In contemporary practice, the photographing of animals in nature has largely been subsumed within the genre of wildlife photography. Our present understandings of animals and animal imagery are shaped by what we might call the discursive regime of wildlife photography, which is characterized by a separation of human and animal that positions animals on the far side of a nature-culture divide. According to the rhetoric of wildlife photography, real animals, wild ones, occupy a realm of deep nature that must be pristine and untouched to be authentic. By positioning real animals as occupying a realm of deep nature, wildlife photography transforms animals into spectacle, severing the human-animal connection; real animals, therefore, only exist when humans are absent. Wildlife photography provides evidence

of a gap between human and animal, separating us from animals as it brings us closer to their daily lives. The rhetoric of wildlife photography naturalizes itself and implies that the wildlife photograph is the inevitable result of taking a camera into the woods to photograph animals. My analysis makes clear this is not the case. Examining other articulations of animal and camera reveals the extent to which wildlife photography is constructed and how its imagery shapes contemporary conceptions of animals. We see animals through the lens of photography. By analyzing the historical realizations of early American animal photography, I aim to denaturalize the rhetoric of wildlife photography and the conception of animals and human-animal relations it supports.

Berger suggests that animal images in modernity substitute for a lost, direct relationship with animals founded on the exchange of looks between human and animal.[16] In this reading, animal imagery is compensatory and inauthentic; we look at animal images because animals can no longer look back at us.[17] Seeing animal imagery as compensatory leads to a focus on its ideological content. Thus, animal images are read for what they can reveal about human culture and interests. The animals in the images are treated as proxies for human issues and concerns. This tendency treats the animal subject as an essentially passive object for the projection of human meaning rather than as an actor intervening in the production of the image. As Burt has argued in his analysis of animal films, to assert that the images are completely arbitrary and shaped by human convention is to deny the animal's agency and to further inscribe the animal's domination.[18]

This book argues that we need to move beyond the question of why we look at animals. What needs to be understood is not the motivation for animal imagery but how it works. Animal imagery does not simply soothe a nostalgic desire for direct contact with animals. It structures the understanding of animals. In short, we need to ask what do animal images do? How do we look at animals? Animals in photographs and films are often seen as

more real (more animal) than the animals encountered in daily life.[19] This preference for the image over the animal is an important part of photographic animal imagery. For example, starting with Muybridge's famous images of Leland Stanford's galloping horse, photographic representations of animals have been seen as offering us access to an otherwise inaccessible "truth" of animals. But this access has come at the cost of devaluing the unmediated experience of animals. After Muybridge's photographs, traditional representations of the horse in motion have become unsatisfactory as viewers expect representations to conform to the truth of the photographs even though this truth is inaccessible to their senses. As the example of Muybridge's horse photographs indicates, animal imagery is not transparent. It does not provide unmediated access to the animals depicted, but rather it structures its audience's understanding of animals in particular ways.

Developing Animals examines three American practices of photographing animals in nature from the late nineteenth and early twentieth centuries: camera hunting, the development of the photographic blind, and Abbott Thayer's attempts to photograph animal camouflage.[20] While I focus on some of the earliest photographs of living animals in nature, my aim is not simply to provide an analysis of either the origins or prehistory of wildlife photography. That subject has been covered by C. A. W. Guggisberg's *Early Wildlife Photographers*, which surveys the early attempts to photograph animals in nature.[21] Guggisberg's interpretation of all such photographic practices as prefiguring wildlife photography, however, limits the book's usefulness for thinking through early animal photography. In contrast, I argue that an analysis of the configurations of animal and camera that does not view their relations as striving toward wildlife photography contributes to the understanding of both the historical parameters of wildlife photography and photography's role in shaping contemporary conceptions of animals and structuring human-animal relations.

This analysis entails moving beyond a search for the first

wildlife photograph. In discussions of the origins of wildlife photography, there has been a tendency to focus on historical precedence as a ground for historical significance.[22] For example, in his excellent book *Wildlife Films* Derek Bousé suggests that the first wildlife photograph was a photograph of penguins taken by the *Challenger* expedition in 1872.[23] The question this search for the first wildlife photograph raises is whether wildlife photography is the inevitable result of pointing a camera at an animal in nature. Certainly this was my own approach as I began my investigations into the origins of wildlife photography, yet I have come to believe this approach is problematic. When I began investigating the history of wildlife photography, my initial impulse was to look for the first wildlife photograph, the first photograph of a wild animal in its natural habitat. What became apparent through my research was that early animal photography was a varied phenomenon that could not be reduced to wildlife photography. What was important was the function and uses the photographs served, and these were tied to the images' circulation. Thus, my project shifted from searching for the origins of a practice whose parameters seemed natural to investigating the production of practices of animal photography through their circulation. According to this logic, the *Challenger* photograph only retrospectively becomes a wildlife photograph as part of a quest for an origin for the practice.[24]

I want to suggest that thinking in terms of historical precedence is part of the naturalizing of wildlife photography. Because photographs of animals in nature are unmarked by indicators of historical temporality, it has been possible for the rhetoric around wildlife photography to position wildlife photographs as images of an ahistorical deep nature. Photographs of animals in nature are circulated as biological documents or as images of a nostalgic wildness from which contemporary humanity has been severed.[25] Focusing on historical precedence is not simply a response to the difficulty of historicizing animals,[26] but also the legacy of the his-

torical practices of exhibiting and circulating animal photographs as markers of prowess—as hunting trophies. It positions wildlife photography as a category of photography that was waiting to be discovered by the intersection of camera and animal rather than as a historically produced cultural practice.

In general, scholars have largely overlooked the photographic practices I analyze here.[27] The lack of scholarly attention to these practices is rooted in the general neglect of the study of human-animal relations, which animal studies seeks to redress. In terms of animal imagery, Steve Baker suggests that the neglect of animal representation was a key part of the foundation of aesthetic modernism.[28] Baker's argument finds support in Bill Nichols's contention that the shift from early capitalism to monopoly capitalism grounds the transition from realism to modernism and a parallel shift in humanity's defining other from the animal to the machine.[29] Within the terms of aesthetic modernism, animal imagery is sentimental, reactionary, and nostalgic. Baker's argument helps to explain why photographic historians have not taken animal photography seriously. It does not, however, account for the proliferation of animal photographs that began in the late nineteenth century. It is this proliferation and its effects that I address in the study of these photographic practices.

The animal photographs I examine functioned as, among other things, trophies, documents, and scientific evidence. Their circulation occurred primarily within sporting and scientific journals, where the images appeared alongside articles contextualizing and explaining them. The images and articles also appeared in general interest and children's publications. My analysis focuses on the conceptual and perceptual structures of these photographic practices: the kinds of thinking and viewing they require and the kinds that they enable. Through analyzing these practices, we can see the construction of new conceptions of animals and the positing of new models of vision. Thus, my aim in reading these images is to expand our understanding of

the function of photography and its role in the historical constitu-
tion of the animal. To do this, I examine the structure of photo-
graphic appropriation, how photography captures animals, as it
comes into contact with discourses of hunting, the natural, and
science within Progressive-Era America. I examine photography
in terms of its effects and affordances rather than asking what
photography is or what it means. My analysis is influenced by
those animal historians who have insisted on the centrality of the
mode of animals' visualization to the understanding of human-
animal relations. Key figures in this approach include Hilda Kean,
Jonathan Burt, and Steve Baker.[30] My analysis is also influenced
by poststructuralist photographic theory.

PHOTOGRAPHIES

As John Tagg has argued, it is necessary to think in terms of pho-
tographies having different histories rather than a singular his-
tory of photography.[31] Tagg famously describes photography as
"a flickering across a field of institutional spaces," and suggests,
"it is this field we must study, not photography as such" (63). For
Tagg, photography's lack of a unitary history is due to photogra-
phy's lack of a unitary identity. Thus Tagg argues, "photography
as such has no identity" (63). Instead, its status varies depending
"on the institutions and agents which define it and set it to work"
(63). This dependence on institutions means that photography's
"function as a mode of cultural production is tied to definite con-
ditions of existence, and its products are meaningful and legible
only within the particular currencies they have" (63).

Tagg's argument, that it is the effects of photography in insti-
tutional spaces that historians should study, draws attention to
the variety of work photographs do, to the enormous variety of
contexts in which photographs operate, and to the ways in which
the effects photographs have in these contexts depend on the
organization of those institutional spaces. Especially compelling
is Tagg's analysis of how exactly photographs came to be accepted

as evidence in British law. He illuminates the construction of conceptual frameworks and adjustment of institutional structures required for the acceptance of the idea that photographs provided evidence of anything to the court.[32]

Similarly, Anne McCauley argues against the "parading of a history of a single function (the 'aesthetic') as a history of technology (photography)."[33] McCauley explains that "historically there has been no single, coherent physical object that one can call a 'photograph,' and the very term is a convenient catch-all for a wide array of pictures on paper, metal, glass, fabric, canvas and so forth whose only common quality is the involvement of light and chemistry at some point in the generative process" (87). In emphasizing both the historical and the technological specificity of the photograph, McCauley's argument focuses our attention on the concrete practices involved in the production and distribution of photographs as an essential component of their function. McCauley reminds us that while we may call them all photographs, a daguerreotype, a photogram, and a Polaroid, to take three examples, operate rather differently from each other. To fail to consider the materiality of photographic practice is to mystify the function of the photograph.[34] Photographs must be produced and circulated, and their modes of production and circulation shape them.

Both McCauley and Tagg stress the variety inherent in the photographic domain and the elisions involved in any attempt to reduce it to a single essence.[35] As Tagg demonstrates in his analysis of institutional practices, photographic history must engage with the specificity of photographic practices. Accepting that we must think in terms of photographies (and histories) presents us with a difficulty in creating models and concepts of photography and with a difficulty in drawing on these models for further historical work. One solution, proposed by Douglas Nickel, is to retract photographic history to the study of self-consciously aesthetic photography.[36] However, rather than adopting a frame-

work derived from traditional art history, my analysis situates the photographic histories it studies within a broader conception of visual culture. This means acknowledging that photography's connections to other visual forms and social institutions are often more important to the workings of the images than the internal coherence of some idea of the photographic.[37]

Giving up the search for a single overarching principle to explain all of photography does not suggest that there are not consistencies and conceptual frameworks operating within the larger field of photography that organize and structure photographic practices. One model for thinking about these frameworks is Geoffrey Batchen's use of Foucault to ask the question of "photography *as* power."[38] What this move to considering "photopower," to use Batchen's term, implies, is an attempt to think through the ways that photography changes the institutions in which it is deployed. It also requires paying attention to the way that photography itself alters in entering into these institutional spaces. Batchen argues that the "politics of photography isn't something that identifies itself only when the medium is in action within obviously oppressive institutions" (202). Instead he suggests, "power inhabits the very grain of photography's existence as a modern Western event" (202). Power inhabits all photographs and makes them possible. For Batchen, this understanding of photopower is "the very photography as such that postmodernism is so anxious to disavow" (202). He argues that we must study photopower, as "we can no longer afford to leave the battlefield of essence in the hands of a vacuous art-historical formalism" (202). I take Batchen's point here to be that there are things that photographs do. Photography has effects that are not simply due to its "investment" by external relations. Photographs do not simply or transparently relay the ideologies of the institutional frameworks within which they operate. Instead photographs open up possibilities that relate to those institutional structures in complex ways. It is the task of photographic history to examine these

possibilities in their concrete historical situations and in relation to each other.

I agree with Batchen that taking up this analysis of photo-power means refusing to cede the question of photography's essence to art historical formalism. However, I find his attempt to locate that essence in photography's essentially deconstructive nature problematic.[39] This is due in part to the difficulty I have in reconciling deconstruction's liminal analysis with Foucault's epistemic genealogy. That is, deconstruction reads discourses against themselves by using the logic of the supplement. Although deconstruction sits on the edge of discourses, it reads a discourse's statements in terms of their internal logic, ultimately showing how that internality is inevitably compromised. This approach conflicts with the genealogical method, which, according to Foucault, operates externally to the discourses it analyzes, tracing the field of possibilities (which Foucault calls *énoncés*) that the discourse inhabits.[40] More importantly, within deconstruction's own terms it is meaningless to suggest that photography in some way embodies or exemplifies deconstruction—within the logic of the supplement everything is deconstructive.[41] My argument follows Foucault's genealogical concern in being concerned with the function of photographs as opposed to their meaning. It thus avoids the deconstructive imperative attached to any attempt to posit deep meaning. I focus on what the photographs enable and constrain, in other words, on photopower.

An analysis of photopower requires a concern with the production and distribution of photographs. It also requires careful attention to the specific circumstances in which the photograph operates. As Batchen notes, the same technical arrangements when arranged in a different context function as a different apparatus:

> According to Foucault, new forms of knowledge, such as photography, inscribe themselves in the space left blank by their (non)predecessors. Thus the camera of John Locke and Tom Wedgwood can be the same but different, equivalent as opti-

cal instruments but representing radically different worldviews (which in turn means that they are also radically different optical instruments).[42]

To think photopower requires an engagement not just with the technical conditions of photography but also with their conceptual surrounds. It requires an engagement with the reciprocal (if often asymmetric) relations between the technical structures of photography's production and distribution and the cultural context in which they operate.

Three analyses of the complex effects of technical and social conditions on the functions of the photographic image that have been particularly important in shaping my approach are Walter Benjamin's "The Work of Art in the Age of Mechanical Reproduction," Rosalind Krauss's "Photography's Discursive Spaces," and Jonathan Crary's *Techniques of the Observer.*[43] These analyses provide models for examining local structures within photographic practices. In his essay, Benjamin shows how the development of reproductive technology led to images structured for reproducibility. He argues that this change undermined the historical understanding of authenticity, reorganizing the structures of perception and altering the social function of images. Benjamin's essay has been important in thinking through photography's role in structuring the social conception of the animal. Krauss's essay shows how the conditions of a photograph's intended display structure the image. She argues that scientific landscape photographs intended for reports and archives function differently from art images that incorporate the space of the gallery wall. Krauss's concern with the relation between intended display and image function has influenced my attempts to think of trophy photography as a distinct photographic modality. Crary's book examines the changing historical ordering of perception brought on by new technologies of representation (of which photography is just one). His work has provided a model for thinking through the photographic blind's effects on animal photography.

ANIMAL PHOTOGRAPHY AND PHOTOPOWER

In this book, I engage in a historically specific analysis of American animal photography. I examine three practices of photographing the animal body in nature: camera hunting, the photographic blind, and Thayer's photographs of animal camouflage as three separate modalities of photopower. Inserting these images into photographic history requires the expansion of our understanding of the possibilities of the photograph. I examine how these images make animal bodies visible and what those modes of visualization do. This requires that I provide some account of the continuing work these images do—to give an indication of the similarities and differences between the work the photographs originally did and the different positions available to them today.

The drive to reduce photographs to genre is compelling. As Pierre Bourdieu argues, because the photograph has no aesthetic discourse proper to itself, the apprehension of photography is largely generic taking this form: it's an x, it's a y.[44] However, despite this tendency to read photographs in terms of their content, it must be stressed that genres have rules.[45] What Bourdieu points to is the tendency for these rules to become invisible and for the genre to naturalize itself. This is particularly the case with photographs of nature.[46] For this reason, I examine earlier examples of animal photography to shed light on the photographic practices studied here.

The first chapter, "A Red Herring: The Animal Body, Representation, and Historicity," explores the conception of animality and animal representation at work prior to the development of live animal photography. To illustrate this I analyze two photographs taken by John Dillwyn Llewelyn in Wales in the 1850s. Looking at the Welsh photographer Llewelyn's experiments photographing taxidermic objects on his estate reveals the strangeness of early animal photography. The chapter reads Llewelyn's photographs in order to clarify the distinction between early animal photography and the contemporary practice of wildlife photography. Some of Llewelyn's early animal photographs are iconographi-

cally indistinguishable from wildlife photographs. I argue that to read them as such is to misread these images by reducing them to contemporary terms of understanding. More importantly, to do so is to miss their importance for highlighting the relations between photographic function, the development of photographic technology, and broader epistemic conditions. The chapter situates Llewelyn's photographs within nineteenth-century animal photography and traces the development of the practice from the 1840s to the 1890s. The chapter makes clear that any attempt to understand early animal photography cannot be through the category of wildlife photography with its reified notion of deep nature and imposed separation of human and animal.[47] Rather, the analysis of early animal photography has to grapple with the conditions of human-animal relations extant at the time *and* with the role of animal photography in shaping those relations.

The second chapter, "Camera Hunting in America," examines the 1890s American practice of camera hunting in relation to issues of gender and nationalism. In camera hunting, photographers adapted hunting techniques to assist in the production of animal photographs. These photographers described their practice as hunting and their photographs as trophies. The chapter focuses on the photographs' circulation in hunting journals, general interest magazines, and books. By examining the rhetoric of camera hunting's images the analysis shows how camera hunting positions the photograph as a moment of contact between human and animal. The argument situates camera hunting within late-nineteenth-century American hunting culture and the emerging conservation movement. It focuses on George Bird Grinnell's theorization and promotion of the practice in *Forest and Stream*. To explain the gendered structures of camera hunting, the chapter examines Theodore Roosevelt's advocacy of camera hunting, as a way to preserve both game and hunting's cultivation of virility, in order to explicate the logics underlying the practice. The argument draws on Krauss's concept of photographic dis-

cursive spaces to position camera hunting as a discursive space
in nineteenth-century photography. The chapter also investigates
the logics of the hunting trophy in order to suggest that trophies
constitute a modality of photographic appropriation. The analysis
of trophy photography supports a rethinking of the oft-cited link
between photography and death.

The third chapter, "The Photographic Blind," examines the
development of the photographic blind as a technology for pho-
tographing animals in the years 1890–1910. The photographic
blind is an enclosure that obscures the photographer's presence,
assisting in the capture of animal imagery. The chapter tracks the
changing representational and discursive effects of the blind as it
moves from a hunting technique adapted to animal photography
to its emergence as a paradigm for human-animal relations and
mode of spectatorship. The blind's discursive location shifts from
an adapted hunting technique to a disciplinary technique within
ornithology that functions to authenticate the objectivity of the
animals depicted. The blind assists in making animals visible by
hiding the observer. As the blind is adapted to photography, the
observer's invisibility comes to authenticate the image and the
animals depicted, fostering a conception of animals as occupying
a radically nonhuman space. Thus, the blind comes to locate the
truth of the animal as occupying a realm that is only accessible
when humans are absent. The chapter reads the blind as an in-
verse panopticon. Rather than inducing the observed to internal-
ize the disciplinary effects of observation, the photographic blind
induces the observer to externalize their relation to the observed
by fostering in the observer a state of conscious and permanent
invisibility. Positing the blind as a mode of disciplinary spectator-
ship, the chapter argues that the development of the photographic
blind is at the basis of the conception of animals at work in wild-
life photography.

The fourth chapter, "The Appearance of Animals: Abbott
Thayer, Theodore Roosevelt, and Concealing-Coloration," looks

at Abbott Thayer's use of photography to present and develop his theories of animal coloration and the Thayer-Roosevelt debates over animal display in the years 1896–1921. Thayer advocated for a generalized understanding of animal coloration as adaptive camouflage protecting its bearer. He thus suggested that the normal condition of animals is invisibility. Thayer used photography as a key method for demonstrating his discoveries. His work emphasized photographs in which the animals depicted are indistinguishable from their environment. The chapter argues that Thayer's work opens up a number of key questions for thinking about animal photography. His photographs highlight the difficulties involved in photographing invisibility, and in doing so, they emphasize photography's bias toward visibility. They also draw attention to the important difference between seeing and knowing animals, which animal photography generally obscures. Thayer's work highlights the limits of photography for depicting animals by opening the question of the animal's relation to its environment. The chapter engages with Roger Caillois's work on animal appearance, and its rethinking by Kaja Silverman, to argue for the importance of a biosociological concept of the gaze, the mutual immersion of human and animal in a field of visuality, to an understanding of human-animal relations.[48]

A brief conclusion summarizes the arguments of the book and relates them to later developments in animal representation. By tracing the effects of photography on cultural conceptions of animals, *Developing Animals* demonstrates photography's centrality to contemporary discourses of animality. It also troubles the separation of the human and the animal that photographic technologies have helped to enable and the need to now look at the history and rethink the implications of this imposed and somewhat artificial separation.

CHAPTER 1

A Red Herring: The Animal Body, Representation, and Historicity

A READ HERON

The Photographic Exchange Club of London's *Photographic Album* of 1857 contained a photograph of a heron titled *Piscator No. 2* (Figure 1). The photograph was accompanied by an epigram that read, "And in the weedy moat, the heron fond of solitude alighted. The moping heron motionless and stiff, that on a stone as silently and stilly stood, an apparent sentinel, as if to guard the water-lily."[1] John Dillwyn Llewelyn (1810–82) took the photograph in 1856. Llewelyn, a cousin of photographic inventor William Henry Fox Talbot, was a pioneering Welsh photographer.[2] He specialized in images of nature taken from around his family's estate, Penllergare.[3]

The image is a rectangle taller than it is wide (24.2 × 18.9 cm). At first glance, to a contemporary viewer the image appears to be of a common type; it reads as a genre photograph—specifically, a nature, or wildlife, photograph. As such, it appears to be immediately legible, presenting us with an image of deep nature: a wild

1

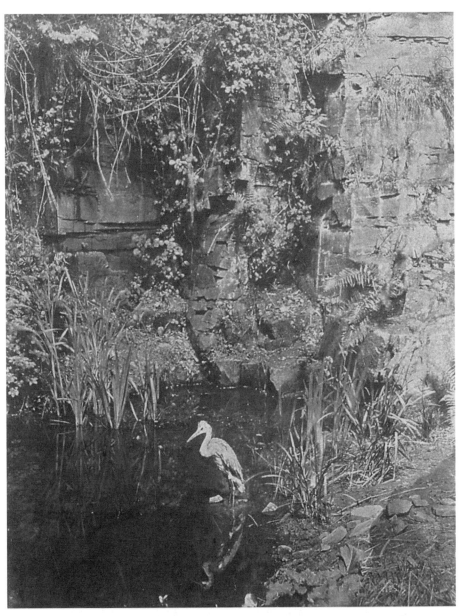

FIGURE 1. John Dillwyn Llewelyn, *Piscator No. 2*, 1856. City and County of
Swansea, Swansea Museum Collection.

animal in its natural environment. It depicts a heron standing in a pool of water in front of a rock wall. The heron is centered about one-third of the way up in the image. The heron's reflection extends below it on the water almost to the edge of the image. The water is dark, almost black, and fills the bottom left quadrant of the image; against it the bright white of the heron stands out in marked contrast. Behind and above the heron is a rock wall covered in vines. The wall forms a dark mass occupying the upper left-hand quadrant of the image. The mass of the wall combined with that of the water create a dark vertical rectangle occupying the left side of the image.

The right side of the photograph is a lighter band of gray composed of two separate elements. In the upper right corner the light illuminates a bulge in the rock wall. In the right foreground the light illuminates a grassy bank topped by a mound of stones. The bank in the foreground situates the viewer and provides an entry point to the image by giving a sense of scale and distance with which to read the image. By contrast, the overgrowth along the back wall suggests a space of human absence. The heron falls on the nonhuman side of this divide.

There is a large clump of bulrushes directly behind the mound of stones. The bulrushes are echoed on the other side of the pool by another clump of rushes, which together frame the heron. This framing provides a strong diagonal line to the composition. The sharp contrast of the heron with its background, its compositional framing by the other elements of the image, its central positioning in combination with the image's title (*piscator* meaning "fisher"), and the attached epigram from Thomas Hood suggest that the image is focused on the heron. The structure of the image announces that the heron is its center (subject); this *is* a photograph of a heron.

Like any wildlife photograph, the image has a timeless quality that makes it appear contemporary.[4] There are no markers within the image restricting it to a particular historical period.

The heron, the rocks, and the rushes are not marked by historical traces. Within the visual rhetoric of the wildlife photograph there is no meaningful difference between a contemporary heron and one from 1856. By this I mean that while the image is labeled with a particular date, as a wildlife photograph the elements it presents are not determined by that date. Although the image of the heron was taken in 1856, the meaning of the heron as it appears to us is not confined to that historical moment.

What I am suggesting is that wildlife photography operates within a rhetoric in which nature as nonhuman is ahistorical. Estelle Jussim and Elizabeth Lindquist-Cock argue that "the inclusion of a human figure, clothed in the appropriate fashions of the day and season, removes the photograph of Nature from the generalizing, abstracting experience which would place the contents of the photograph in some iconic eternity."[5] Jussim and Lindquist's argument implies that given that the wildlife photograph is predicated on the absence of the human, the wildlife photograph presents an image of ahistorical eternal nature. The image gives us access to deep nature—an essentially unchanging nature untouched by human hands. Although since Darwin we understand that nature changes, those changes are thought to occupy a deep time accessible only through science.[6] Evolution's time frame is vast and inhuman, positing changes over millions of years.[7] The evolutionary temporality of nature positions nature as an eternal and unchanging base outside of human affairs.[8] Thus, in presenting us with an image of deep nature, the image detaches itself from the moment of its taking, adhering instead to a deeper chronology.[9]

It is in this sense that the image remains contemporary. The nature the image depicts continues essentially unchanged.[10] If the date of the image is of any particular interest, it is that we could be looking at one of the earliest examples of a wildlife photograph: a heron in its natural environment. Read as a wildlife photograph, there would be no significant change to the image's

meaning if the date attached to the image were 1840 or 1890.[11] The date would only acquire an additional meaning if an ecological catastrophe had intervened in the time since the image's taking. If there were no more herons, or, at a minimum, no more herons in Wales, the image's date would be charged with significance. For example, the pictures of the last quagga from the London zoo are difficult to view without experiencing a haunting sense of loss.[12]

THE READY-MADE HERON

Yet perhaps the image is not so easily deciphered. Our contemporary ways of seeing may cause us to assimilate the image too quickly to familiar categories of interpretation. What if, despite all appearances to the contrary, the image is not a wildlife photograph? How then could we read the image? More to the point, given the image's structural homology with a wildlife photograph, what would convince us that the image is not a wildlife photograph?

The image is reproduced in *Nature and the Victorian Imagination* in a photo essay, "Images of Nature" by Charles Millard.[13] While briefly discussing the image, Millard mentions in passing that the heron we see here is probably stuffed. He suggests that in Victorian landscape photography "animal and human figures were used for compositional accent and emotional overtone" (25). Following this logic he argues that "the heron—presumably stuffed—in J. D. Llewelyn's *Piscator* . . . acts merely to focus the composition" (25). Millard inserts Llewelyn's image into a series of nature images of which animal images are only one kind. This is a tradition in which human and animal figures have a structural equivalence. Yet this equivalence is difficult for a contemporary viewer to comprehend. If it were a human figure standing in Llewelyn's pond, we would read the image rather differently. Thus, Millard's assertion presents us with two questions. One, why this assurance, what guarantees that the heron we see here

is, or rather was, a dead heron and not a live one?[14] Two, what is this "merely," as in "merely to focus"? What might it mean to "merely focus a composition"?

The state of photographic technology at the time of the image's taking assures us that the heron is stuffed. According to the caption in the *Photographic Album,* this particular image required a twenty-minute exposure. Thus, this photograph, as with all photographs from this period, was posed. Photography had yet to become instantaneous; we had not yet reached the technology of the snapshot. For this reason, as Edmund White has noted, "In the earlier decades the chief subject of nature photography was scenery, mostly because it didn't move. The long exposures required ... gave the nature photographer little choice."[15] In other words, the length of the exposure time determined the available subjects. To be photographed, animals had to be rendered as stationary as the landscape they inhabited. Thus, the time required for the image's taking confronted Llewelyn with the problem faced by all depicters of animals; the less domesticated the animal, the less tame the animal, the more difficult it is to have it remain motionless long enough to depict without first killing it.

The depiction of live animals was a problem.[16] Most animal paintings from this period and before were made from dead animals.[17] Animals depicted from "life" were usually modeled from the dead. This was true of the images of both art and science. As Nicholas Hammond assures us, "all the nineteenth-century illustrations of animals were based on dead specimens."[18] The inclusion of a dead animal, substituting for a live one, was common practice in nineteenth-century image making. This practice continued in animal photography as well. As Andrew Lanyon informs us, the "usual method" in early animal photography "was to employ stuffed specimens."[19] As common practice the use of a stuffed animal would not have concerned either Llewelyn or his audience. They would not have understood the emphasis we put on the distinction between an image of a live or dead animal.[20]

In 1856, photographing a stuffed bird was a perfectly reasonable solution to the problem of getting a heron to pose for twenty minutes. It strikes us as odd because we no longer accept a taxidermic object as an adequate substitute for a live animal. Realizing that the heron is stuffed changes how we see the image. By definition a photograph of a stuffed animal cannot be read as a wildlife photograph. How then are we to read the image?

Deciphering the image requires addressing the Victorian conception of nature. The Victorians viewed nature primarily through the lens of the picturesque. Although scientific discoveries were altering the understanding of nature, the romantic conception of nature continued to influence the Victorian experience. Nature functioned as "a repository of feeling," a healing space outside the confines of civilization.[21] Although this vision of nature is in many ways still our contemporary one, the type of sanctuary that nature provided and the ideal nature that provided it were different in the Victorian worldview. The ideal landscape was an improved one, and the nostalgic dream it embodied was Arcadia and not the prehuman landscape of the fifth day of creation.[22]

U. C. Knoepflmacher and G. B. Tennyson argue that the composition of early Victorian nature photographs is both indicative of and determined by the Victorian conception of nature. The lengthy exposures required by early photography ensured that these images were carefully crafted and composed. This attention to the detail of the images made "the choice of subject and the arrangement of objects in themselves indicative of the Victorian attitude to nature" (xxi). Knoepflmacher and Tennyson thus read "the setting, the placement, and the tones of the photographs" as revealing "Victorian Nature as it was perceived by contemporaries" (xxi). It is precisely because these photographs are composed and artificial that they reveal to us how Victorians wanted to see nature. Knoepflmacher and Tennyson provide us with a program for reading Llewelyn's image, seeing the elements of Victorian nature photography as overdetermined by the romantic

conception of the landscape. Millard concurs, noting that it was a common Victorian practice to increase the picturesque qualities of the landscape by adding props.

Millard sees the Victorian nature photograph as a textual image coming out of an "essentially literary tradition" (24). The imagery is determined by a conceptual ideal exemplified by Words-worth's depictions of the Lake District.[23] It is also shaped by the pictorial tradition of landscape art. Ultimately, Millard argues, "For the Victorians, Nature photography becomes a species of portraiture, inevitably revealing the spirit of place, an inviolable atmosphere" (24). The Victorian nature photograph is thus about the mood evoked by the picturesque more than it is about any particular element within it.

The heron is a prop added to create, or increase, the pictur-esque quality of the image.[24] Reading the image through the lens of the picturesque makes plausible Millard's claim that the heron is not the focus of the composition but rather it "acts merely to focus the composition" (25). Although we might see the heron as *the* focus of the image, Millard indicates that Victorians would have seen an aura of place (of *the* place), and the heron would have appeared as merely a compositional object. The Victorian viewer would have been led from seeing the heron to the con-templation of the picturesque. The heron thus appeared as an adjunct to the spirit of the pond and not that which proclaimed the pond's authenticity as a natural space. Thus in "merely focus-ing the composition" the heron acts as a vehicle for the apprehen-sion of the picturesque.

STAGING

Analyzing an earlier photograph by Llewelyn, *Deer Parking*, of a deer in a forest taken around 1852, makes the staging of his animal images more apparent (Figure 2).[25] The photograph is a calotype measuring 20 × 25 cm.[26] The image presents a stag in a clearing surrounded by oaks and ferns. Large trees flank both

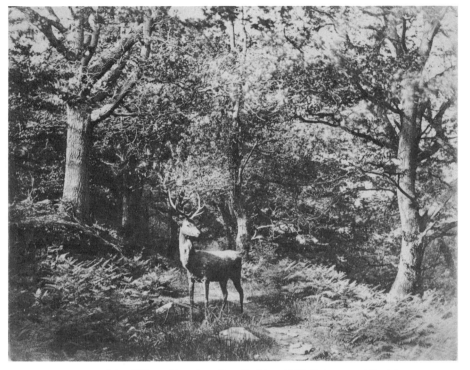

FIGURE 2. John Dillwyn Llewelyn, *Deer Parking*, 1852. Science and Society Picture Library.

sides of the image. The tree on the left sits on a slight hill, giving a diagonal thrust to the composition. A raking light from the left side of the image produces sharp contrasts of light and dark. The stag stands mid-image with its head cocked. The stag's head is highlighted, while its body is in deep shadow, emphasizing its look of noble alertness. The stag's head occupies the focal point of the diagonal formed by the two trees, positioning it and its antlers as the focus of the composition.

Yet, a closer look at the conjunction of the stag's head and body reveals that something is not quite right. The deer's pose seems at odds with its surroundings. The angle of the neck is wrong. The stiff front legs and square chest betray the deer's sta-

tus as a stuffed animal. Rather than merging with the natural background, the deer stands out as a human intervention. The deer is "abrasively visible," appearing as what Steve Baker has called "botched taxidermy."[27] According to Baker, in postmodern art botched taxidermy opens a space for thinking the animal outside of the already known. In Llewelyn's photograph it undoes the temporal logic of the wildlife genre.

The marked difference between the deer and its surroundings leads to one of the most striking differences between the photograph of the deer and that of the heron: how dated the image of the deer seems in comparison. Unlike the image of the heron, which appears contemporary in its timelessness, the photograph of the deer appears antiquated and historically distant. As a stuffed animal, the deer falls on the culture side of the nature-culture divide. The deer appears as a cultural artifact embedded in the time of its making rather than as a natural object participating in an evolutionary temporality.

While the heron offered itself to us as an immediately legible image, the image of the deer resists our interpretation initially, becoming legible only as a fake or a fraud. Although Millard cautions us to read the animals inserted into Victorian nature photography as accent pieces, to not read the photographs as animal or wildlife photographs, it is difficult to resist seeing the deer, standing out as it does, as the focus of the image. Yet, because the deer appears to a contemporary viewer as a foreign object in a natural setting, it is difficult to read the image as anything other than a failed or faked attempt at a photograph of a deer. The image does not read as a photograph of a stuffed deer, precisely because of its use of a "natural" setting. The "deer" in this photograph is obviously "fake." The deer is what we would now consider to be a crudely stuffed taxidermic specimen that has been placed in an outdoor setting. The stuffed deer appears to be masquerading as a live deer—and failing. This failure is double. There is a taxidermic failure to achieve lifelikeness, and there is the failure of

the photographed deer to merge with its surroundings. It is only due to this second failure that the first failure seems so marked. A photograph of a stuffed animal in a different setting would not read as a failed wildlife photograph. Ironically, while the forest is the natural setting of a deer, it is an unnatural setting for a stuffed animal, whose natural habitat includes trophy cases, game lodges, and natural history museums.

STUFFED ANIMAL PICTURES

To reiterate, the image of the deer was not intended to be a wildlife photograph. Taking it as such misreads the image, presuming as it does an ideal toward which the image is not striving. What was lacking was the concept of wildlife. Although Victorians often spoke of wild animals and savage beasts, the notion of authentic animals existing outside the realm of the human was not significantly present in a culture that celebrated the discovery and capture of exotic species as tangible evidence of their civilization's triumph.[28] We cannot read the image through its similarity to our own familiar categories. As Miles Orvell reminds us, "Our contemporary conception of photography is in many ways narrower than [a nineteenth-century viewer's], shaped as it has been by our predilection for 'straight photography,' which we think of as an 'honest' use of the medium."[29] Orvell points to the gap between contemporary viewers and the nineteenth-century image. He cautions us on the temptations of reading nineteenth-century photographs in light of contemporary predilections. Our sense that we know photography and understand its meanings makes it difficult for us to see early photography as anything other than a prefiguration of present practices.[30]

While the image of the deer is not a wildlife photograph, it is not clear that it belongs simply to the picturesque. The image appears to be strongly influenced by a different image-making tradition. The deer's pose resembles the stag's in Edwin Henry Landseer's *Monarch of the Glen*. Landseer's image was painted

in 1851, a year before the photograph was taken. This similarity of pose suggests the influence of the tradition of sporting art exemplified by Landseer.[31] This would further suggest that the photograph attempts to portray the nobility of the deer by having it stand erect with its head held high displaying its "crown" of antlers.[32]

However, while the poses are similar, the images' effects are different. Rather than expressing nobility, the photograph of the deer appears bathetic. In animal photography the encounter with the animal necessarily registers itself in the image. This registration interferes with the sporting art tradition's practice of deploying the animal as a site for projection: Llewelyn's deer cannot do what Landseer's does. The biological specificity of the animal's behavior interferes with the cultural construction.[33]

The erect head-up pose of the deer is a response to a potential threat. It is a momentary pose held while the deer evaluates the threat. The deer's pose implies an engagement with the viewer. Its gaze appears fixed on the camera and through it the viewer. The viewer is assigned a position within the internal economy of the image. Our space becomes enfolded into that of the image. We come to occupy the position of the camera. The deer's pose incorporates us, positioning us as the threat to which it responds. We reenact the deer's appropriation by the camera.

Yet, as a taxidermic object the deer is itself already appropriated. The viewer is placed in the position of appropriating an already appropriated object. How then does the viewer come to experience the photograph's appropriation of nature? Do the appropriations double, thereby increasing the viewer's implied control over nature, or do the appropriations conflict, removing the image from the realm of the natural? For a contemporary viewer, the answer is the latter. The awkwardness of the taxidermy exposes the limitations of nineteenth-century attempts to assert domination over nature. The poor quality of the stuffed animal betrays an incomplete knowledge of animal anatomy, and its

deployment in a photograph "reveals" the inability of the photographer to capture an image of a live animal. Both the taxidermist and the photographer fall short of the contemporary vision of the wild animal—a vision predicated on the further development of wildlife photography.[34] By violating the logic of that vision, the deer appears unnatural.

James Ryan argues that for a nineteenth-century British viewer, the two appropriations would have been mutually reinforcing. According to Ryan, "Photographs of stuffed animals … represent a kind of double mimesis, and reinforce the shared ways in which photography and taxidermy are manifestations of a desire to possess and control nature."[35] Ryan differs from Millard in seeing Victorian animal photography not simply as an evocation of the spirit of nature but as an attempt to possess and control that spirit. For him, images of nature assert power over place. Although Ryan acknowledges that photography ultimately supplants taxidermy, he maintains that "as modes of representation the two practices are closely related" (206). In arguing for this connection Ryan is influenced by the work of Kitty Hauser. In her discussion of the use of taxidermy in contemporary photography, Hauser argues for a strong conceptual link between the two practices. For Hauser, both photography and taxidermy are based on their isolation of a surface from the world since "both peel a layer from the world which they then present as truth."[36] It is their shared indexical quality as representations that permits "their social function as trophies and souvenirs" by acting as "the visible proof of experience" (9). Hauser argues that this indexical appropriation of the world links both forms of representation conceptually and structures their social reception as evidence. Ryan takes up this conceptual relation identified by Hauser and grounds it in the historical interplay between early photography and taxidermy. As Ryan notes,

> Early photographers employed taxidermy in order to capture portraits of animals in a seemingly live pose and outdoor setting.

In the 1850s J. D. Llewelyn took photographs of stuffed deer, badgers, otters, rabbits and pheasants posed as if photographed in the wild. Just as photographers drew on the skill of the taxidermist to overcome their cameras' technical shortcomings, taxidermists drew in turn on the photographer to provide them with an appropriate model of realism for their displays. (206–7)

Ryan situates Llewelyn's work photographing stuffed animals within a larger movement in which photography and taxidermy progressively sharpened each other's appropriation of nature.[37] Thus, according to Ryan, the image of the deer would have been unproblematic to nineteenth-century viewers because the taxidermic deer would have been the model used to validate the success of the image.

Ryan situates the interplay of photography and taxidermy within the larger context of the imperial British appropriation of nature.[38] Focusing on African colonial photography, Ryan argues that animal photography functions as part of the imperial politics of display.[39] The wild animals appropriated by colonial photography and taxidermy became objects for the display of white Anglo-Saxon male power. This emphasis on the creation of objects for the display of prowess leads Ryan to argue that the interplay between stuffed animals and photography was such that photographs of stuffed animals should be seen as the paradigmatic example of early nature photography. "Stuffed animals," he writes, were "the ideal photographic target: a re-creation of nature as apparently authentic, yet utterly docile" (214). Ryan suggests that it is in the photograph of a stuffed animal that the logic of British colonial nature photography is at its most apparent.

Ryan's argument indicates that as an image of a dead animal, the deer photograph is in part a trophy shot. Yet rather than appearing on the walls of a hunting lodge or an aristocratic shooting club, Llewelyn has placed his trophy in a picturesque "natural" setting. An image that initially appeared as a wildlife

photograph becomes a form of still life.[40] It is, to use the French term, a *nature morte,* literally "dead nature," in which a dead animal is represented as a live one, a substitution in which dead nature is (re)added to nature as a supplement intended to bring out its picturesque qualities.

AGAINST WILDLIFE PHOTOGRAPHY

The difficulty in reading Llewelyn's photographs highlights two points: the strangeness of early photography and the instability of the concept of the animal. It is this second point that gives the lie to the posit of the animal as simply an unchanging given outside history. The image of the animal body connects to a network of practices relating to the conceptualization of nature, the human, and technology. The analysis of Llewelyn's heron shows that local contexts and practices shape the function of the animal image.[41] What seemed obvious on first reading, that the image of the animal was a wildlife photograph, quickly became impossible to sustain. The image of a stuffed animal is definitionally not a wildlife photograph, and this shift in genres entailed a concomitant shift in the perceived temporality of the image. The reading of the deer photograph has brought out the relation of animal photography to taxidermy and to trophies. The image of a stuffed animal appears to participate in some of the same economies of display as the taxidermic animal. Ryan's work raises important questions about the relation between animal photography, trophies, and the politics of display. Yet it is uncertain whether the photograph of the stuffed animal is, as Ryan has suggested, the ideal form of the animal photograph as trophy.

As the analysis of the two images by Llewelyn highlights, the production of the photographic image of the animal occurs in a complex reciprocal relation with the broader cultural understanding of nature. Photography is not one site among many in the construction of the animal but rather a privileged site in the constitution and maintenance of the contemporary conception of

the animal. Analyzing how we see animals in photography is the first stage in denaturalizing the image of the animal presented in wildlife photography. Escaping from the logic of the Garden and the Fall opens up the possibility of understanding that our relations to animals are as inevitably authentic and real as the animals themselves.

THE DEVELOPMENT OF ANIMAL PHOTOGRAPHY IN
THE NINETEENTH CENTURY

There is a temptation to read the development of animal photography through a teleological understanding of history and to see the photographs as stages on the way to current practice. Such a reading would explain away the questions raised by Llewelyn's images by suggesting they were faked wildlife photographs because it was not technically feasible to take a real one. Guggisberg suggests this line of argument in *Early Wildlife Photographers*, as does Margaret Harker in her catalog essay "Animal Photography in the Nineteenth Century."[42] Harker describes Llewelyn's stuffed animal images as simulations and suggests that "today many people are contemptuous of such simulations, and are not prepared to give credit to what was technically possible at the time" (24). Harker's formulation implies Llewelyn was simulating wildlife photography because it was not technically possible to produce it. This explanation finds some support in the difference between the photographic media that Llewelyn used to take the two photographs. Llewelyn made the photograph of the heron with a photographic process that was not available when the deer photograph was taken.

The photograph of the deer was made with Talbot's calotype process, while the heron photograph was made with the oxymel process. The calotype process, discovered by Talbot in 1840 and patented in 1841, used a paper negative and a paper positive.[43] Talbot's work on the process was sparked in response to the French artist and entrepreneur Louis-Jacques-Mandé Daguerre's

(1787–1851) 1839 announcement of the daguerreotype process, which created a single, irreproducible image on a silver positive plate. Talbot's paper process was cheaper and used less dangerous chemicals; the daguerreotype was developed in mercury vapor. While it was thus more attractive to amateurs, the calotype lacked the precise detail of the daguerreotype and was not as widely used in the 1840s.[44]

In 1852 Llewelyn's use of calotype was on the verge of becoming old-fashioned. The wet collodion process was introduced in 1851 and quickly became widespread.[45] The process used a mixture of gun cotton and ether (collodion) on a glass plate to make the negative. The collodion process required a "wet plate"; once coated with solution, the plate had to be exposed and developed before the solution dried. While cumbersome, the process enabled photographers to make multiple prints with the depth and clarity of the daguerreotype. To do outdoor photography, photographers had to carry a portable darkroom into the field along with photographic chemicals in fragile glass vials. Despite the difficulty, the collodion process led to a surge in outdoor photography. Llewelyn adapted the oxymel process from the collodion process in 1856 to facilitate taking outdoor photographs. Llewelyn's process coated the glass plate with a honey and vinegar mixture (oxymel) that kept the plate moist and greatly extended the time that could elapse between sensitizing and developing the plate, allowing it to be both coated and developed in the studio.[46]

Given the difference in photographic technologies, it might be suggested that the difference in the image of the animal between the two images is the result of their different photographic technologies. The difference between the two images would then reduce to a difference in photographic technology, and the intervening technological development would explain their distance from contemporary practice. However, while the oxymel process produced sharper images than the calotype, its exposure times were still long enough to make the exposure of unconfined, live

animals exceedingly difficult. Instead, the difference in the appearance of the specimens is due to the species involved and the development of taxidermic technology. Bird taxidermy has always outpaced large animal taxidermy, and it was not until the 1890s that what contemporary viewers would think of as lifelike large animals were created.[47] The attempt to account for the strangeness of early animal photography through technical development projects a smoothly unfolding development of animal photography running alongside the development of photographic technology. It also effaces the strangeness of the images by reducing them to a prefiguration of contemporary practice. Llewelyn's images would then function as a record of a desire thwarted by the limitations of technology.[48] Such an argument does not take in to account either the variety of animal photography at the time or the variety of Llewelyn's own photographic practice. This becomes clear when we place Llewelyn's animal photographs in the context of nineteenth-century animal photography.

While he made many such images, Llewelyn was not the only photographer to make pictures of stuffed animals in nature.[49] According to Harker, Talbot produced an image of two stuffed deer in the 1840s, "which were made to look as lifelike as possible, one seated and the other standing and apparently cropping grass" (24). In 1842 the Scottish brothers John (1809–70) and Robert Adamson (1821–48) made photographs of stuffed animals from the collection at St. Andrews University.[50] Robert Adamson became well known as a calotypist through his partnership with the Scottish painter David Octavius Hill (1802–70). During their brief collaboration, from 1843 to 1847, Hill and Adamson produced several thousand calotypes that have been described as the first art photographs.[51] Llewelyn, and other photographers, also produced photographs of live animals. Talbot photographed Elizabeth Barrett Browning's sleeping dog in the 1840s.[52] In 1853 Llewelyn made a picture, titled *Donkey Party*, showing his daughter Elinor riding a donkey held by her mother, Emma.[53] Llewelyn's image was part

of a larger trend toward photographing domesticated animals in the 1850s. As Harker notes, "distant views of horses and carriage and domestic pets asleep or which had been trained to remain still appear more regularly in albums of the period" (24). Llewelyn's younger sister, Mary Dillwyn (1816–1906), photographed pigeons on a roof at Singleton in the early 1850s.[54] Dillwyn's photograph could be considered a photograph of wild birds and thus a wild-life photograph. Yet, because the image was taken in a clearly domestic setting and pigeons are not typically seen as "wild" ani-mals in contemporary understanding, the image does not read as a wildlife photograph. Instead, it highlights the difficulty in policing the boundaries of wildness inherent in bringing contemporary standards of wildlife photography to early photography.

Most of the images of "wild" animals from the time were taken in captivity. Llewelyn took a collodion negative of a great horned owl as well as a photograph of lion cubs with the keeper's son at the Clifton Zoological Gardens at Bristol in 1854.[55] Zoo-logical photography became an important part of nineteenth-century animal photography. In 1855 Don Juan, comte de Mon-tizón (1822–87) made the earliest surviving photograph from the London Zoo. His image of a sleeping hippopotamus shows the animal lying beside its pool with a crowd of onlookers visible behind it through the bars. Others followed in de Montizón's footsteps, and zoos became an important site of animal photog-raphy. Frank Haes (1832–1916) made eleven-second exposures of lions at the London Zoo in the 1860s.[56] Zoo photography pro-duced some of the only photographs we have of extinct animals. For example, Haes photographed the last quagga in 1870.

Alongside images of living and stuffed animals, photogra-phers also made images of dead animals. In 1850s, the English photographer Roger Fenton (1819–69), among others, photo-graphed still life groups of dead fish and game as aesthetic sub-jects.[57] The South African elephant hunter James Chapman (1831–72) mounted an expedition in 1850s to take pictures of

African game animals but ended up taking pictures only of the animals he shot.[58] In 1857, the English explorer and photographer Francis Frith (1822–98) produced a stereograph of a crocodile on the banks of the Nile in Egypt, which Carol Armstrong suggests is presumably stuffed.[59] However, one observer at the time believed the crocodile in Frith's photograph was asleep. As Elaine Evans describes, "In its January 1, 1858 issue, *The Times* of London noted, 'You look through your stereoscope, and straightway you stand beside the fabled Nile, watching the crocodile asleep upon its sandy shore, with the superb ruins of Philae in the distance.'"[60] Colonial photographers also produced images of dead animals as part of their documentation of the hunt. For example, William Willoughby Hooper (1837–1912) photographed a dead tiger posed after the hunt in the 1860s.[61]

Following André Adolphe Eugène Disdéri's (1819–89) invention of the multiple-lens carte-de-visite camera in 1854, the middle and upper classes began circulating portrait photographs of themselves as part of bourgeois social interaction.[62] To meet this demand, professional photographers set up studios to make carte-de-visite photographs filled with socially appropriate props and backdrops. Some studios had stuffed dogs and horses to pose with clients, and as technical developments shortened exposure times, studios began producing photographs of people and their pets.[63] These images presented animals as social markers, status symbols, and family members. Choosing to focus on champion hunting animals, instead of pets, Léon Cremière (1831–1913) created an album of French coursing dogs in 1865.[64] Animals were also photographed for scientific purposes. Derek Bousé, in his book on the history of wildlife films, suggests that the photographs of nesting penguins and albatrosses produced by the 1872–76 *Challenger* expedition, as part of their project of scientific documentation, were the first wildlife photographs.[65] With the introduction of practical and effective dry plates in the 1880s, it became possible for amateur photographers to produce images of birds on

the wing. Benjamin Wyles produced images of shorebirds in 1888 and published the images in *Stand* magazine in 1892.[66] The English photographer R. B. Lodge (Reginald Badham) (1852-1936) began photographing birds in the early 1890s.[67] His compatriots Richard (1862-1928) and Cherry Kearton (1871-1940) began photographing birds around the same time and published their first book of bird photographs, *British Birds' Nests,* in 1895.[68]

What this brief history of nineteenth-century animal photography shows is that nineteenth-century animal photographs were produced for a variety of purposes that are not reducible to a desire to make wildlife photographs. More importantly, any attempt to explain early animal photography in terms of contemporary understandings of wildlife photography is significantly complicated by Jonathan Burt's work on the animal as a historical agent driving the technological development of film and photography. Burt reminds us that the animal is integral to the development of photographic technology. "Rather than simply being a suitable subject for photography, the animal presented technical and conceptual problems whose solution helped advance the technology of film making."[69] Animals were not simply one photographic subject among many. They were one of the key subjects driving the technical development of photography. Human subjects adapted themselves to the technology of photography (e.g., wearing back braces for early portraits), whereas animal subjects necessitated the adaptation of photographic technology to their situation.

The main figures who developed photographic technology through the attempt to image the animal body were the Prussian photographer Ottomar Anschütz (1846-1907), the English photographer Eadweard Muybridge (1830-1904), and the French scientist Étienne-Jules Marey (1830-1904).[70] Muybridge began his experiments with horse photography in 1872 at the request of railway magnate and former governor of California Leland Stanford. Stanford sought visual proof of the motion of the horse's

legs to determine "whether or not there were moments in the stride of a galloping or trotting horse when it was entirely free of the ground."[71] Muybridge's first attempts to capture a single definitive image were unsuccessful. However, he returned to the problem in 1876 and began, under the direction of Stanford, to seek instead a series of photographs of the horse in motion. Marta Braun suggests that Stanford's understanding of the project changed due to his exposure to Marey's work on the mechanics of animal motion.[72] Muybridge installed a battery of cameras at Stanford's racetrack in Palo Alto. Crossing the track were trip wires connected to the cameras' shutter releases. Behind the track Muybridge placed a panel with vertical lines marking off the distance to provide a legible backdrop for the horse's motion. Muybridge's experiments succeeded in June 1878 in producing serial images of the horse in motion, and the resulting images were widely reproduced. Muybridge's images were enormously successful, and he developed the zoopraxiscope, a magic lantern with a revolving circular disk with painted images of the horse in motion, to accompany his lectures.

In 1881, Stanford sent Muybridge to Paris, where he met Marey. While Marey was initially excited by Muybridge's work, he soon became convinced that the multiple cameras and imprecise timing between exposures meant that Muybridge's technique was ultimately useless for his purpose of scientifically documenting animal motion. Instead, Marey developed his own photographic techniques beginning with his photographic gun. Marey's gun, which used a revolving plate with a single negative to capture motion, enabled him to take pictures of birds on the wing in 1882. By precisely controlling the speed of the revolution and the operation of the shutter, Marey was able to create images from which accurate measurements of movement could be taken. Marey later used a revolving shutter, in place of the revolving plate, to create images of animal motion on a single plate in front of a black backdrop.

While Marey was developing the scientific uses of photography for capturing motion, Muybridge was creating an encyclopedia of animal movement for the use of artists and scientists. In 1884, at the invitation of the American painter Thomas Eakins (1844–1916), Muybridge moved to the University of Pennsylvania to continue his work photographing animals. In 1887, he published *Animal Locomotion,* an eleven-volume work containing 781 plates of animals and humans in motion. Lewis S. Brown breaks the plates down as follows: "Nearly three-quarters of the plates in the original *Animal Locomotion* dealt with the human figure, but there were 219 on the motion of birds and beasts—95 on horses, 40 on mules, asses, oxen and other domestic mammals, 57 on wild animals (in which category Muybridge put camels and elephants), and 27 on birds."[73] The wild animal subjects for the work came from the Philadelphia Zoo. Muybridge's work in *Animal Locomotion* attempted to contribute to both science and aesthetics. While his work involved "wild" animals, the animals involved did not conform to the logics of wildlife photography.

Inspired in part by Muybridge's images of the horse in motion, Anschütz began experimenting in the early 1880s with fast shutters to enable photography of animals in motion. His experiments produced the focal plane shutter, which he patented in 1888.[74] Focal plane shutters—in which an opening sweeps across the negative rather than opening and shutting—allowed exposure times of 1/1000th of a second. Anschütz's shutter formed the basis of modern shutter technology. With it, he photographed flying and nesting storks in 1884, producing a series of images that built his reputation. In the late 1880s he photographed animals in zoos and game preserves, and in 1886 he produced a series of photographs of roe deer.[75] Anschütz also invented an early motion picture projector, which he called a projecting electrotachyscope, and used it to present his photographs of animals.

Muybridge, Marey, and Anschütz made key contributions to the development of "instantaneous" photography and film.[76]

Their images shaped the social perception of animals and became the standard for animal representation.[77] However, as Burt has noted, the centrality of animals to their work has been effaced by a scholarly emphasis on the role of the chronophotography in the technologization of the body.[78] Burt's point is not to deny the importance of this work in the disciplining of the body but rather to highlight its role in structuring human-animal relations. Animal images are always produced within a human-animal relation. Early animal photography was not only intimately involved in the development of photographic technology but also implicated in structuring the social conception of animals. The differences between early animal photography and wildlife photography cannot simply be explained away by increased technical capabilities. The attempt to image the animal body was integral to the development of the photographic technology necessary for the production of wildlife images.[79] Thus, it cannot then be said that the wildlife image was an ideal inherent in the development of photographic technology. The desire to photograph animals is not equivalent to the desire to produce wildlife photography. It is necessary instead to grapple with the specificity of animal photography's cultural imbrication. This is the very imbrication that wildlife photography denies through its naturalization of the image.

CHAPTER 2

Camera Hunting in America

Writing in 1900, the American critic James B. Carrington claimed that "as a test of skill in bagging game there is no comparison between the gun and the camera."[1] In other words, he argued that hunting animals with a camera was more difficult than hunting with a gun. To justify this claim, Carrington suggested that "to get a picture of some shy animal or bird calls for all the resources and knowledge of woodcraft that the best of sportsmen may command, and pits the intelligence of one against the other" (455). Animal photography was more difficult and demanding than gun hunting and thus a truer test of woodcraft. Carrington described animal photography as both a test of woodcraft and a means of bagging game. In doing so, he treated animal photography as a form of hunting. He claimed the camera was superior to the rifle, and the camera hunter to the rifle hunter. In making this comparison of camera and gun, Carrington was advocating the practice of camera hunting.

The American practice of camera hunting developed in the early 1890s. In camera hunting photographers attempted to capture images of birds and animals in their native haunts. They claimed that photographing animals in nature *was* hunting because photographing animals required all the skills of hunting. While the camera hunters promoted the camera as an alternative to the rifle, they stressed that choosing the camera did not mean abandoning hunting.[2] Rather, they celebrated the camera as a superior instrument for hunting because of the greater degree of skill and prowess required for its use. For the camera hunters, the essence of hunting lay in the chase and not the kill.

In thinking of their photography as hunting, the camera hunters saw their photographs as hunting trophies. The camera hunters circulated and displayed their images as hunting trophies; the photographs connected photographer and animal and stood as a monument to the photographer's prowess. Although the rhetoric around these images focused almost entirely on what happened in the woods, the locus of camera hunting took place in sporting journals and general interest magazines. The practice depended on a confluence of American attitudes to nature, technological development, and gender identities. Once this balance shifted, camera hunting ceased to be taken literally, and it has since become difficult for us to see these images as hunting trophies.

Camera hunting occupied the nexus of a number of issues engaging America at the end of the nineteenth century. It constructed an idealized relation to nature in the face of modernity and industrialization by integrating attitudes toward nature, animals, hunting, and masculinity in a period of intense technological change. To make sense of this phenomenon, it is necessary to closely consider the turn-of-the-century American camera hunter's practice. This entails analyzing how photographers came to claim animal photography as hunting. In the camera hunters' description of photography as hunting the term *hunting* does not operate in the ironic sense with which contemporary critics speak of a

camera safari.[3] Given camera hunting's distance from the contemporary understanding of animal photography (its apotheosis in the genre of wildlife photography), I situate camera hunting within its historical context in order to bring its operations into focus.[4]

THE DEVELOPMENT OF OUTDOOR ANIMAL PHOTOGRAPHY

Unlike humans, animal subjects were not easily adjusted to nineteenth-century photography's need for stasis. Humans adjusted themselves to the requirements of the technology by immobilizing themselves with clamps and braces. Although humans might be willing to wear a back brace in order to sit without moving for an extended period of time, animals—particularly wild animals—moved too much to be easily captured by the early camera. As photographic technology developed (and exposure times shortened), animals began to more regularly appear in photographic representation, although, as was discussed in the previous chapter, most of the animals that appeared were dead, tame, or in zoos.[5] The practice of camera hunting developed shortly after it became technologically feasible to regularly take photographs of unconfined live animals in nature. It began after the development of, among other things, dry-plate film and focal-plane shutters, which enabled photographers to consider pursuing images of such fast-moving and potentially uncooperative subjects as animals in nature. However, the development of camera hunting is not accounted for simply by the technological development of photography. While the technology of photography provides the constraints for photographic practices and determines their limits, the function of photographs is articulated in relation to their social context.

That being said, it is difficult to overstress the degree to which these new photographic processes simplified outdoor photography. Outdoor photography using collodion wet plates entailed significant difficulties. In this regard, Worth Mathewson is a

study in understatement when he writes that "early photographic equipment did not lend itself easily to fieldwork."[6] Glass-plate photography was cumbersome, fragile, and difficult. The materials involved were delicate and easily broken. Photographers using glass plates in the collodion wet-plate process had to deal with the logistical difficulties of transporting large and fragile glass plates as well as the effects of working with ether in the confined spaces of the darkroom tent.[7] However, the rewards of the process were such that photographers were willing to deal with the difficulties. Philip Stokes argues that "such was the potential of their process, that photographers felt justified in looking with equanimity upon the logistics of packing cameras and darkroom kits sufficient to handle plates larger than most modern photographers can imagine."[8] Nineteenth-century outdoor photography, particularly of the kind practiced in the American West, was a difficult, painstaking process. However, this process, as Stokes suggests, produced breathtaking images of the American landscape that were regarded as near hallucinogenic in their level of detail.[9]

Appreciating the difficulty of outdoor wet-plate photography allows us to understand the revolutionary impact of simplified processes on outdoor photography. It also allows us to better understand photographing animals in nature as a historical problem, and it makes those images of animals obtained before the development of dry plates all the more impressive. The new photographic processes made photographing animals feasible but not easy. After the development of "snapshot" technology—cameras and film fast enough to capture an instant—it was still necessary to find an animal and get close to it in order to take its picture.

The reproduction of photographs also underwent a technological revolution in the late 1880s and early 1890s. Although photography had automatically reproduced reality, it was itself very difficult to reproduce. As Estelle Jussim notes, "while photography seemed the ultimate in the mechanization of visual information, it could not itself be easily mechanized."[10] Prior to

the 1890s, developing and circulating images were difficult. For example, in his discussion of Western expeditionary photography, Weston Naef says that in the 1860s a single negative could take an hour to develop, and a photographer might only produce fifteen photographs in a long day's work.[11] Given these limitations, any sort of mass dissemination required the circulation of photographs in reproduction. Lithography (and other printmaking processes) allowed for the mass reproduction of photographic images. However, as Naef notes, "When photographs were transferred to a stone for printing they were robbed of their resolution" (71). Thus while wet-plate photographs were highly detailed, they were costly and difficult to publish and so often circulated as drawings after the image.[12]

The development of the halftone reproduction process resolved the difficulties involved in reproducing photographs. First patented in 1881 by Frederic Ives, the halftone process allowed mechanically produced photographic reproductions to be printed on the same page as text. The 1880s saw the continuous refinement of the process, and by the early 1890s, halftone reproduction was fast, cheap, and in widespread use. The resulting proliferation of photographic imagery changed magazine and newspaper publishing. It also, some argue, marked a shift to the modern image economy of "visual consumption."[13]

The development of new photographic processes changed not only what could be and what therefore was photographed, but also who photographed it, and how those photographs circulated and functioned. The developments in photographic technology that enabled animal photography undermined the earlier generation of entrepreneurial photographers in the American West. Among the significant figures in this generation of photographers were Carlton Watkins (1829–1916), William Henry Jackson (1843–1942), and Timothy O'Sullivan (ca. 1840–82). All of these figures found their practices changed by the onset of what John Tagg has called "the era of throwaway images."[14] As Peter Hales

notes, the new photographic technologies simplified image pro-
duction, which, combined with new printing techniques, made
"professional photography technically easy."[15] This resulted in
what Hales describes as "a glut in negatives that corresponded
with the glut in reproduced and distributed images" (198). Hales
argues that the surplus of images made possible by the new tech-
nologies led to

> the steady phasing out of the photographic entrepreneur as the
> quintessential figure in American photography and his replace-
> ment on the one hand by wage-earning members of larger con-
> glomerates and on the other by gentleman amateurs seeking to
> redirect photography into the central streams of fine art print-
> making. (198)

Hales's description of the new photographers reproduces the cen-
tral art historical distinction between art photography and com-
mercial imagery. Art photographers framed this distinction during
the late nineteenth and early twentieth century in order to justify
their practice and distinguish it from commercial and amateur
imagery.[16] The camera hunters, however, belonged to neither cat-
egory. The camera hunters were amateur photographers who took
advantage of the new photographic possibilities without framing
their work in terms of art and without becoming subsumed into
larger conglomerates. Their photography participated in another
discursive space.

CAMERA HUNTING'S DISCURSIVE SPACE

Rosalind Krauss articulated the idea of photography's discursive
spaces in her analysis of O'Sullivan's work as the official photogra-
pher for the Geological Exploration of the Fortieth Parallel.[17] Her
concept of a discursive space draws on Michel Foucault's descrip-
tion of discursive formations in the *Archaeology of Knowledge*.[18]
For Krauss, a discursive space is made up of the historically spe-
cific requirements, the practices, institutions, and relationships,

shaping the image and in relation to which the image forms a coherent discourse.[19] Krauss argues that nineteenth-century landscape photography was articulated through its intended mode of circulation and display. She thus distinguishes between two main modalities of mid-nineteenth-century American landscape photography based on their relation to display. These modalities are the landscape—traditional aesthetic imagery incorporating the space of exhibitionality—and the view—scientific and expeditionary photography destined for reports and archives. According to Krauss,

> The one composes an image of geographic order; the other represents the space of an autonomous Art and its idealized, specialized History, which is constituted by aesthetic discourse. (141)

Krauss argues that given the centrality of landscape to the formative questions of art history, it is unsurprising that art historians have tended to interpret those photographs that she describes as views through the framework formed by landscape art. Yet she is unequivocal in asserting that to do so imports a number of concepts including artist, career, and oeuvre into a discourse that "not only tends not to support but in fact opens to question" these very notions (142).

Krauss's interpretation of O'Sullivan's work is controversial. Joel Snyder questions Krauss's analysis of O'Sullivan's work and argues that O'Sullivan's photography is not scientific but disciplinary.[20] While I find Snyder's points provocative, his rethinking of Krauss's position does not challenge her argument that the photographs are not landscapes in the traditional art historical sense, nor does he disturb her link between photographic function and display. Instead, Snyder sharpens Krauss's reading by specifying that the photographs' contribution was to the discipline of geology rather than the larger, and vaguer, space of science. This sharpening of Krauss's argument is continued in Robin Kelsey's thorough reexamination of O'Sullivan's prac-

tice.[21] Kelsey's detailed examination of the production and circulation of O'Sullivan's work nuances Krauss's argument by showing how O'Sullivan's work came to incorporate the visual language of geology into its structure. Estelle Jussim and Elizabeth Lindquist-Cock have also questioned Krauss's interpretation of O'Sullivan's work. They argue that despite the scientific function of O'Sullivan's photographs his images may still be shaped by aesthetic considerations and thus open to aesthetic analysis.[22] While I believe that Jussim and Lindquist-Cock are right, I do not see their argument as undermining Krauss's larger point. She is not arguing that the photographs are poorly composed or without aesthetic interest. Krauss is arguing that to interpret these photographs through traditional art historical categories is to ignore both the conditions of their production and their discursive function and thus fail to understand them. Yet, as François Brunet points out, given the multiple contexts (both internal and external) in which these images circulated, it is difficult to specify a single original context for them.[23]

In thinking of camera hunting as a discursive space, I am thus asserting that camera hunting forms a coherent discourse that is distinct from the photographic discourses of the landscape and the view. I am also arguing that the discourse of camera hunting is not homogeneous with traditional art historical categories of interpretation. Specifying camera hunting's discursive space requires an analysis of the institutional structures shaping its relation to display and a description of the field of practices regulating its articulation.

CAPTURING ANIMALS: HUNTING TECHNIQUES AND ANIMAL PHOTOGRAPHY

By the late 1880s technical advancements in photographic equipment made photographing animals in nature possible, if difficult. Technical advances in photography continued to simplify the photographic process during this time period. However, the dif-

ficulties involved in obtaining images of animals in nature were not solvable simply by improvements in photographic technology. To make successful images, photographers needed to bring about the proximity of animal and camera under appropriate light conditions. Although in the early 1890s cameras were fast enough to capture mobile objects, the limited focal length of the available fast lenses necessitated close proximity to the subject for a decent exposure.[24] This need for close proximity created difficulties for photographers attempting to take pictures of wary game animals in the wild. To solve the problem of obtaining images of unwilling and non-posing animal subjects at close range, the camera hunters availed themselves of hunting techniques.[25] These included blind-hunting, set-gun hunting, jacklighting, and dog hunting.

In blind-hunting hunters hide behind a wall or screen and shoot the animals from behind it (see Figure 19). Hunters generally set blinds up next to a water hole or game trail and then wait inside for animals to arrive. In some cases they actively solicit the animals from within the blind using mating calls, decoys, or bait. In the photographic version of blind-hunting the camera and operator hide in the blind and wait for the animal to come into focus. Initially the camera hunters followed traditional blind-hunting practice and "shot" animals from ambush. Later, the modern practice of the photographic blind developed in which photographers set up a blind next to a nest or animal den and use it to erase the photographer's presence.[26]

In set-gun hunting, the hunter hooks a shotgun up to a trip wire running across a game trail. This is a poacher's technique and is highly dangerous. The set-gun was one of the first "hunting" techniques to be outlawed in America. In set-camera hunting the photographer focuses the camera on a game trail, watering hole, or piece of bait attached to a triggering mechanism (Figure 3).[27] This practice was often described as getting the animal to take its own picture. For example, in 1897 *Scientific American* provided the following description of the practice:

FIGURE 3. George Shiras 3d, This was the First Animal to take its own Picture, 1891. George Shiras / National Geographic Image Collection.

The apparatus by which the deer was made to photograph itself was arranged by Mr. Charles Hughes, of Red Bluff, California, who conceived of the idea of causing a wild animal to take a flashlight photograph as it passed along a trail in the Coast Range of mountains under the cover of night.[28]

In jacklighting hunters go out at night with a lantern (Figure 4). The light fascinates deer, who freeze when it shines in their eyes. The hunter sees the reflection of the light in their eyes and simply fires between them. This practice came to be seen as unsportsmanlike and was one of the first hunting techniques to be broadly banned. Jacklighting with a camera also takes place at night. The

FIGURE 4. George Shiras 3d, These Flashlight Hunters in 1892 were the Pioneers of the Sport, 1893. George Shiras / National Geographic Image Collection.

photographer freezes animals with a light and then exposes them to the camera with a flash.

In dog hunting, the hunter sets dogs on the trail of an animal. The hunter follows the hounds until they either tree the animal or bring it to bay. In dog hunting with a camera, the photographer uses dogs to track down and immobilize the animal, either by treeing it or bringing it to bay, in order to photograph it (Figure 5). One writer described this technique in an article on William E. Carlin's animal photography:

> They followed with dogs till they caught up with the snarling creature, and then, planting the camera a yard from his face, Mr. Carlin growled till the lynx set back his ears and looked ugly. At

FIGURE 5. Allen Grant Wallihan, *Brought to Bay*, 1894.

that moment he was "snapped." It went against the grain to kill him afterward, but as "lynxes is varmints," as an old trapper used to say, they had to.[29]

In this example, while obtaining the image was the impetus for the chase, photography was only a stage in the hunting process that culminated in the death of the animal.

All of these techniques used hunting practices to obtain photographic access to animals. Photographers employed hunting technologies in order to produce animal images. The relation between these images and hunting was productive; structurally the technologies of hunting shaped the images. Traces of these hunting techniques mark the surface of these images. They can be seen in the startled, frightened, and angry animals engaging with both the camera and the photographer in these images. This marking of the image with the moment of contact emphasizes the interaction and proximity of the photographer and the animal.

However, the use of hunting techniques in the production of these images, while significant for understanding the physical structure of camera hunting, is insufficient for explaining its discursive structure. Contemporary animal photographers continue to use hunting techniques to produce their images yet no longer conceive of their practice as a literal form of hunting. Contemporary animal photography also no longer emphasizes the individual photographer's contact with the animal and no longer conceives of the resulting photographs as hunting trophies. Contemporary wildlife photography relies extensively on the photographic blind and the telephoto lens. These techniques structure the images they produce in a different manner than the application of more intrusive hunting techniques. John Berger argues that these techniques inscribe an invisibility in the photograph:

> Technically the devices used to obtain ever more arresting images—hidden cameras, telescopic lenses, flashlights, remote controls and so on—combine to produce pictures which carry

with them numerous indications of their normal *invisibility*. The images exist thanks to a technical clairvoyance.[30]

Although engaging with the technical elements involved in camera hunting is important to understanding its operations, the analysis of camera hunting has to go beyond its technical conditions. It requires an analysis of the social and cultural surround within which the photographs circulated and that constituted camera hunting's discursive space. This entails a shift in focus from the images' production to their circulation as hunting trophies.

TROPHY SHOTS: DEAD ANIMAL PHOTOGRAPHY

A typical nineteenth-century trophy photograph—such as the photograph by Shiras of A. O. Jopling and a whitetail buck—displays the hunter alongside *his* kill (Figure 6).[31] In this photograph, Jopling stands, rifle in hand, next to a strung-up buck.[32] The figures pose in front of a log cabin, indicating they are at a hunting lodge or camp. Jopling gazes admiringly at his prize, inviting us to gaze on it as well. Shiras's extended caption tells us that this is "a fine buck" of "extraordinary size" and describes Jopling as a "successful hunter."[33] In telling us this, the caption appears to simply reinforce and repeat the message of the image. A satisfied man with a gun standing next to the displayed carcass of a dead deer reads as the image of a successful hunter.[34] Yet without the caption we would no longer read the image in terms of Jopling's prowess.[35] We would instead see the photograph as a generic image of a nineteenth-century hunter and game rather than as the image of a specific hunter's trophy. The photograph offers a second-order display; it shows Jopling's display of his deer, moving that performance of prowess from a local economy of exhibiting one's kill at the hunting camp to a potentially general economy.[36] Jopling's strung-up deer is not just displayed to the boys at the camp; its being photographed means we can all "appreciate" Jopling's success.

FIGURE 6. George Shiras 3d, A Fine Buck is the Trophy Displayed at the end of the Log Cabin Built in 1856, 1933. George Shiras / National Geographic Image Collection.

Shiras's photograph is one of many nineteenth-century trophy photographs. Photographs of dead animals were a common component of colonial expeditions and hunting parties by the second half of the nineteenth century. As James Ryan notes, "Such photographs of white men with dead animals or antlers, tusks and skins are a common, even clichéd, feature of Victorian and Edwardian colonial photography."[37] These images take a variety of forms and emerge from a variety of hunting contexts. Some trophy photographs include the hunter with a collection of his trophies, for example, Cherry Kearton's photograph of a Highland gamekeeper (Figure 7). Other trophy photographs present a collection of animals or animal parts displayed by themselves. Occasionally the images present women with their kills, such as the photograph of Mary Wallihan standing over two dead deer (Figure 8).[38] Common to all these images is the display of the dead animal as testimony to the hunter's prowess.[39] Investigat-

FIGURE 7. Cherry Kearton, *Highland Gamekeeper with Trophies*, 1897.

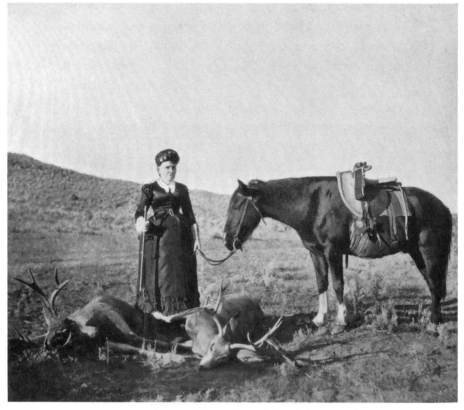

FIGURE 8. Allen Grant Wallihan, *Mrs. Wallihan's Double Shot*, 1894.

ing how the animal photograph comes to function as a display of
prowess will provide a key to understanding its use as a trophy.

Trophies can be divided into two types: (1) those in which
the trophy is indexically related to the endeavor, and (2) those
in which the trophy is an external symbol of accomplishment.[40]
Hunting trophies are the result of the activity of the hunter, and
they have an indexical relation to the activity that they represent.
Only by killing or capturing the animal is there a trophy. Sporting
trophies are cultural symbols. For example, although there is a
mythic relation linking laurel leaves to accomplishment in sport,
they are not produced in or through sporting competition.[41] As

trophies, animal bodies figure indexically the success of a hunter, and, in a synecdochic relation, certain prized animal parts come to stand in for the whole. Thus, antlers, heads, and tusks can come to stand in for the whole of the animal by symbolizing the kill. However, other animal parts escape the trophy relation. Elk teeth watch fobs, feather hats, and fur coats all tend to obscure their indexical connection to a hunter. They function instead as objects of a more general status display.[42] What generally separates the animal trophy from status display is its separation from a monetary economy; a trophy must be earned, not bought.

Although animal trophies are intrinsic to the practice of hunting, the trophy still needs to be produced. Dead animals decay or are cooked and eaten and disappear. When the animal body disappears, the trophy disappears along with it.[43] For this reason, animals are often represented by body parts, such as antlers, that are easier to produce in the field and that can more easily be brought back from it. Nineteenth-century hunters learned taxidermy from books on preparing natural history specimens. Taxidermy required preparation of the kill in the field. The animal had to be dressed, and the skin treated and preserved. The connection between nineteenth-century natural history and hunting was strong. Collecting was a central component of natural history until the early twentieth century. Many naturalists were avid hunters, and as the nineteenth century wore on and conservation became an issue, scientific collecting became a cover that allowed individuals to continue hunting without facing social opprobrium or legal sanction.

Trophies are connected to economies of display. Although trophies are connected to performance within the arena in which they are obtained, their function as objects of display often participates in broader economies of status and display. As was discussed in chapter 1, Ryan argues that in the British colonial context trophies (and trophy photographs) functioned as evidence of imperial power.[44] In nineteenth-century America, however,

hunting trophies connected to nationalism through their symbol-ization of masculinity. They provided evidence of the virile mas-culinity that was believed to result from contact with the frontier and indicated their owner's rightful possession of the continent as a true American native.[45] This difference in function results from a difference in hunting culture.

The American hunting tradition differed markedly from the aristocratic tradition of England. Hunting was, at least ideally, a generalized pastime in the New World.[46] The ability of the gen-eral populace to hunt was promoted in the eighteenth century as a symbol of American liberty in opposition to English tyranny.[47] In practice, while hunting was available to all, other endeavors were generally more profitable. Only those without other pros-pects devoted themselves to hunting as a full-time occupation. By the nineteenth century, this caste of professional hunters had become an industry. Vast quantities of game were brought to the markets of New York and Boston. Nineteenth-century Americans enjoyed a far richer variety of meat than scarcely seems possible today. With the development of the railroad, game from out west became part of menus as well.

There was little recreational hunting in America prior to the 1850s.[48] As the country urbanized, incomes and leisure time rose, fostering an increased desire for recreation among Americans. Upper-class Americans became disconnected from nature and sought to reconnect through hunting. Camera hunting emerged in the context of this broader shift in North American hunting prac-tice. By the late nineteenth century, the status of hunters within American culture had risen considerably. At the beginning of the nineteenth century, farmers were at the center of the American self-image.[49] By the 1890s, the hunter's encounter with the wil-derness was seen as central to the forging of American identity.[50]

With the development of recreational hunting, the aristocratic ideal entered the American hunting scene in the figure of the sportsman. This sporting ideal had its origins in British hunt-

ing practice.[51] However, the meaning of sportsmanship changed radically over the latter half of the nineteenth century. As game populations dwindled, hunters became aware of the need for conservation, and the criteria for success as a hunter changed. Hunters were no longer judged solely by the quantity of game they killed, and massive kills were no longer considered the epitome of the sportsman's prowess.[52] Instead, an etiquette of the kill developed that emphasized elegance and fairness in hunting. This etiquette was promulgated by the newly established national periodicals devoted to hunting and outdoor sport. As John Reiger suggests, "With the establishment in the early 1870s of national periodicals like *American Sportsman, Forest and Stream,* and *Field and Stream,* outdoorsmen acquired a means of communicating with each other, and a rapid growth of group identity was the result."[53] This group identity was particularly strong among the upper classes and was articulated in terms of sportsmanship. This entailed subscribing both to the etiquette of sporting practice and to "an aesthetic appreciation of the whole context of sport that included a commitment to its perpetuation" (45).

The new sportsman engaged in a contest with the animal; only those kills in which the animal was given a "sporting" chance counted. This sense of contest became the crux of the new sportsman's code, displacing both quantity of kill *and* more pragmatic concerns such as supplying food from the proper purview of the hunter.[54] Both subsistence and market hunters, the majority of hunters, were placed outside the purview of the sportsman's code. Those who hunted out of necessity or for profit could never obtain the aesthetic detachment necessary to be considered sportsmen.[55]

Thus, in the late nineteenth century the sporting community constituted itself by declaring that only certain aristocratic hunters were "real hunters." On the basis of this distinction, sportsmen mobilized against other forms of hunting, successfully enacting statutes against them, including the Lacey Act of

1900. The Lacey Act outlawed the transport of game across state lines and effectively ended market hunting in America.[56] Game laws were enacted in part to preserve game for sportsmen at the expense of other hunters.[57] They maintained nature as a space for sportsmen to prove their virility.[58]

The changes in hunting law were supported by a shift in the general attitudes toward animals, reflected in the rise of animal protection societies and an increasing public interest in conservation.[59] This public support for conservation also led to conflict with hunters.[60] Americans began to see animals as beings endowed with intrinsic value. Although the initial focus of animal protection societies was on domestic animals, wild ones soon entered into their consideration. However, the moral biases of the animal protectionists held sway, and predators were condemned alongside human hunters, although both groups were united in their condemnation of predators as "varmints."[61]

The cultivation of American attitudes toward wildlife was part of a broader change in the American outlook on nature.[62] In the words of Ralph Lutts, "Americans were in the midst of a complex process of assimilating a new perspective on their relationships with the natural world" (71). Industrialization made nature both more accessible and less proximate. Although America was urbanizing, decreasing transportation costs made access to nature easier.[63] Americans began to experience nature through the mediation of technology and began to utilize nature itself as a form of technology. Access to nature, conceived as a source of national health and hygiene, was seen as a solution to urban degeneracy.[64] It was in this context that the practice of camera hunting took shape.

CAMERA HUNTING AND THE DISPLAY OF SPORTSMANSHIP

George Shiras 3d (1859–1942) published his first animal photograph in 1892 in the September 8 edition of *Forest and Stream*

DOE.

FIGURE 9. George Shiras 3d, *Doe*, 1892.

(Figure 9).[65] The photograph, titled *Doe*, was a roundel depicting a female deer crossing a stream. The deer occupies the center of the photograph, standing just slightly below the middle of the image. The doe is small in relation to the frame, occupying less than a fifth of the image. Overhanging branches fill the top of the image. Two tree trunks are discernible through the leaves.

These trunks frame the deer's head, acting like a pair of virtual antlers. The belly of the deer is level with the far bank of the stream. A fallen log on the bank forms a diagonal leading the eye back to the doe. The deer's head points toward the viewer, and its eyes are "riveted" on the camera.[66] Its ears are cocked toward the viewer, perhaps responding to the sound of the picture's taking. The deer's instinctive response to an unidentified potential threat—freezing with its head up to evaluate—has composed it for the image. The lack of motion that makes the deer invisible to predators has made it visible to the camera. This pose combined with the round frame gives the image the feeling of being taken through the scope of a rifle. This sense is not inappropriate: the image is an image of prey. In being photographed this deer has been hunted. Shiras's image belongs to the discourse of camera hunting—the image figures the animal's capture by the photographic hunter.

Shiras was the son of U.S. Supreme Court Justice George Shiras Jr. (1832–1924).[67] Shiras was an avid hunter from an early age, following in a family tradition of life in the bush. Born in Allegheny, Pennsylvania, Shiras obtained his bachelor of law from Yale in 1883. He was admitted to the Pennsylvania bar in 1883 and practiced law in his father's firm before entering public life. He was a Republican member of the Pennsylvania House of Representatives (1889–90) and a member of the U.S. Congress (1903–4). In 1905, Shiras retired from the practice of law and devoted his time to wildlife conservation. Throughout his life he was dedicated to the cause of conservation, and while in Congress he was one of the original sponsors of the Migratory Birds Act.[68]

Shiras's photograph was published as part of *Forest and Stream*'s first Amateur Photography Competition. *Forest and Stream* was one of several American sporting and outdoor magazines that began publishing after the Civil War.[69] By the 1890s it was the premiere sporting magazine in America. Like other magazines of its kind, *Forest and Stream* published articles on hunting, shoot-

ing, natural history, conservation, yachting, dogs, and general sportsmanship. The magazine was particularly known for stressing conservation more than other sporting magazines of the time. Its readers included hunting and sporting club members, and it often published the results of club competitions and the minutes of club meetings.

Forest and Stream's 1892 Amateur Photography Competition offered a series of prizes for images related to the magazine's field of interest: "game and fish (alive or dead), shooting and fishing, the camp, campers and camp life, sportsman travel by land or water."[70] The inspiration for the contest was the amateur photographs that readers had been sending to the magazine and that had recently become technically possible to cheaply reproduce.

The contest closed at the end of 1892, and in January 1893 *Forest and Stream* announced the awards committee for the competition.[71] The committee had three members: the photographer Edward Bierstadt (1824–1906),[72] the sportsman and public figure Theodore Roosevelt (1858–1919),[73] and the illustrator Thomas Wilmot. Of the three it was Roosevelt who would continue to play a role in the development of animal photography.[74] Although his deer photograph did not win any prizes from *Forest and Stream*, Shiras went on to become an important and award-winning animal photographer.

In the letter to the editor accompanying the image, Shiras described his photographic practice as "still-hunting" and described himself as a "camera hunter."[75] Shiras wrote that he appreciated *"Forest and Stream*'s advocacy [of] the new field open to sportsmen by the use of the camera in photographing live game" (203). Shiras saw himself as "one of the pioneers in this new sport" (203). Shiras's attempts at photographing deer had begun six years earlier, but his success had increased with improvements in camera technology.[76] He claimed to have produced thirty-two successful pictures of deer and approximately one hundred spoiled photographic plates.[77] While he felt that actual camera

hunting was too difficult for most, Shiras closed his letter by not-
ing the camera's usefulness in producing trophies and suggested
that the camera was superior to both rod and gun:

> While the instantaneous pictures of large game must necessarily
> be confined to a limited number of very patient sportsmen, yet
> the photographing of large game after killed affords an invalu-
> able souvenir in subsequent years. Then, too, the various oppor-
> tunities in camp make such an instrument the winner over both
> rod and gun after the flesh pot has been put away and recollec-
> tions and reminiscences must recall and recount the days gone
> by. (203)

While he described his practice as "still-hunting" and himself as
a "camera hunter," Shiras appeared to draw only a difference in
degree and not in kind between photographing live animals and
photographing dead ones—both produced lasting trophies. Shiras
sharpened these claims in his later publications on the subject,
but he continued to make the photograph's use as a trophy the
core of his defense of camera hunting.[78] His major publications
began in 1906 when he became the first animal photographer in
the *National Geographic* magazine.[79]

In treating his photography as a form of hunting, Shiras fol-
lowed the lead of the editor of *Forest and Stream*, George Bird
Grinnell (1849–1938). Grinnell was born in Brooklyn in 1849 and
grew up in Audubon Park in Ossining, New York, where he was
tutored as a child by Audubon's widow. Upon his death in 1938,
the *New York Times* called him "the father of American conser-
vation."[80] During his life, Grinnell wrote numerous books on
natural history, game hunting, and American Indian life. He ob-
tained a Ph.D. in paleontology from Yale in 1880. In 1876 Grin-
nell became the natural history editor of *Forest and Stream*, and
in 1880 he became its owner, editor, and publisher. He cofounded
the Boone and Crockett club in 1884 with Theodore Roosevelt,
which became the premier big-game hunting society in America.

Although an avid hunter, Grinnell used his public position to argue for conservation. He founded the first Audubon Society in 1886, and that organization successfully launched a campaign to protect wading birds from commercial hunting by stigmatizing the use of feathers in women's hats. He was also instrumental in the passage of the aforementioned Lacey Act.

Grinnell developed the concept of camera hunting in a pair of editorials published in 1892. It was in May 1892 that Grinnell first introduced the term *camera hunting*.[81] His editorial "Hunting with a Camera" drew its inspiration from an earlier article advocating "hunting without a gun."[82] Grinnell drew on its suggestion of gunless hunting by positioning camera hunting as a midpoint between hunting with a gun and hunting without one.

Grinnell appreciated the appeal of wandering the woods without a gun, and he believed gunless hunting allowed a closer communion with nature. The sportsman's relation to nature changed when he stopped seeing it as a target. Grinnell argued that when sportsmen abandon the desire to kill, they "become a part of the life of the woodland" (427). However, he felt this pastime was too refined for ordinary men and suggested that "for the average man, there is something lacking in hunting without a gun" (427). According to Grinnell, "Most of us are formed of very common clay, and we want to bring back something tangible, something that others can see, and touch, and talk about" (427). For this reason, he felt that gunless hunting could only appeal to those refined souls for "whom the spoils of the chase do not constitute the most important part of their outing" (427). While hunting without a gun produced deeply graven memories, it left them inaccessible to others. Simply put, hunting without a gun produced no trophies. No one else could see, touch, or share in the experiences the gunless hunter brought back from the woods. For those sportsmen concerned with bagging trophies (which he saw as the majority), gunless hunting failed to address the center of their activity.

Grinnell looked for a means of enjoying the benefits of gun-less hunting while producing "tangible" results. He found that means in the camera. Grinnell suggested that "something is needed which shall give more tangible results than hunting without a gun, and yet which shall preserve all its delightful features" (427). His solution was to replace the gun with the camera. In making this substitution, Grinnell equated the labor of photography with that of hunting. Photography used all the skills of hunting and added still more demands; thus its claim to be a sport.[83]

Grinnell returned to the theme of camera hunting in October 1892.[84] In an editorial titled "Shooting without a Gun" Grinnell sharpened the case for seeing animal photography as hunting. He began by defining the essence of sportsmanship as woodcraft and not marksmanship. Without "knowledge of the habits of game," he argued, "there cannot be completely successful sportsmanship, however skilled one may be in the use of the gun" (287). Marksmanship, which "may be acquired in great measure by practice at the fixed and flying target," was thus secondary to woodcraft as the true "test of sportsmanship" (287).

By defining sportsmanship as woodcraft and not marksmanship, Grinnell identified photography with hunting. Not only did photography require "all the skill of woodcraft that goes to the making of the successful hunter with the gun," the camera hunter needed more woodcraft, as he must draw "within closer range of his timid game than his brother of the gun need obtain" (287). He transferred this suggestion of superior skill on the part of the camera hunter to the camera itself, and argued that the camera hunter's weapon was superior to the gun. Despite leaving his prey intact, the camera hunter obtained trophies that outshone those of the gun hunter:

> His trophies the moth may not assail. His game touches a finer
> sense than the palate possesses, satisfies a nobler appetite than
> the stomach's craving, and furnishes forth a feast that, ever
> spread, ever invites, and never palls upon the taste. (287)

In arguing for the refinement of the camera's trophies, Grinnell associated gun hunting with the production of food. This association was significant for it struck at one of the central concerns of the American sportsman: distinguishing his noble practice from that of other hunters. This move neatly complemented Grinnell's initial definition of sportsmanship as skill because it was through their adoption of the code of sportsmanship that elite nineteenth-century hunters distinguished their practice from pot hunters and market hunters.

Grinnell emphasized the photograph's preservation of wildlife. Speaking of the camera hunter, he argued, "The wild world is not made the poorer by one life for his shot, nor nature's peace disturbed, nor her nicely adjusted balance jarred" (287). Rather than seeing the camera as a supplement to the sportsman's practice (in the earlier editorial he compared it to the sportsman's notebook), Grinnell now presented it as a superior substitute for the gun; the camera offered a better, more harmonious relation to nature, and it produced finer trophies.

Yet despite Grinnell's arguments, American animal photography of the time did not always mean a sparing of the animal. Many such photographs involved the death of the animal and often as an essential component of the image. For example, the issue of *Forest and Stream* for November 19, 1891, described a "Massachusetts man who had his Maine guide stall a big moose in the deep snow while he first photographed it and then deliberately shot it."[85] However, as an affront to the notion that photography automatically entails an escape from violence toward animals, there is perhaps no better example than the photographic project of one "Pigarth" (Mr. Brelsford of Harrisburg, Pennsylvania). As Pigarth expressed it, his ambition was "to get a photograph of a bird in the air the moment it was struck by a charge of shot."[86] To this end he invented a camera gun—a camera mounted on the end of a rifle-shaped stick.[87] He aimed the camera like a rifle while his assistant shot the birds. Pigarth claimed to have wasted

over "two hundred plates trying to get a picture of a bird the instant the shot struck it" (92). Concomitant with this wasting of photographic plates, of course, was the "wasting" of over two hundred ducks. It seems that the difference between early animal photography as hunting and straightforward trophy photography was a matter of whether the image was taken before, during, or after the moment the animal was killed.

As explained earlier, the relation between hunting and animal photography was driven in part by the difficulty of photographing animals. Given the state of photographic technology, hunting skill was needed to obtain these images. Yet, the leap to conceptualizing photography as hunting is not accounted for by this requirement. This can be seen by examining the work of a contemporaneous animal photography team who conceived of their initial work differently, even though their work revolved around the relation between animal photographs and hunting.

ALLEN GRANT AND MARY WALLIHAN: ANIMAL
PHOTOGRAPHY AS PRESERVATION

Allen Grant Wallihan (1859-1935) was a frontier postmaster who became a pioneering animal photographer and celebrated woodsman. Wallihan was born in Fortville, Wisconsin, in 1859. He became the postmaster at Lay, Colorado, in 1885. During his life he was involved in ranching and mining in Colorado. He began photographing animals in 1889 and had his first successful results in 1890. His wife, Mary Augusta Wallihan (née Higgins), was born in Milwaukee County, Wisconsin.[88] Mary assisted Allen Grant in his photography and was coauthor of their first book.[89] The Wallihans' 1894 book *Hoofs, Claws and Antlers of the Rocky Mountains* was the first book devoted to the photographing of animals in nature.[90] (The second edition of the book, published in 1902, added an introduction by Buffalo Bill.) The book was originally published in a numbered edition of one thousand and was illustrated with original photographic prints mounted on card.[91] In

the book the Wallihans showed images of freshly killed animals alongside images of live ones and described in detail how many of the live animals they photographed were shot shortly after exposure. Mary described their photographs as an attempt to preserve "the game in photography for the world at large."[92] Seeing the game as bound to disappear in the face of continued progress, they sought to document it for future generations so that they too could experience the animals. Describing the animals as game indicates they saw animals through the lens of hunting. While the Wallihans wanted to preserve animals, it was for use and not as free roaming wild animals. The centrality of the concept game to their understanding of animals can be seen in their photographs.

One of the more striking images from the book is *Mrs. Wallihan's 30th Deer* (Figure 10). The photograph depicts Mary Wallihan standing over a dead deer. The image was taken on an upslope with the camera looking uphill at Mary and the deer. She stands slightly right of center facing the camera with her rifle by her side. She is wearing a full-length print dress, cinched at the waist, and leather gloves. Her left hand appears to be pointing to the dead buck at her feet. The buck lies across the bottom of the image and obscures Mary's feet. His back hooves start at the left of the image, while his antlers stretch to the right edge. The deer lies on a cross slope, and its body slopes downward from left to right. The image is tightly framed: the deer's front legs reach almost to the bottom of the image, while Mary's head comes almost to the top. Mary is framed by a bush on the right and tree trunks on the left, and the clearing around her head provides a slight halo effect. Despite being on a hunting party, Mary is dressed in feminine garb that seems to make no concession to the rough ground and thick brush around her. She holds the rifle confidently and stares decisively at the camera. The image seems to assert that while Mary is quite competent in the woods, she is still feminine.[93]

Among the other images included in the book is *Treed at Last* (Figure 11). The image shows a cougar in the fork of a cedar tree

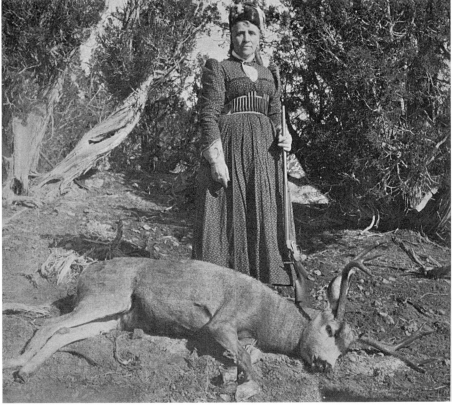

FIGURE 10. Allen Grant Wallihan, *Mrs. Wallihan's 30th Deer*, 1894.

shot from below. The cougar is centered in the image but is small in relation to the frame. The cougar is glimpsed through the dead branches of the tree. It is turned away from the viewer but is looking down at the camera. The image stages the encounter between animal and camera. The Wallihans produced the image by running the cougar down with a pack of dogs. They used the cougar's attempt to escape the dogs to enable them to photograph it. Although this is a form of hunting, it does not conform to Grinnell's understanding of the ideal relation between the photographer and his "prey." After being photographed, the cougar was shot.

FIGURE 11. Allen Grant Wallihan, *Treed at Last*, 1894.

It was in an article published a year later that Allen Grant Wallihan's photography was first addressed as camera hunting.[94] The article gave sole credit for the photographs to Wallihan and reprinted images from *Hoofs, Claws and Antlers*. The article includes the photograph *Treed at Last*, and the text describes the hunt for the cougar and its death after being photographed.[95] The article makes two key moves: it reconceives Wallihan's practice as hunting, and it erases his wife's contributions.[96] These two moves are linked: in order to function as hunting trophies the photographs must be seen as evidence of manly prowess.[97] Central to both Shiras's and Wallihan's photographic practice was the use of

animal photography and hunting as the production of manhood. In their claims to sportsmanship the emphasis is on the man. This emphasis was key to the workings of camera hunting. The centrality of manhood to camera hunting is most clearly articulated in Theodore Roosevelt's advocacy of the practice.

THEODORE ROOSEVELT ON CAMERA HUNTING, THE STRENUOUS LIFE, AND THE DISPLAY OF MASCULINE PROWESS

Inspired by Wallihan's photographs, Roosevelt argued for the importance of camera hunting in 1901.[98] His advocacy of both hunting *and* conservation led Roosevelt to be an early and avid advocate of camera hunting even though it did not lead him to alter his own hunting practices.[99] His article puts into play the majority of the issues surrounding camera hunting and deserves close analysis. Roosevelt saw camera hunting as form of sport that preserved game in the face of its rapid decline. He argued that Wallihan's photographs were not merely "records of a fascinating form of life that is passing away" (1549). Instead, he felt that these photographs "should act as spurs to all of us to try to see that this life does not wholly vanish" (1549). For Roosevelt these photographs addressed a national need. They encouraged conservation *and* engaged the populace in the strenuous life. Roosevelt argued fiercely for game preservation, suggesting "it will be a real misfortune if our wild animals disappear from mountain, plain and forest, to be found only, if at all, in great game preserves" (1549). He continued by linking conservation to the preservation of democracy:

> It is in the interest of all of us to see that there is ample and real protection for our game as for our woodlands. A true democracy, really alive to its opportunities, will insist upon such game protection, for it is in the interest of our people as a whole. More and more, as it becomes necessary to preserve the game, let us hope that the camera will largely supplant the rifle. (1549)

Roosevelt thought game protection was necessary because of the importance of hunting to the development of manly character. Without game there could be no hunting. He felt the chief importance of hunting and sport lay "in the physical hardihood for which the life calls," and he argued that the camera would allow the experience of hardihood while preserving the game (1549). Camera hunting produced the kind of virile citizenry that Roosevelt felt was essential to the health of the nation. Replacing the rifle with the camera would allow the nation to continue to experience the stimulus of hunting without completely destroying the game. Camera hunting was offered as a solution to the problem that increased population and industrialization had created for American nature. Roosevelt hoped that camera hunting might allow the continuing pursuit of sportsmanship in the face of modernity because it allowed the continuing experience of "physical hardihood" so essential to the strenuous life. In doing so, Roosevelt located camera hunting at the intersection of American attitudes toward nature, animals, hunting, and masculinity in a period of intense technological change.

The moral benefits of nature underlay Roosevelt's advocacy of the strenuous life.[100] Sporting contact with nature enabled the development of a virile citizenry. As Gary Gerstle describes, "Roosevelt conceived of his personal life as a crusade against the enervating effects of excessive civilization. He was determined to excel at hunting and ranching, to develop the qualities that made the Scotch-Irish backwoodsmen such a vigorous race."[101] The result of this crusade was that Roosevelt became the model for a new form of American manhood based on a "sporting" relation to nature. In the words of one contemporary observer,

> As an apostle of the "strenuous life," as an enthusiastic explorer and hunter, as a fearless leader of men in war and peace, and as a close observer and truthful writer on many subjects, especially sporting subjects, President Roosevelt has done noble service in behalf of the army of American boys who, when their

turn comes, may be called upon to duplicate some of his greatest
feats.[102]

While Roosevelt was taken as a model of manhood, Roosevelt
himself saw manhood as threatened. In his speeches and writings
Roosevelt railed against the feminizing effects of overcivilization.
He was concerned that the prosperity of America's cities was
ruining American men and hence the nation. In his speech "The
Strenuous Life," Roosevelt listed the types of men who threatened
the country's potential greatness. Roosevelt warned against

> the timid man, the lazy man, the man who distrusts his country,
> the over-civilized man, who has lost the great fighting, master-
> ful virtues, the ignorant man, and the man of dull mind, whose
> soul is incapable of feeling the mighty lift that thrills "stern men
> with empires in their brains"—all these . . . are the men who fear
> the strenuous life, who fear the only national life which is really
> worth leading.[103]

As the list indicates, Roosevelt's ideal American male is martial,
masterful, and knowledgeable. His list also indicates the ways in
which American masculinity could fail. In particular, Roosevelt
linked overcivilization with a lack of fight and mastery. He was
concerned with the effects of progress on the character of Ameri-
can men. Roosevelt's concerns reflected the massive changes that
had occurred in American society during the nineteenth century.

The American population had become largely urban due to
steady migration from the country to the city and through steady
immigration from Europe. This demographic shift made the city
the center of American culture. One consequence of this shift was
that the heterogeneous social space of the city broke down tradi-
tional rank-ordered ways of performing social identity. Historian
of manners John Kasson describes the crisis of meaning brought
on by the city as a "semiotic breakdown."[104] Kasson suggests
that the late-nineteenth-century American city offered a constant

threat to middle-class propriety and identity. Not only were the middle class uncertain of proper urban behavior, but the city also confronted them with the nonconforming bodies of immigrants and the poor. These threatening bodies became a site of social concern and motivated a moralizing response that demonized both these nonconforming bodies and the city they inhabited.[105]

Roosevelt's assertion of masculine identity was articulated as part of a broader response to the moral threat posed by the city. As Peter Filene argues, "Amid such 'progress,' men yearned desperately for tangible proofs of manly character."[106] In opposition to the feminizing city, nature was seen as the place were the proofs of manhood could be had and was seen to be, as Gregg Mitman puts it, "where the trappings of civilization might be shed, the purity of God's hand felt, and the real self found."[107] Of course, the manhood whose proof was sought in a return to nature was also a new ideal.

As Kathy Peiss argues, "The complex passage from Victorian culture to modernism involved . . . a redefinition of gender relations."[108] During the latter half of the nineteenth century the dominant term for cultural maleness shifted from *manliness* to *masculinity*.[109] Gail Bederman identifies in this linguistic shift evidence of a broader cultural change in the ideality of maleness. "'Manliness,' in short, was precisely the sort of middle-class Victorian cultural formation which grew shaky in the late nineteenth century. Thereafter, when men wished to invoke a different sort of male power, they would increasingly use the words 'masculine' and 'masculinity'" (18). Middle-class manliness gave way to a less reserved performance of virility that was mapped onto the comparatively neutral term masculinity.[110]

Roosevelt epitomized this shift from manliness to masculinity.[111] Originally mocked as an overrefined "Jane-Dandy" sissy in Albany, he transformed himself into a figure of unquestioned virility. Moreover, his movement from an East Coast effete to a virile frontiersman took place through the medium of hunting.

Roosevelt's published accounts of his life as a rancher re-created him as "a modern Western hero" in the eyes of the public.[112] By celebrating his accomplishments as a hunter, Roosevelt was able to shed the overrefined veneer of Harvard and become the prototypical man's man of his age.[113] Roosevelt was conscious of the site and nature of his transformation and throughout his life advocated the preservation of the woods as necessary for the production of virile citizenry. He also sought to ensure that nature was represented accurately, feeling that misrepresentations of nature were as harmful as its lack.[114]

HUNTING TROPHIES AND DISPLAY

In his discussion of camera hunting, Roosevelt linked the use of nature to produce virile men with the production of hunting trophies.[115] Hunting trophies symbolized the hunter's grounding in nature and asserted his identity as a true American native.[116] However, as Roosevelt notes in his discussion of Wallihan's photography, there are potential problems with using the display of trophies to assert identity. Most obviously, from a contemporary perspective, is the potential for the pursuit of trophies to lead to the elimination of the animal sought. Yet, despite emphasizing the role of hunting in the decline of game animals, Roosevelt took great pains to stress that big-game hunters were not the problem. The sportsman's pursuit of trophies, performed within the boundaries of the game laws, was positioned by Roosevelt as being of minimal impact on nature. Roosevelt argued that "the part played by true sportsmen, worthy of the name, in this extinction has been nil, and indeed very little appreciable harm has been done by any men who have merely hunted in season for trophies."[117] He also excused pot hunters from blame, acknowledging the temptations of easy meat. Roosevelt felt that subsistence hunters should be taught to view wildlife as a resource that would bring sportsmen tourists and with them "many times as much money as the dead carcass would represent" (1549). He proposed that the

poor who actually used animals for food should give way to the elites who use hunting for more valuable pursuits. The poor were not to blame for eating animals; they just needed to be taught how best to exploit them.

Roosevelt laid the blame for the decline of wildlife squarely on the shoulders of market hunters, arguing "the real damage has come from the professional hunters and their patrons" (1549). Market hunters, he argued, had "no excuse of any kind" for their wanton slaughter of animals. Instead of pursuing trophies, "they kill the animal for the hide and for the flesh" (1549). Yet, while the market hunters were not producing trophies for themselves, they were willing to sell antlers to "a certain class of wealthy people who wholly lack the skill and hardihood necessary to those who would themselves be hunters, and who have not the good sense to see that antlers have their chief value as trophies" (1549). Thus, market hunters were enabling wealthy, overcivilized men who lacked hardihood to impersonate sportsmen. While Roosevelt believed that "nothing adds more to a hall or a room than fine antlers when they have been shot by the owner," he also felt that "there is always an element of the absurd in a room furnished with trophies of the chase which the owner has acquired by purchase" (1549). Hunting trophies were for Roosevelt the highest form of display, and their counterfeit display by a purchaser was an absurd imposture of sportsmanship. However, for Roosevelt, the use of purchased animal parts for fashion was even worse than false trophy display. He was particularly concerned with the use of elk's teeth for watch fobs, which he saw as being "responsible for no small amount of slaughter" (1549). To solve this problem he proposed to follow the Audubon Society's campaign against the use of feathers for millinery:

> It would be well if some similar society would wage war against the senseless wearing of elk's teeth when the wearer has not shot the animal; for such fashion simply becomes one cause of extermination. (1549)

Roosevelt linked conservation with the rightful use of trophies by arguing that the key problem facing animals was their inappropriate use as fashion and decoration.[118] His argument dissociated store-bought antlers from real trophies, associating them instead with women's fashion. He thus stressed that real trophies are about manhood—those who buy antlers lack "hardihood." Roosevelt may have sought to preserve game for the elite but only for those among them who possessed the necessary virtues to hunt for themselves. Hunting and trophies were about manliness for Roosevelt. Camera hunting was important because it brought together conservation, manliness, and trophies. Yet false trophies, indistinguishable in appearance, threatened to undermine both manliness and conservation.

Despite Roosevelt's desire to police the display of trophies and ensure their proper function, his efforts were doomed to fail. The instability of the trophy's conferred status is inherent. As Thomas Strycharz argues in his analysis of trophy display in the work of Hemingway, "The trophy is nothing without the man; but the man, allegedly autonomous, cannot make the trophy mean 'manhood' in a theater where roles are assigned communally."[119] In other words, trophy display is social; the display of trophies requires an audience's approval to succeed. This approval is threatened by the display of false trophies and by the display of other, more impressive, genuine trophies. In short, the trophy leaves the hunter in the same situation in which he started: faced with appearing as a man in a social situation that threatens his sense of self. The trophy cannot stabilize the identity its production is supposed to guarantee because the logic of its display is contestatory. The trophy's conferral of status is not accumulative and is continually subject to challenge. Like the trophy, trophy photographs are connected to status display, and as the stakes change, the trophy photograph's function changes with them.[120] As Roosevelt's argument suggests, the trophy relation is haunted by bourgeois appropriation and when displaced, collapses into it.

TROPHY PHOTOGRAPHY'S DISCURSIVE SPACE

Camera hunting was shaped by a complex confluence of factors. The camera hunters' image-making practices were connected to modes of display asserting both masculine and national identity. Their rhetoric emphasized the proximity of photographer and animal in order to suggest that some sort of contact and transfer from animal to human had taken place. As Finis Dunaway argues in his discussion of American camera hunting, "Nature photographers emphasized their presence in the wilderness; they did not render themselves invisible or absent from the scene."[121] Thus, the discursive space of camera hunting differs from the proprietary bourgeois aesthetic typically associated with nineteenth-century landscape photography (what Douglas Nickel has called "the commanding view"[122]) and that is sometimes thought to be inherent in photography as a whole.[123] In camera hunting, the "ownership" displayed in the image does not belong to the viewer but rather to the photographer. This connection between photographer and subject meant camera hunting's images could circulate only in certain ways. They could not be separated from their taker and still function as trophies. In this way, the trophy photograph reverses the traditional understanding of the relation between creator and image. Like the art historical concept of the oeuvre, we are intended to see the author within the image; however, the manner of the author's appearing is very different. The image is not the result of, or manifestation of, the particular innate genius, or vision, of the author but rather confers on the author a status that he did not have until he could produce such trophies.[124] The camera hunter's trophy photographs also differed from the discursive space of the view. While the images circulated in published form, they were not part of a disciplinary archive and were intended for public display. When animal photographs came to circulate in scientific contexts, they lost their trophy function. As Krauss indicates, the discursive space of the view was shaped by the archive; the requirements of the archive determined the pho-

tographs produced and undercut the connection between photograph and photographer necessary for art historical authorship.[125] Thus, camera hunting and its trophy photographs form a discursive space distinct from both landscape and view.

Camera hunting was articulated in relation to the discourse of American sport hunting. Photographs of wild animals were able to function as trophies because wild animals were conceived of as game. The concept of game divided the animal kingdom into those animals worthy of the sportsman's notice and those unworthy of notice. However, photography altered the structure of this distinction. Curator and ornithologist F. M. Chapman described photography's effect on the concept of game in his brief 1903 history of the development of camera hunting. According to Chapman, the value of an animal as a hunting trophy was not inherent but determined by its position in the sportsman's hierarchy of game:

> Some animals were considered game, and as such were worthy of the sportsman's attention, while others were esteemed beneath his notice. The desirability of any animal was determined by its size, its wariness, its courage and powers of defense or offense, its rarity, its edibility and individually its horns, fur and other physical conditions.[126]

As Chapman notes, camera hunting increased the number of animals that could be thought of as game.[127] It thus increased the number of animals worthy of pursuit and whose bodies could produce trophies. Chapman believed that photography would continue to reshape the discourse and practice of hunting and ultimately displace it altogether. While this did not happen, photography did, over time, have effects on the American practice of hunting.

HUNTING AND THE CAMERA

The American discourse of sport hunting may have framed the conception of animal photography as camera hunting, but pho-

tography also changed America's conception of sport hunting. In his cultural history of American hunting, Daniel Herman suggests that "perhaps the biggest factor working toward the depopularization of hunting has been the camera" (273). According to Herman, "The camera permitted individuals—particularly those of the middle and upper classes—to venture into the wilderness to practice the virtue of self-reliance without breaching the ethic of domesticity" (272). Herman argues that without the finality of the kill photography did not provide the same access to a space outside of the social order that traditional hunting did. Herman also argues, however, that it was the circulation of animal photographs and films that largely undermined the status of hunting in American culture. According to Herman, the camera "undermined hunting" through its presentation of "anthropomorphic images of animals to the millions" (272). Exposure to these kinds of animal images made American children "less likely to grow up to be hunters" and often led them to oppose it (272).

Herman's argument reminds us that the confluence of American attitudes toward hunting, nature, and masculinity that allowed the photographing of animals to function as hunting and produce trophies was not stable. Continued changes in technology and attitudes to nature made recreational hunting unfashionable: ironically, sport hunters' advocacy of conservation was too successful, and pot hunting came to be seen as the only acceptable form of hunting. These developments changed the social understanding of both hunting and trophies.

THE TELEPHOTO LENS

The development of photographic technology also reshaped the practice of camera hunting. Camera hunting changed as photographic technology continued to improve. One important change was the introduction of the telephoto lens. The telephoto lens was one of a number of nineteenth-century advances in lens technology that improved image quality and shortened exposure times.

For example, the Petzval lens of 1840, by increasing the illumi-nance the lens let through, cut exposure times for a daguerreo-type from twenty minutes to under a minute; the Petzval was the first of the so-called fast, or rapid, lenses. Over the course of the nineteenth century, lens makers experimented with different lens formations, shapes, and materials in order to increase the quality and amount of light let in by the lenses. Yet, this is not a story of straightforward improvement. It was also found that the different lenses changed the quality of the images produced by introducing various aberrations into the images caused by the different ways the lenses focused light. Thus, lens development was also driven by a desire to correct for the various optical aberrations the dif-ferent lenses produced.

The Swiss optical firm Carl Zeiss AG introduced the tele-photo lens in 1898. The Zeiss lens allowed magnifications of up to three times, greatly increasing the distance animals could be photographed from. The trade-off was a shallow depth of field and the compression of space between objects in the images.[128] The ability to photograph animals from long distances changed the dynamics of camera hunting. These changes can be seen in a 1902 description of the effect of telephoto lenses on William E. Carlin's animal photography:

> No longer did he spoil four dozen plates to get four pictures—his usual average in the Bitter Roots, where he had made a record of a hundred exposures for a single successful picture of a wood-rat. The animals still persisted in getting out of focus, but the perfection of the telephoto camera allowed him to focus farther and farther away from his "sitter" with a decreasing chance of frightening it, and he hopes soon to go back to Idaho and "get" a thousand things.[129]

The improved technology made animal photography easier, but it also decreased the sense of contest involved in obtaining the image. The decreased chance of frightening the animal indicated

a decreased need for woodcraft to expose it. By allowing photographers to take pictures from a greater distance, telephoto lenses diminished the sense of contact between animal and photographer in the images. By weakening the sense of contest, it also weakened the connection between animal and photographer, undermining one of the major justifications for thinking animal photography as hunting. Instead, the shallow depth of field produced by the telephoto lens separated the depicted animals from their background and compressed the space of the image. In producing this separation and isolation of animals, Derek Bousé suggests that telephoto images create a false sense of intimacy between viewer and animal.[130] By erasing from the image any sense of contact between the animal and the camera, the telephoto lens produces images that give their viewers a sense of proximity to the animals depicted. Thus, the introduction of the telephoto lens began a movement in animal photography away from the contact between photographer and animal necessary to the logic of camera hunting. This movement away from camera hunting can also be seen in the effects of another technological advancement on animal photography: the use of flash photography to take pictures of animals at night.

FLASH PHOTOGRAPHY AND CAMERA HUNTING'S AFTERIMAGE

Nineteenth-century flash photography was expensive, dangerous, and often unsatisfactory until the invention of flash powder (*blitzlicht*) by Adolf Miethe (1862–1927) and Johannes Gaedicke (b. 1835) in 1887. Their process expanded on earlier attempts to use magnesium as a light source by combining magnesium powder with potassium chlorate (an oxidizing agent) and antimony sulfide.[131] While it remained dangerous and noxious, flash powder made flash photography practical. The intensity of the light given off by the explosion of flash powder enabled the production of instantaneous photographs regardless of the ambient light condi-

tions and the exposure of moving subjects. To show the effects of flash photography on camera hunting, it is necessary to examine Shiras's practice of nighttime flash photography of deer. (However, the circulation of Shiras's flash photographs also reveals the limits of the discourse of camera hunting.)

Shiras was the first photographer to use a flash to photograph animals at night. He spent the 1890s experimenting with flash technology, seeking ways to photograph animals at night by adapting the flash apparatus for photographing in the woods. As was discussed earlier, Shiras began his nighttime photographic experiments by jacklighting deer. Shiras froze animals with a jacklight and then exposed them to the camera with a flash.[132] To assist him in his endeavors, he developed a pivoting boat mount for the camera and a handheld flash plate. The plate held the flash powder and shaped its explosion. His method of opening the shutter and then setting off the flash to expose the animal came to be called the shutter speed method of nighttime flash photography.[133] In 1893, Shiras invented and patented a device for automatic flashlight photography that timed the camera's exposure to the moment of the flash's greatest illumination.[134]

In 1896, he photographed the *Midnight Series,* a suite of ten photographs of deer taken at night, all of which were taken from a boat using a jacklight and illuminated by flashlight. For this reason, the photographs are all high-contrast black-and-white images with large expanses of deep black. The first of the series, *Innocents Abroad,* shows twin fawns bracketing a doe (Figure 12).[135] The fawns are facing the camera while the doe looks off into the upper right of the image. *Innocents Abroad* is a dark image with few highlights. There is a large tree on the left of the image that has been highlighted by the flash. There is also a highlighted fallen log entering the image about halfway up the frame leading the eye to the group of three deer that are slightly to the right of center. The animals are standing in shallow water near the shore of the lake. The doe's front feet appear to be onshore. The fawns' bodies face

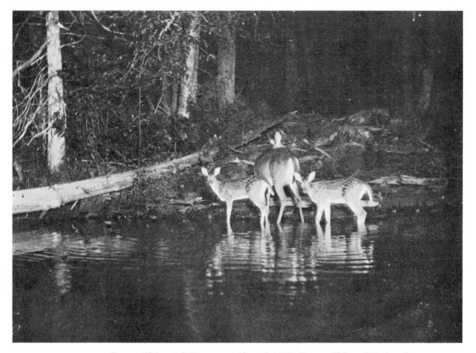

FIGURE 12. George Shiras 3d, *Innocents Abroad*, 1896. George Shiras / National
Geographic Image Collection.

left with their heads turned to stare toward the camera. The doe
stands between them facing away. The animals are small in rela-
tion to the frame of the image and are not seen in a close-up; the
camera, and the viewer, are positioned approximately twenty-five
yards away, outside of fight or flight distance.[136] There are reflec-
tions of the deer in the ripples of the water.

The fawns are staring toward the camera after Shiras whistled
to get their attention.[137] By staring at the light, the fawns engage
with the camera and the viewer. The image shows a moment of
interaction between animal and human that at the time of the
image's taking was framed as hunting. The flash has exposed the
animals. Because of the noise from the explosion of magnesium
powder, the animals scattered after the image's taking. Because

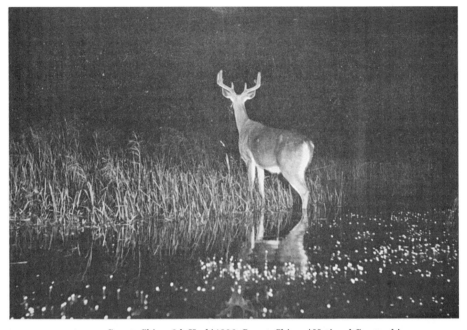

FIGURE 13. George Shiras 3d, *Hark!* 1896. George Shiras / National Geographic Image Collection.

of the light from the flash, the fawns were blind when the deer scattered and were separated from each other and their mother.[138]

The second image, *Hark!*, shows a buck facing away from the camera with his horns silhouetted against the blackness by the flash (Figure 13).[139] The buck stands on the edge of a patch of reeds. The buck's body is in three-quarter profile to the camera while its head faces away. Shiras suggested that the deer was fascinated by the reflection of the jacklight on the trees behind it.[140] The buck's legs are reflected in the water beneath it. The buck is larger than the animals in *Innocents Abroad,* giving the impression of greater proximity. The buck is standing at attention with its head cocked just right of center. *Hark!* is a dark image interrupted by reflections of the flash on the reeds and the highlights of the buck's coloration, particularly its underbelly and tail.

The rest of the series included (3) *Midnight Reflection,* a photograph of a deer on the bank reflected in the water taken at a pond south of Lake Superior; (4) *Spike Horn Buck* (also known as *A Big Surprise for a Little Buck*), a photograph of a young buck in reeds taken at White Fish River; (5) *Alert!,* a photograph of a buck onshore facing into the darkness; (6) *Suspicion,* a photograph of a doe standing parallel to the camera; (7) *Has He Gun, or Camera?,* a photograph of a large buck facing the camera taken at La Pete's Slough; (8) *Deer and Porcupine,* a photograph of deer beside water with a feeding porcupine taken at White Fish Lake; (9) *Monarch of the Night,* a photograph of a buck in water taken on Lower White Fish River; and (10) *A Midnight Wader,* a photograph of a young buck standing in water and facing away from the camera.[141] The series of photographs circulated widely and, as we will see, in a variety of contexts.

Shiras was invited to display the photographs as part of the U.S. forestry exhibit at the 1900 Paris Exposition. This brought the series to a broader audience whose interests in the images were not shaped by their interests in sport and conservation. He showed four enlargements from the *Midnight Series* in the exposition, including *Hark!* and *Innocents Abroad.* The photographs were a great success; one French sportsman wrote Shiras a letter suggesting his work was "not mere photography—it is high art! How happy I would be to place these splendid pieces in my hunting castle. I am determined to tell you with how much admiration I have seen them, and count surely on seeing them again."[142] The sportsman was not alone in admiring the series. Shiras's photographs won a gold medal in the forestry section of the exposition. Significantly, they also won a silver medal in the photography section, a competition in which they were not even entered. The American juror for the photography section, Edward Shier Cameron, wrote Shiras a letter in 1913, explaining how the committee came to award him the medal. According to Cameron, the award turned on a question of authenticity. The German juror, Professor

Miethe,[143] had encouraged the committee to award a medal to an exhibit at the German pavilion showing photographs of animals in nature.[144] One of the French jurors, Professeur Wallou, noticed the photographs were composites and argued that "the animals were generally against snow or on rocks against the skyline, and that the edges showed the prints were made from two negatives."[145] Later, Cameron took the French juror to see Shiras's photographs as an example of "real results of photography of wild animals at liberty" (83). The juror brought the committee to see Shiras's work and proposed he be awarded a silver medal, the highest award for work by an individual in the category.[146]

The series circulated further.[147] In 1906 Shiras became the first animal photographer to publish in the *National Geographic* magazine.[148] His article, "Photographing Wild Game with Flashlight and Camera," was based on a talk given to the National Geographic Society by Shiras in April 1906. The article contained seventy-four photographs and a small text. Included among the images were the *Midnight* photographs.[149] Approximately half of the text was reprinted from Shiras's 1892 article in *Forest and Stream,* which argued for treating animal photography as a sport. "Photographing Wild Game" argued that Shiras was the first to photograph animals at night and suggested that he had spent fifteen years being the sole practitioner of this form of photography.[150] The large number of photographs in the article combined with only a short text was an unusual format for the time.[151] It was also controversial; two of the National Geographic Society's board members resigned over the issue's publication.[152] The resigning board members, Alfred H. Brooks and R. D. Salisbury, complained that the editor had "'turned the magazine into a picture book.'"[153] The resignations solidified the magazine's transition from a technical journal to a magazine aimed at a popular audience that the new editor, Gilbert Henry Grosvenor, had begun in 1899.[154] While the resigning board members disagreed with the direction the photographs suggested for the magazine, the

article and the photographically based approach of the magazine impressed the general public.[155] The issue was reprinted shortly after publication to meet the demand. The society also saw an increase in membership following the publication of the article.[156] Shiras's photographs were an important part of *National Geographic*'s change to a photographically illustrated magazine.[157] Indeed, the issue was also reprinted again in 1964.[158]

In addition, two of the *Midnight* photographs were published as special pullout pictorial supplements in *National Geographic*. *Innocents Abroad* was published in July 1913, and *Hark!* was published in August 1921. These were also available from the society as framed reproductions.[159] The supplements accompanied articles by Shiras published in the magazine. His 1921 article "The Wildlife of Lake Superior" also included a reproduction of *Innocents Abroad*.[160] The illustration accompanying the article was tightly cropped to focus on the three deer, providing a sense of intimacy lacking in the full version. The result of the cropping was an image that resembled the effects of the telephoto lens. It was this cropped version of the image that circulated after its first publication in 1906, suggesting that aesthetic concerns were more important than documentary accuracy in the image's circulation.

Four of the series, including *Innocents Abroad* and *Hark!*, were reproduced in William Nesbit's *How to Hunt with a Camera* as exemplary flashlight photographs demonstrating the potential of the technique.[161] The *Midnight Series* was reprinted again in Shiras's autobiography, *Hunting Wildlife with Camera and Flashlight*.[162] The book included *Innocents Abroad,* here titled *A Doe and Her Twin Fauns,* as the frontispiece of volume one, and *Hark!* as the frontispiece to volume two. The text described the taking of the two photographs and situated them as part of Shiras's lifelong pursuit of conservation.[163] Between the two editions, thirty thousand copies of the book were published.[164] *Innocents Abroad* was included as an illustration in a 1939 *National Geographic* article on the "Deer of the World" where it was hailed as a "masterpiece of animal

photography."[165] It was further reproduced in a 1952 *National Geographic* article as an illustration of the recreational possibilities available in Michigan.[166] The article reversed the logic of Shiras's initial claims for animal photography by using the image as an advertisement for the hunting available in Michigan.[167]

As the *Midnight* photographs circulated, their function and meaning changed. In 1892, Shiras saw his animal photographs as trophies, and his photography came from his desire to hunt deer. Shiras's articles on camera hunting from the mid-1890s suggest that his photographic practice in 1896, when he took the *Midnight Series*, was based on the same principles. The series was sent to Paris in 1900 by the U.S. government as documents of forest life. However, in Paris the series was described as "high art," and the photographs were awarded for their aesthetic accomplishment. As they detached from Shiras's exploits as a hunter, the photographs began to function as records of animal life and objects of aesthetic contemplation. Because of *National Geographic*'s use of the first-person format, the images continued to function as signs of Shiras's prowess as a photographer.[168] They also began to function as images of an idealized nature. In *National Geographic*, the photographs were first presented as both advertisements for camera hunting and documents of animal life, while the dissenting board members saw them as mere spectacle. The magazine republished the photographs as images of spectacular nature, cropping *Innocents Abroad* to look more like a telephoto photograph and enhance its visual appeal to the audience. In doing so, they helped codify wildlife photography's aesthetic. The *Midnight* images sit at the beginnings of both wildlife photography and the emergence of *National Geographic* as an important photographically illustrated magazine.

What this analysis shows is that the shift from hunting journals to *National Geographic* and general interest magazines was part of the metaphorization of camera hunting. It is this later stage of the practice that Finis Dunaway and Gregg Mitman

describe in their work on American camera hunting. Mitman's analysis of camera hunting in early-twentieth-century American nature films situates it on the border between science and entertainment. Dunaway's work argues that nature photographers used the camera as a technology of memory attempting to preserve and regulate their relation to nature. He suggests that the turn to nature photography in Africa was part of a search for a revitalizing Eden on the part of elite Americans: "By turning nature into an estheticized, distanced Other, the images reflected the deepest form of amnesia encouraged by commodity civilization: the denial of human emplacement in nature, the forgetting of our ultimate dependence on the natural world."[169]

The other side of this erasure can be seen in Shiras's later series of flash photographs. Shiras continued to experiment with flash photography, and in the late 1890s he began to make photographs using a series of synchronized flashes to first capture an image of an animal and then capture another of the animal running in fear from the explosion (Figures 14 and 15). (Frank Michler Chapman criticized the ethics of this series.) These images enable us to see that what we are shown in the *Midnight Series* is the equivalent of photographs of deer frozen in the headlights. What these images make clear is that the *Midnight Series* are not candid shots of animal life; they are photographs of hypnotized deer that are being traumatized by the process. They reveal the effort required to produce an image of nature.

In the early 1900s, Shiras was followed in his practice of nighttime flash photography by the German adventurer and photographer Carl G. Schillings (1865–1921) and the British photographer Arthur Radclyffe Dugmore (1870–1955), both of whom produced flash photographs of African animals at night. Schillings's 1905 book *Mit Blizlicht und Büchse,* based on his 1903–4 expedition, produced a sensation in Europe and inspired the European practice of camera hunting (Figure 16).[170] Dugmore and Schillings were followed to Africa by a number of American

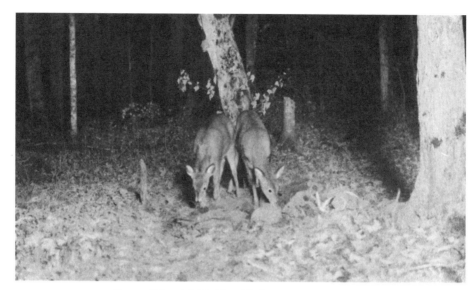

FIGURE 14. George Shiras 3d, *The First Flash*, 1921. George Shiras / National Geographic Image Collection.

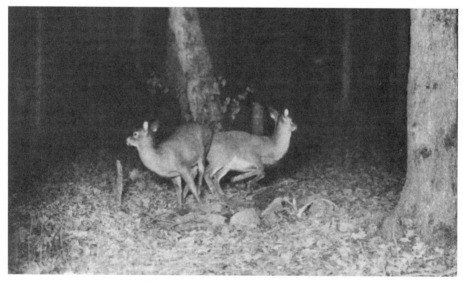

FIGURE 15. George Shiras 3d, *Doubly Interrupted Meal*, 1921. George Shiras / National Geographic Image Collection.

adventurers and scientists who sought to include the camera on their safaris. I argue, however, that while they often described their practice as hunting with a camera, it operated with different logics and constructed a very different relation between human and animal than the practices I have been discussing. Like the meaning of a trophy, the meaning of trophy photography was unstable and always liable to collapse into a different practice.

SNAPSHOT: TROPHY PHOTOGRAPHY AND DEATH

The analysis of camera hunting and trophy photography offers a space for thinking the effects of photography. I have argued that camera hunting was one of photography's discursive spaces. Beyond that, I want to suggest that the trophy relation is one of the modalities of photographic appropriation. Thinking the trophy photograph as a photographic modality entails making explicit the relation that Donna Haraway describes between "the culturally important practice of hunting with a camera and the deeply predatory nature of a photographic consciousness."[171] Haraway proposes thinking all photographic violence as "predatory." In contrast with Haraway, I argue that the predatory relation is but one modality of photographic appropriation. Predation involves the consumption of kills by the killer; in camera hunting photographers symbolically kill the animal and produce its image as a trophy following a predatory logic. The trophy is the consumption of the animal for status display. However, not all photography operates by this logic. This relation between photographer and subject is peculiar to camera hunting and is not generalizable to all photography. Instead, I suggest that the trophy relation is a potential in photography activated and constrained by its mode of circulation.

The equation of photography and violence is common in the literature on photography. For example, in his essay "Photography and Fetish," Christian Metz draws attention to the linguistic link between cameras and guns. Metz writes that it is "not by chance"

FIGURE 16. Carl Schillings, *Zebras Approaching Waterhole at Night*, 1905. Carl Schillings / National Geographic Image Collection.

that photography "has been frequently compared to shooting, and the camera with a gun."[172] As Metz highlights, much of the language with which we refer to photography is shared with guns. However, while Metz indicates this overlap is not accidental, he is not arguing for the historical link between photography and hunting discussed in this chapter. Instead, he bases his argument on his comparison of the operation of the snapshot, in its freezing of a moment, to death and to the freezing of a psychic moment in the etiology of fetishism. In mounting this argument, Metz makes use of the oft-cited notion that photography is implicitly connected to death.[173] The analysis of camera hunting and the trophy photograph provides us with the possibility of exploring this connection differently.

Thinking through the implications of the practice of camera hunting allows us to reread the relation between cameras and guns. I suggest that the analysis allows us to move beyond the psychoanalytical analogical understanding of this relation and to instead read it as the trace of a forgotten moment in photographic history. As Brian Coe and Paul Gates suggest, the very idea of the snapshot is connected to hunting: snapshot was a shooting term applied to photography by Sir John Herschel.[174] Instantaneous photography has from its inception been conceived of in terms of hunting. Furthermore, as Beaumont Newhall indicates, with the spread of instantaneous point-and-shoot photography, all of photography has come to be conceptualized in terms of the snapshot. After the introduction of the Kodak Brownie in 1900, "the words 'snapshot' and 'photograph' became, in the public consciousness, synonymous."[175] Thus, in the nineteenth century a conceptual link was established between photography, hunting, and death in the idea of the snapshot. It is important here not to reduce photography to the snapshot. As Shelley Rice reminds us, thinking photography in terms of the snapshot causes us to misread the early history of photography.[176] However, that there was, as the analysis in this chapter has shown, a moment in photographic history when the link between cameras and hunting was taken literally suggests that we should examine this issue historically rather than simply through an analysis of the supposed effects of the operation of the ideal photograph. The relation between photography and death is neither simple nor linear. It is always articulated through a particular photograph's mode of appropriation and manner of circulation. In camera hunting photographic appropriation's link to death is highlighted and connected to the photographer. The trophy photograph links the photographer as a predator or hunter to the animal subject; it situates the photographer as the consumer of photography's symbolic kills. Other photographic practices articulate the relation between photography and death according to the logics of their own discursive spaces.

CONCLUSION

The increased circulation of animal photographs in scientific and other contexts obscured the connection between the photographer and the animal essential to reading the image as a trophy. Although the concept of camera hunting continues to circulate, for example, in camera safaris, it can no longer be read literally and is instead taken as metaphorical evidence of nostalgia, irony, and loss. As Susan Sontag wrote, "Guns have metamorphosed into cameras in this earnest comedy, the ecology safari, because nature has ceased to be what it had always been—what people needed protection from. Now nature—tamed, endangered, mortal—needs to be protected from people. When we are afraid, we shoot. But when we are nostalgic, we take pictures."[177] Remembering that the metaphor was once taken literally can help us to read animal photographs against the grain. While technology may have made capturing animals on film easier, the animals captured are no less real.

CHAPTER 3

The Photographic Blind

Our aim has been to show the natural world in all its infinite variety, almost as if man were the one animal that did not exist in it.
—Editors of Time-Life Books, *Photographing Nature*

WILDLIFE PHOTOGRAPHY AND THE PHOTOGRAPHIC BLIND

In the introduction to the book *Photographing Nature,* the editors of Time-Life Books suggest that within the logic of the photographs of nature they present, "man is really just an offstage voice" (7). While he might be the "the inventor-operator of the image making apparatus," they argue that man "is not in the picture itself, and does not belong there" (7). Instead, they aimed to present photographs that showed the world "almost as if man were the one animal that did not exist in it" (7). In their view, true nature photography presents a vision of the world empty of humans and their traces. This is the rhetoric of the wildlife photograph.

As the editors argue, "man" is not in the wildlife photograph and "does not belong there." If there are humans in a photograph, we know it is not a wildlife photograph. Wildlife photography is a representational regime constituted by human absence. This is a radical exclusion. Not only does the infinite variety of the natural world not include humans, but the pure landscape of wildlife photography has no place for the backpacker or the scenic view. It seems that in nature photography, no matter how minimal the impact, or how respectful the occupation of the landscape, human beings do not belong. As was discussed in chapter 1, this conception of nature and humans as fundamentally separate is a redeployment of the Garden mythos, which envisions nature as pure and human beings as fallen and corrupting. Wildlife photography posits a vanishing nature corrupted by human traces that the photographer must work to overlook.

Yet, as the editors' argument also suggests, hiding or erasing human presence from photographic images is not easy, it takes work. As the German critic Walter Benjamin's classic essay on the camera's reconstruction of perception argues, creating photographic imagery with no trace of humanity requires special procedures.[1] (Not least because the photographic image itself can imply the presence of the photographer through the photographic apparatus.) In other words, photographs without human traces do not occur naturally. They must be produced. For the representational regime of wildlife photography to function, human presence must be regularly effaced. The required erasure is both practical and conceptual. Humans and their traces must be physically erased from the images, and the images must be understood as unmarked by human presence. Wildlife photography thus depends on a double erasure of human presence from animal photography.

The representational regime of wildlife photography, as articulated in such works as *Photographing Nature*, differs from the discursive regime of camera hunting presented in the previous

chapter. Camera hunting centered on the interaction between animal and human figured in the photograph; the images figured the trophy photographer's conquest of the animal. In contrast, wildlife photography is predicated on the radical disjunction of humans and animals; animals are presented as occupying a separate realm of nature from which humans are fundamentally excluded. Thus, the change from camera hunting to wildlife photography has been marked by a change in the function of animal photography from asserting the presence of the photographer to denying it. I argue that the development of the photographic blind is central to understanding this transformation. In this chapter I trace the emergence of the photographic blind out of the hunting blind and the shift in its function from enabling the production of trophy images to producing images of wild animals.

THE OPERATION OF THE PHOTOGRAPHIC BLIND

The photographic blind is a key apparatus in the production of wildlife photography; the other is the telephoto lens. Photographic blinds allow photographers to take candid shots of wild animals in their natural habitat. However, the photographic blind, like the images it helps produce, has been naturalized. To borrow a term from science studies, the photographic blind has been black boxed. It is not presented as an achievement but as a commonsense solution to a simple problem. For this reason, its functions have not generally been examined. Commentators discuss the photographic blind as if its workings were both self-evident and natural.[2] For example, in the context of a short history of nature photography, Edmund White presents a brief account of the photographic blind's development. According to White,

> Modern nature photographers know that birds are shy of strange movement but will continue their normal activity if human beings are out of sight, inside a canvas blind. Earlier photographers, however, felt they had to hide in fake trees or under piles of hay.[3]

White argues that the photographic blind lets us see the "normal" activity of birds. Because birds are "shy," we need to be hidden in order to really see them. The implication is that without the photographic blind, the animals we see will be somehow tainted, abnormal, or invisible. As White's formulation suggests, the photographic blind is a key site in the production and maintenance of the modern understanding of the "normal" or natural animal. To understand how the blind comes to produce natural animals, it is necessary to analyze both the function and history of the blind.

Modern photographers, per White, understand that the simple canvas tent—a blank space within the landscape—is enough to allow wildlife photography. As White's description indicates, the ideal figure of the modern photographic blind is a plain canvas tent in which photographers and scientists can spend long hours observing and documenting wild animals.[4] He also suggests, however, that in contrast to modern photographers, early photographers did too much with their photographic blinds; they felt they had to hide in the landscape by mimicking some feature of it.[5]

White's description presents a trajectory for the photographic blind from its appearing as something specific in the landscape to its appearing as something abstract.[6] Appearing as something else is refined to simply not appearing human. Yet, his description minimizes and obscures the history of the photographic blind. It minimizes the work that was necessary to get from fake trees to canvas tents and erases the work required to invent fake trees. It also obscures the connection between photographic blinds and hunting blinds. However, before exploring the historical emergence of the photographic blind from the hunting blind, I want to stress that the photographic blind is not reducible to the specific configuration of the canvas tent in the woods. Rather, the photographic blind is a set of practices and principles governing the disposition and use of an apparatus.

The photographic blind is a machine for viewing and pro-

ducing images of animals in a specific way. The resulting images are considered candid because the blind assures us that the animals being photographed are unaware of the image's taking. It hides the observer from the observed, providing images of animals untainted by human contact. The photographic blind is not a single object but is instead the set of structuring principles that produce a variety of apparatuses.

The photographic blind provides images of the private lives of animals by allowing us to read the images it produces as if neither we nor the photographer were there. It is an essential component of wildlife photography. I argue that the photographic blind is both a central technique and a central trope of wildlife photography. The photographic blind produces images of "the heart of nature," images of wild animals behaving "authentically"—as they behave with no humans present. Yet, in making nature available to us, these images are at the same time asserting a separation between us and nature by suggesting that the only "real" animals are wild animals—animals untainted by human contact.

THE PHOTOGRAPHIC BLIND AND PHOTOGRAPHIC INVISIBILITY

John Berger has argued that the techniques used to produce candid shots in wildlife photography, like the photographic blind and the telephoto lens, mark the images they produce with indications of their normal invisibility:

> Technically the devices used to obtain ever more arresting images—hidden cameras, telescopic lenses, flashlights, remote controls and so on—combine to produce pictures which carry with them numerous indications of their normal *invisibility*. The images exist thanks only to a technical clairvoyance.[7]

By normal invisibility I take Berger to mean that these are images of scenes that would not be available to human sight. Berger clarifies the character of this invisibility thusly: "Baby owls or

giraffes, the camera fixes them in a domain which, although entirely visible to the camera, will never be seen by the spectator. All animals appear like fish seen through the plate glass of an aquarium" (14). In other words, in wildlife photographs viewers see animals they could not normally see and that they will likely never see directly. These photographs are not the representation of what viewers would see if they were there. Instead, Berger suggests, in these images animals are seen as if the viewer was not there. Wildlife photography, like an aquarium, allows viewers to observe the daily life of creatures whose world they cannot inhabit. The animals are behind the plane of the image, which the viewer only becomes aware of in terms of its transparency. Wildlife photographs offer their viewers transparent access to nature by erasing the traces of their taking, which Berger calls technical clairvoyance. But by erasing their taking, wildlife photographs leave no space within the images' visual economies for the viewers to occupy, and no entry points from which they can locate themselves in relation to the image. Wildlife photographs present a closed internal economy with no space inside for humans. Of course, the closed internal economy of the images is figured as the external, nonhuman economy of nature. Wildlife photographs offer their viewers access to a deep nature from which they are fundamentally excluded.[8]

Berger takes the "normal invisibility" inscribed in wildlife photographs as evidence for his argument that late-capitalist Westerners can no longer really be in nature. He argues that the dislocations of industrialization and modernization have made it impossible for us to have an "authentic" encounter with an animal. Because animals are no longer an integral part of our daily lives, we can no longer engage with animals, or nature, except as figures of nostalgia. For Berger,

> In the accompanying ideology, animals are always the observed.
> The fact that they can observe us has lost all significance. They
> are the objects of our ever-extending knowledge. What we know

about them is an index of our power, and thus an index of what separates us from them. The more we know the further away they are. (14)

In this passage, Berger suggests there is a vertiginous quality to wildlife photography. The closer to the animals the images bring us, and the more they show us animals as they behave when we are not there, the farther they distance us from those animals they bring close. Berger's argument thus overlaps with Derek Bousé's claim that the images produced by the telephoto lens construct a false intimacy for their viewers.[9] Wildlife photographs function as a substitute for a real nature that the images themselves assert is impossible for modern humans to occupy.[10]

The disjunction between the human and animal marking wildlife photography is identified by Berger as a by-product of the industrial revolution.[11] According to Berger, the animal's ability to meet our gaze, its ability to challenge and confirm us with its look, disappears as animals disappear from the immediate circle of our lives.[12] Industrialization transfers the mechanization of movements first developed on animals to humans, alienating us and creating within us a nostalgia for nature in which nature is seen as a pure space, untainted by society.

> According to this view of nature, the life of a wild animal becomes an ideal, an ideal internalized as a feeling surrounding a repressed desire. The image of a wild animal becomes the starting-point of a daydream: a point from which the day-dreamer departs with his back turned. (14–15)

Within this conception of nature, wild animals are thought to provide a bridge to the natural in the human, to the part of the human untouched (untainted) by social forces, to an ideal state of innocence (other animals, like pets, do not count for Berger). The wild animal is thus the figure of a desire; it represents the connection of the human to nature, conceived of as a ground of purity.

This desire is repressed because its symbolic deposit, its figure, is an unrealizable engagement, one that is only presented to us in a manner that increases its distance. This distance serves to further alienate us from our experience of nature. Wildlife photography is thus part of a feedback loop in which we turn to images of animals in nature to compensate for a lack of contact with nature. These images provide us with an entry into the natural world while at the same time telling us that we are necessarily excluded from the Eden they depict. Thus for Berger, wildlife photographs provide hollow comfort for the dislocations of modernity and can only deepen our alienation.

Berger's argument treats the invisibility marking wildlife photographs as a symptom of the dislocations of capitalism. He explains the separation marking the images as a reflection of the separation from animals in modern Western lives. Yet, as I argued in chapter 1, Berger presumes too much in reducing animal images to an effect of industrialization and in asserting that these images can only be compensatory. As Jonathan Burt notes, "Berger valorizes a view of pre-industrial practical relations with animals that are by implication pre-imagistic and unmediated by forms of representation."[13] Berger's argument is driven by a belief in what Burt calls "the fiction of the direct encounter" (26). Berger compares all our encounters with animals to the exchange of glances that he posits occurred between early humans and animals.[14] Within this logic, as Burt notes, *any* representation of animals "will inevitably be considered palliative (substitutive), empty (spectral), and excessive (mass produced)" (26). Thus, Berger's argument proves too much. The invisibility inscribed within wildlife photographs is not accounted for by a simple appeal to the representational structures of capitalism. Not all images of animals are marked by invisibility. More importantly, Berger's ideal human-animal relation—the mutually confirming exchange of glances—is a fiction.[15] If, as Berger argues, animals are at the origin of human representations (he argues that animals were

the first metaphor), it seems strange to assert that representations now block the encounters they used to figure and enable.[16] Berger is both critiquing the opposition between nature and culture and at the same time asserting its inevitability. Berger fails to see through wildlife photography and ultimately accepts its naturalization by ignoring its history.

The invisibility marking wildlife photographs requires a historical rather than an ideological explanation. But first, it is necessary to clarify exactly what the normal invisibility in wildlife photographs is and how it operates. It is necessary to distinguish the specificity of the invisibility marking wildlife photography from the general operations of photography. For example, instantaneous photography depicts frozen moments of movement that are not visible to the naked eye, which are, we might say, normally "invisible." A snapshot photograph's representation of something that declares itself to be unseeable disrupts our ability to trust our own experience. Like in wildlife photography, the use of the photographic apparatus to access an otherwise inaccessible reality increases our dependence on the apparatus and our alienation from our experience. This is a point Joel Snyder brings to the fore in his discussion of Benjamin's essay "The Work of Art in the Age of Mechanical Reproduction." Snyder asks, "If photographs are about 'the visible world' and most writers on photography maintain at least this, then in what sense is a picture that shows us something unseeable still to be thought of as about 'the visible world?'" [17] He suggests that instantaneous photography challenges our understanding of reality by leaving us "in the unusual predicament of maintaining at one and the same time photographs show us facts about 'the visible world' that have no counterparts in our world outside their occurrence in photographs" (161). As Snyder points out, there is a gap between what is visible in instantaneous photographs and what is visible in the world. This gap is resolved by having the photograph become the lens through which we understand the visibility of the world.

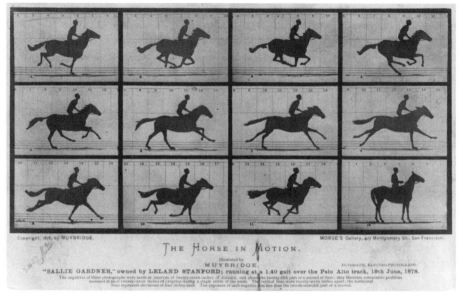

FIGURE 17. Eadweard Muybridge, *The Horse in Motion*, ca. 1878. Library of Congress Prints and Photographs Division.

Instantaneous photography presents us with images of the world that we cannot physically see.

This aspect of photography is central to the history of animal photography; the connection begins with Eadweard Muybridge's famous photographs of the horse in motion. As was discussed in chapter 1, at the request of railroader Leland Stanford, Muybridge sought to determine photographically whether horses ever had all four feet off the ground. He built a battery of cameras at Stanford's Palo Alto racetrack that could be triggered in rapid succession capturing the sequence of movements comprising the horse's gait. The resulting images, published in 1878 as *The Horse in Motion*, conclusively demonstrated that the horse's feet do indeed leave the ground while moving (Figure 17). The images also flatly contradicted the traditional manner of representing a horse in motion, the spread-legged figure of the hobby horse (Figure 18).[18] After Muybridge, we no longer see the traditional spread-legged

horse figure as an adequate representation of movement and instead see it as unsophisticated and unrealistic.

As Snyder argues,

> It is not only that these pictures may represent what we cannot see, but finally, they provide testimony for us, as we cannot for ourselves, of what we actually do see—they authorize us to make claims about what we see right in front of our eyes—and finally educate us about how we ought to judge what we see. Chrono-photographs then, can bring us into a domain we cannot see; yet at the same time, they can also show us what we do see, though we cannot warrant having seen apart from the pictorial evidence produced by precision instruments.[19]

The movement of the horse's legs is something we cannot see for ourselves because our eyes cannot focus fast enough.[20] Instead, we take Muybridge's images as showing us what we would see if we could resolve the movement into its component parts. Any evidence our sight offers us that contradicts the apparatus is dismissed as optical illusion.[21] The images disrupt our relation to the visible world, convincing us that the truth of the visible world is not what we see, it is what the apparatus shows us. Muybridge's photographs were the first instances of what Étienne-Jules Marey would come to call chronophotography; the sequential depiction of movement. Yet, as Snyder argues in relation to Marey's discussion of Muybridge's chronophotography and its effect on art,

> The education of sight, as elaborated by Marey, involves a process of reconciliation between what we see and what we can only come to know through chronophotography. We cannot be taught to see what we cannot see, but we can learn to expect artists to represent "Nature" without mistakes, and the standard of correctness is set by chronophotographic discoveries.[22]

Chronophotography, like *The Horse in Motion*, presents images marked by their normal invisibility that we take as a standard

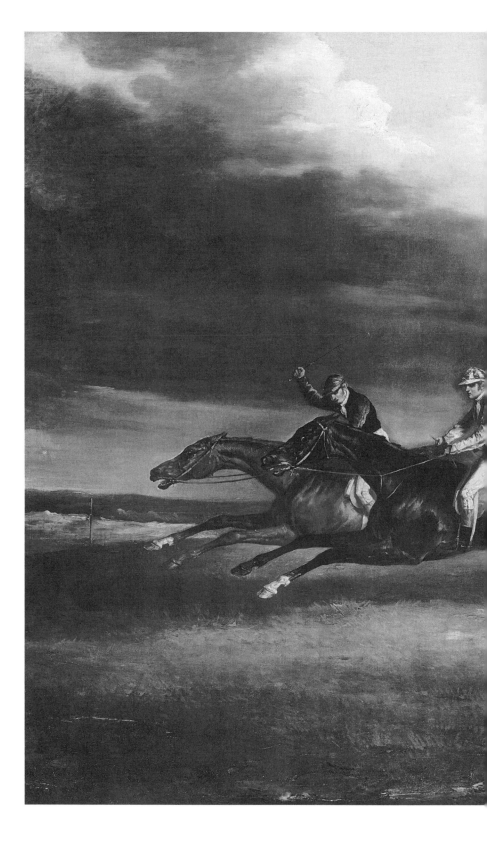

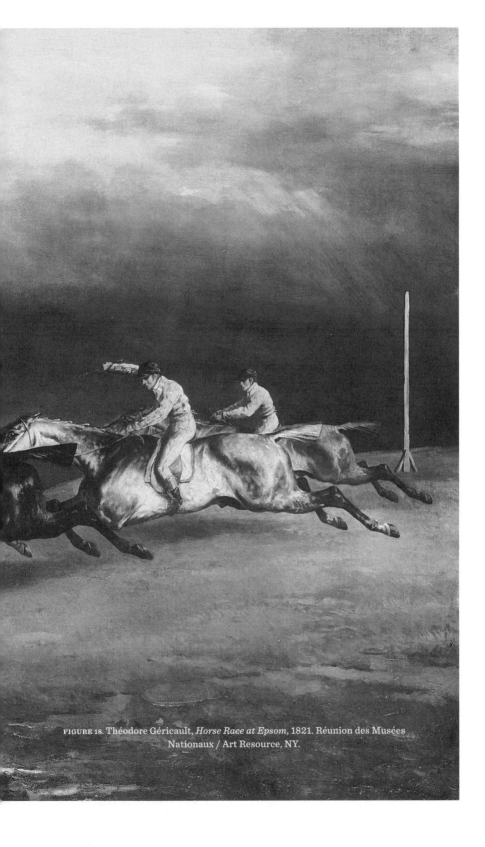

FIGURE 18. Théodore Géricault, *Horse Race at Epsom*, 1821. Réunion des Musées Nationaux / Art Resource, NY.

for our engagement with reality and its representations.[23] This is similar to the effects of wildlife photography described by Berger, yet it differs in one key aspect; Muybridge's images are not predicated on our absence. We cannot see the movement of the horse's legs with the naked eye, and in fact that inability was the impetus for their production. However, we believe that the truth of the movement these photographs depict was always there for us to see. This is in sharp contrast to the relation between visibility and invisibility in wildlife photography. The animals in wildlife photography can physically be seen by the naked eye, and almost all of them are available to be seen in zoos.[24] The "normal invisibility" marking wildlife photography suggests that the real animal is ontologically, and hence optically, inaccessible to us. According to the logic of the wildlife photograph, the real animal is not the one we see. The logic of the images is as follows: when we are there, the animal behaves in an unnatural way or refuses to appear; when we are not there, the animal is both natural and visible. Thus, we could not see what the images show us, not because the apparatus extends beyond the capabilities of our sight, as in chronophotography, but because the apparatus stands in for us in a situation in which we ourselves cannot be.

The animals in wildlife photography assert their authenticity on the basis of a radical detachment between human and animal. Unlike Berger, I am not arguing that this separation is a symptom of capitalism, and I do not believe that contemporary humans are incapable of having meaningful encounters with animals. Rather, I am arguing that photography has shaped the way we see and think animals. What I am interested in is showing how in becoming wildlife photography, animal photographs come to be marked by this disjunction between human and animal. The key is the link between the production of animal images and the production of normal invisibility. The apparatus that produces both is the photographic blind. The photographic blind produces animal images by making the photographer invisible. It is a machine for

controlling the relation between seeing and being seen. However, the function of the photographic blind depends on its historical constitution. Although the photographic blind naturalizes itself and the images it produces, its function is historically constructed. As will be seen, it was hard work getting from fake trees to canvas tents.

THE HUNTING BLIND

The photographic blind developed out of the traditional practice of the hunting blind, a millennia-old practice whose origins are both multiple and obscure. Blinds are found in many hunting cultures. This is not surprising given how simple the apparatus is in its most basic form. In practice there are a wide variety of types and kinds of hunting blind. In their most general form, hunting blinds are screens or obstructions behind which the hunter can wait for prey. The hunter locates the blind facing an area in which the animal's presence is anticipated, that is, alongside a game trail, near a watering hole, nest, or den. In practice this can mean setting up a portable blind, building a blind out of reeds or branches, or even simply finding something to hide behind as in the case of a convenient boulder. The blind faces a targeting ground, an area in front of the blind from which the hunters cannot be seen and upon which they can focus their firepower. Hunters often use various techniques to hasten the arrival of the desired animals to the blind. In some cases, as with duck or moose hunting, hunters call the animals to the blind by imitating an animal call.[25] A related technique, appealing to sight, not sound, used to bring animals to the blind is to place decoys—replica animals—in front of the blind to signal that the area is safe and/or attractive to the desired animals.[26] The use of decoys necessarily implies the use of some form of hunting blind. Replica animals cannot attract other animals without the presence of the hunters being obscured. Hillel Schwarz traces the use of decoys, and by implication that of hunting blinds, back to the time of Tutankha-

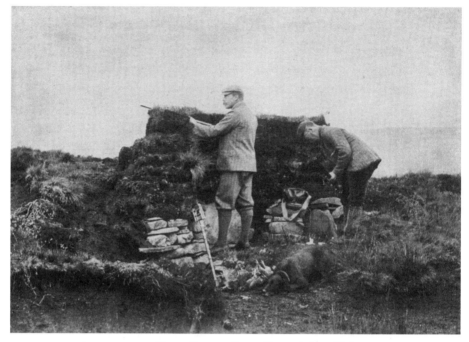

FIGURE 19. Cherry Kearton, *Grouse Shooter in Butt*, 1897.

men.[27] Hunters use a different sort of lure to bring animals to the blind when they bait animals. Bear hunters hang rotting meat in trees to accustom bears to coming to an area to be fed. Once bears become accustomed to the bait as a source of food, the hunters can then wait in a nearby blind, assured that a bear should soon come into range. However, in all of these cases, regardless of how the animal arrives at the blind, the final act is the same: when the animal is within range, the hunter springs forth from ambush and attempts to take its life. The point of the apparatus, and perhaps why it is now called a blind, is that it obscures the hunter's presence from the animal.[28] Animals will approach much closer to the blind than they would to an unhidden hunter. The blind allows a clear shot at what would otherwise be elusive game.

The hunting blind's principles are concealment and surprise.

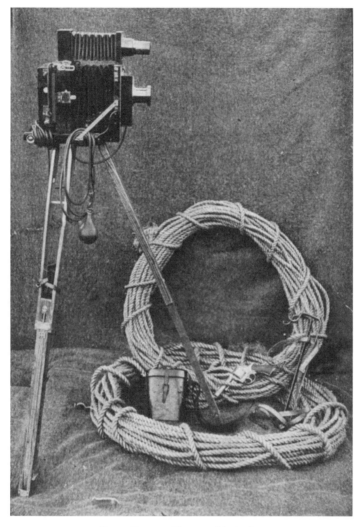

FIGURE 20. Cherry Kearton, *Photographic Equipment*, 1897.

Blind-hunting requires patience. Blind hunters must be able to remain still and silent for long periods of time. The use of the blind confers certain advantages on the hunter. Blinds allow hunters to catch animals that move faster than they do, animals they could not track down (like birds), and animals that can enter

terrain that they find difficult or impassable (a moose in dense brush). Blinds allow hunters to surprise animals but generally give them only a brief window of opportunity to capture or kill the animal before it flees.

We can see the structure of a nineteenth-century hunting blind in Cherry Kearton's photograph *Grouse Shooter in Butt* (Figure 19).[29] "Butt" is the late-nineteenth-century British term for a simple hunting blind devoted to shooting grouse. The image was published in Richard Kearton's 1897 volume *With Nature and a Camera, Being the Adventures and Observations of a Field Naturalist and Animal Photographer.*[30] In the book the Keartons described their practices of photography and their time spent photographing in St. Kilda, an island in the Western Hebrides. The brothers describe the bird hunting practices of the islanders and their own photography as part of a continuum. They illustrate both hunting blinds and the beginnings of the photo blind as well as their other mechanisms for photographing birds (these include rappelling gear, tree climbing equipment, and their camera) (Figure 20).

Richard (1862–1928) and Cherry Kearton (1871–1940) were pioneering naturalists and wildlife photographers.[31] *With Nature and a Camera* was the brothers' second book of animal photographs. Their first book, *British Birds' Nests—How, Where and When to Find and Identify Them,* was the first British book to feature photographs of wild birds.[32] The brothers were famous for the acrobatic feats they performed to obtain photographs of birds, including rappelling down sheer cliff faces to photograph sea birds and rigging up ladders in treetops to photograph songbirds (Figure 21).[33] The brothers wrote many books both together and separately.[34]

Cherry's photograph *Grouse Shooter in Butt* shows two men and a dog behind a low stone wall (Figure 19). The photograph is posed; it is not a document of the blind in action but rather a demonstration image.[35] Thus, while we can read the image to gain an understanding of the structure and operation of the hunt-

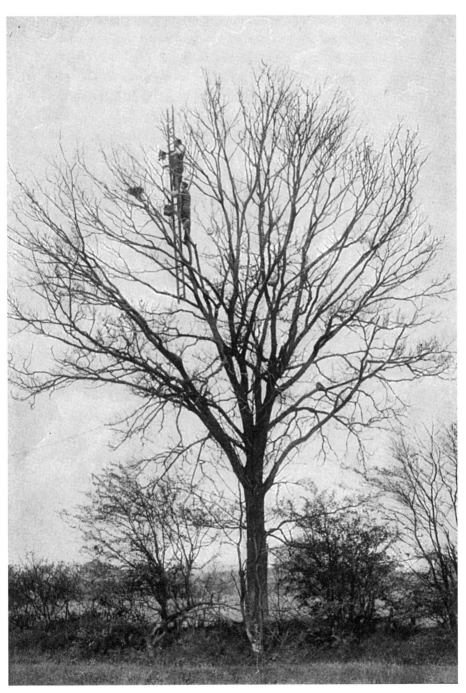

FIGURE 21. Cherry Kearton, *Photographing in Treetop*, 1897.

ing blind, we must remember that it shows us the hunters' and photographer's idealization of its use, not its actual use. The wall is set into the ground and forms a rough semicircle facing left and occupying the center of the image. We see the wall from an oblique angle—we can see inside the blind and the ground behind it but cannot see in front of the blind. The wall is a permanent fortification; the moss on the rocks indicates the structure has been in place for a long time. As a semicircle, the blind is oriented, it only works in one direction, and it faces an out-of-frame feature that functions as its targeting ground. The continued use of the same hunting location indicates either infrequent use of the blind or that the blind overlooks some choice feature of the landscape that is especially attractive to grouse. While the second option seems to make more sense—why build a stone butt facing ground grouse are not particularly attracted to?—we are not given to see the targeting ground and can only tell that the blind is located on the uneven terrain of a Scottish heath.

The photograph shows two men engaged in grouse hunting. One man stands to the left of the image with his shotgun readied, peering out over the blind and his gun resting on top of the wall. Only his head protrudes above the top of blind. He is wearing a tweed jacket with matching knickers and a cap. His clothes are well cut and expensive looking, suggesting he is a figure of some stature. The second man is on the right of the image and is crouched over behind the wall near a bundle of provisions. He is wearing a jacket and trousers that appear to be not as well cut as those of the first man. He too is carrying a gun but not in a manner that would enable him to quickly fire it. He is bent over and holding the gun with one hand by the barrel. From his posture it seems likely that he is loading the gun.[36] The dog lies in front of the first man, facing the photographer and hence the viewer. The dog is a retriever, a gun dog bred to fetch shot animals. After the shooting, the dog will be sent out to fetch the kill. There is a pile of dead grouse beside the dog.

The first man is obviously ready to shoot some grouse, but the second man's role is more ambiguous. He could be preparing to shoot, or he could be there to assist the first man. The Keartons' caption for the image helps to decipher the relation between the figures.[37] Their title, *Grouse Shooter in Butt,* is singular, grouse shooter not grouse shooters; this suggests that the second man is in the service of the first, most likely as a loader. The use of a loader was common and makes sense given the mechanics of grouse hunting from a blind. A shotgun loaded with bird shot has only a limited range of effectiveness. Shotguns are the favored weapon for bird hunting, as a charge of small shot can kill a bird without destroying the body. Shotguns produce a spread of pellets rather than a single bullet and are pointed, not aimed, at their target. Breach-loading shotguns have a single shot per barrel and cannot be reloaded in the firing position.[38] The gun must be broken open, and the shells replaced by hand. As well, once fired upon, the grouse will fly away. Having a loader allows the shooter to fire more shots, and hopefully kill more grouse, in the brief period the grouse remain in range. The retriever, like the loader, is there to assist the grouse shooter. Both the loader and the retriever remain completely behind the wall so that whatever movements they make are completely invisible from in front of the blind. The bundle of provisions beside the loader suggests that the men are prepared to remain in the butt for a significant length of time waiting for grouse to come into range.

I suggest that we can understand the butt, and the supporting cast, as a mechanism for killing grouse with a minimum of effort on the part of the shooter. The loader and the dog supplement the operations of the blind and make the shooter more efficient, but they do not fundamentally alter them. The butt is a very rudimentary hunting blind; it is an unenclosed semicircle and is thus open to the elements, limiting the length of stay to hours rather than days and restricting it to functioning in only one direction. It circumscribes a limited field of effectiveness; its targeting ground

is the arc described by the curve of the wall in combination with the shotgun's effective range. Should conditions on the heath change, should the targeting ground cease to attract grouse, the blind would have to be abandoned, as it is impractical to move and not easily changed.

Contemporary hunting blinds are much fancier, but the underlying mechanism remains the same: the shooter waits in the blind focused on a location where animals are expected and catches them by surprise when they arrive.[39] Blind-hunting is marked by long periods of waiting punctuated by brief periods of activity. As noted above, the blind can be supplemented with other techniques to encourage the arrival of animals, such as mating calls, decoys, bait, or the use of beaters to funnel animals toward the blind. However, while these techniques can shorten the wait or increase the number of animals on the targeting ground by making it more attractive, they do not fundamentally alter the mechanics of the blind.

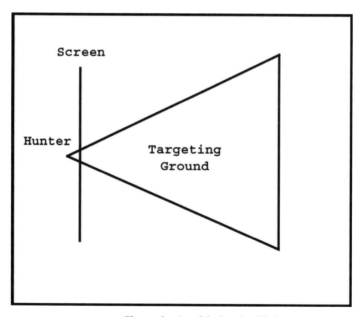

FIGURE 22. The mechanics of the hunting blind.

In its mechanics the hunting blind is a screen that allows seeing without being seen (Figure 22). The hunter hides behind an obstruction waiting for the animal. The "invisibility" conferred by the hunting blind is serial rather than permanent. It allows hunters to surprise animals, but once they have revealed themselves by attacking, it does not continue to provide invisibility beyond the moment of attack. The hunting blind produces dead animals by controlling the hunter's visibility. In contrast, the photographic blind produces images of animals by controlling the photographer's visibility. However, the difference between the operation of the photographic blind and the hunting blind is not simply reducible to the difference between camera and gun. While the difference between the camera and the gun is both significant and important, the role of the apparatus is determined not simply by the kinds of representations it enables but also by the social and discursive networks it inhabits.

ADAPTING THE PHOTOGRAPHIC BLIND

The hunting blind was one of many hunting techniques pressed into service by nineteenth-century animal photographers in their quest to obtain images of live animals in their natural habitats. It was independently adapted by several photographers on separate occasions. The earliest animal photographers utilized the form of the hunting blind without making claims for the blind's effects on the images produced. These photographers emphasized stalking in their discussion of photographic techniques. Their discussions of blinds were without rhetorical emphasis. The earliest animal photographers used blinds in an almost identical manner to a hunter in a hunting blind. They waited in their blinds and took "snap-shots" at animals.

In this section I examine the adaptation of the hunting blind to animal photography. This is not an exhaustive survey of animal photographers and their use of photographic blinds, nor is it a listing of all the early photographers who used some form

of blind. Rather, it is an analysis of the formation of the photographic blind as an apparatus, an assemblage of practices and discourses thought to produce images in a certain way. I concentrate on those moments in which the function of the blind changes and on the development of its rhetoric. The focus is on published imagery and discussions of the photographic blind, as my interest is in explicating how the photographic blind comes to circulate as a public discourse. My interest is in the photographic blind's coming into representation. Thus, my interest in the material practice of the photographic blind goes only so far as it becomes public and circulates.

THE WALLIHANS AND THE UNREMARKED PHOTOGRAPHIC BLIND

Allen Grant and Mary Wallihan, one of the first teams of photographers to use a hunting blind to photograph animals, provide a useful description of the difficulties involved in using the hunting blind for photography. As detailed in the previous chapter, at the beginning of their photographic career the Wallihans did not describe their photography as hunting. It must also be said that they did not strongly differentiate their photography and hunting either. In their 1894 book of animal photographs, *Hoofs, Claws and Antlers of the Rocky Mountains,* the Wallihans provide several descriptions of photographing animals from blinds.[40] However, they include no pictures of their blinds. While they include a picture of their camera and multiple shots of each other, they treat blinds as a basic hunting technique that should be well known and thus not worth illustrating. For the Wallihans, the photographic blind is essentially unmarked; they make no claims for its effects on the imagery and only discuss it in passing. Many of their photographs were taken from blinds, and while blinds are mentioned, they are never described in detail.

As pioneers of animal photography in nature, the Wallihans ran into many difficulties trying to adapt the hunting blind to

photography. For example, in November 1893, Allen Grant Wallihan described building a blind and then waiting in it to photograph antelope:

> Building a blind where a small side gulch came into the larger one, out of sage brush and weeds, I was soon ready for Mr. Antelope and all his family. Here comes a buck, but they come in below me, scare at something, run back and come right down in front of me. When they walked out in front of me as you see them on top of the bank of the gulch and stopped, I was suffering with buck fever, but after I made the exposure I felt relieved. They came right down within thirty feet of me to the water, but scared again and went higher up to drink. I made exposures on one or two other bunches but got my camera aimed too low and cut off parts of them.[41]

While Wallihan described waiting in the blind for the animals to approach, the focus of the description was on his excitement at being able to photograph animals. Waiting in blind, Wallihan described thinking like a hunter and suffering from "buck fever," the desire to blast away at anything that moved.[42] Needless to say, this feeling was inappropriate to animal photography. It was inappropriate not because animal photography and hunting are fundamentally opposed but rather because it conflicted with the limitations of the Wallihans' equipment. As his description indicated, one of the difficulties in 1893 of using a hunting blind to photograph animals was that if the camera was not well aimed prior to the animal's arrival, it would not produce decent exposures. The camera needed be aimed and focused prior to the arrival of the animal. If the animal did not pass in front of the focal point, there would be no good exposure. Mr. Wallihan emphasized this point in another description of photographing from the blind: "Next day I made an exposure on the best bunch at this same spot, forty-five feet, but the camera was pointed too low. If it should be wrong I could not move to alter it, as they

would leave instanter. And it is very much a gamble to tell when they will come."[43] Although there were animals in front of the blind, Wallihan was unable to photograph them. Moving the camera to refocus would have spooked the antelope. Because of the materials that the Wallihans were working with, they could not catch an animal on the run the way a gun hunter could; if the animal moved too quickly, it would simply fail to expose.

As well, working with plate negatives made it impossible to change the plate while the animals were present. This difficulty is brought to light in Wallihan's description of a failed attempt at photographing deer. He wrote, "Shortly after I took a snap shot at five but the negative was not good. One of these came within ten feet of me and veered off, landing above me. I had exposed him on the five and could not change, as she would have scared at the motion."[44] Late-nineteenth-century cameras were generally bulky and difficult apparatuses to maneuver through the woods. As such they could not easily be moved or aimed without alerting animals to their presence. Thus, the cameras had to be focused in advance, sometimes on a very small area, in order to take a successful picture. If the animal failed to occupy the focal point, there would be no picture. Even the act of exposing the film, the click of the shutter, could alert the animal and ruin the picture.

Most of the Wallihans' blinds appear to have been traditional hunting blinds of the kind briefly described in the first quotation.[45] These were bower blinds crafted out of available materials. However, Allen Grant also used his camera cloth as a blind, suggesting an alternative conceptual genealogy for the photo blind.[46] Camera cloths were used to allow the photographer to look through the lens without spoiling the plate. The Wallihans' use of the camera cloth as a blind suggests a link to the photographic camera's prehistory in the camera obscura. The camera obscura is a darkened chamber with a small hole in the side admitting light. The hole acts as a lens, and inverted images of the outside world form on the opposite wall of the chamber. Walli-

han's use of the camera cloth can be thought of as reextending the camera obscura of the photographic camera's body to include the photographer. Yet, while drawing this analogy, we must understand that the photographic camera, while indisputably drawing on the camera obscura in its construction, cannot be understood in terms of the camera obscura; it is a radically different apparatus.[47] However, thinking through the camera obscura may be helpful for understanding the photographic blind as an apparatus. As Jonathan Crary argues, the camera obscura provides a model for thinking of the world in terms of internal and external; the viewer in the camera obscura is seeing the world reproduce itself as an image.[48]

Crary suggests the camera obscura's enclosure of the observer demarcates a "meaningful" separation between an inside figured as private and an outside figured as public. The inclusion of the observer in the apparatus is the key to this effect. Crary's description provides a model for thinking the effects of the photographic blind on photography. We can think of the blind's incorporation of the observer in the apparatus as reactivating the camera obscura's enforcement of a distinction between interior and exterior. To be inside the blind is to not be in the world. Thus, we can think of the normwal invisibility marking wildlife photographs as the inscription of the separation between interiority and exteriority presupposed by the blind on the image. Yet, as Wallihan's descriptions of waiting in the blind make clear, he was unconvinced of his radical separation from the animals. He felt exposed and worried that at any minute he might alert the animals to his presence. As well, the analysis of the Wallihans' images in the previous chapter indicated that their photographs are continually marked with traces of human presence. To resolve this disjunction, it is helpful to recall Crary's caution that "the formal operation of a camera obscura as an abstract diagram may remain constant, but the function of the device or metaphor within an actual social or discursive field has fluctuated decisively" (29). That is to say, this

inscription of a sharp distinction between inside and out by the form of the camera obscura is not inevitability or necessarily the dominant effect. For the photographic blind to come to mark the image with a sharp distinction between interiority and exteriority, the blind's potential to inscribe such a distinction must start to become an important part of its use. For this to happen, photographers have to begin adapting the blind to photography.

THE KEARTONS AND THE ADAPTATION OF THE BLIND

The Keartons, like the Wallihans, experimented with many different techniques to photograph animals. In fact, it would be fair to say that the Keartons were far more inventive in their attempts to find ways to get their camera within range of animals. Unlike the Wallihans, the Keartons represented their blinds.[49] They also experimented with them and adapted them to photography.[50] As we have seen, the Keartons photographed a traditional hunting blind. They also photographed from bower blinds though they never photographed them. Traditional bower blinds did not hold up to the extended observation required to photograph birds and were abandoned.[51] Their representational absence is significant, as the Keartons made images of most of their techniques for photographing animals.

The Keartons' representations of their photographic techniques perform at least a dual function. They show how the photographers photographed the animals, and they perform the function of authenticating the photographs that are produced. As Jennifer Tucker informs us, "the acceptance of photographs as objective, meaningful representations in Victorian science and culture did not happen automatically; on the contrary, assent to claims supported by the evidence of photographs was contingent upon their meeting several criteria, for example, of production and of use, established in different settings by a pool of experts."[52] In the late nineteenth century, photography was not yet seen as objective and needed additional evidence to testify to the validity

of its results.[53] Thus we find the techniques used to enable the photographs photographed themselves. "The photograph," Lorraine Daston and Peter Galison have argued, ". . . did not end the debate over objectivity; it entered the debate."[54] One of the ways photography bolstered its authority was to require "witnesses to the production of the image."[55] The means of representation are represented to testify to the authenticity and objectivity of the representations. This meaning of the representation of the photographic process should be understood to be operating in tandem with their overtly espoused pedagogical purpose. The "how-to" functions both to explain how to photograph animals and to authenticate the resulting photographs.

The first photographic blind the Keartons photographed was a compound blind they used to photograph a kingfisher (Figure 23). The image, *Photographing a Kingfisher,* shows a photographer lying on a path hiding behind a board propped up on an angle.[56] The camera lies ahead of the photographer on a footbridge covered by a cloth and focused on the pond. The photograph shows a snow-covered field in the foreground with barren trees as background. The photographer is wearing thick winter clothes and a winter cap. The shutter will be sprung using the long pneumatic tube extending from the man to the camera. It requires dedication to lie unmoving on cold ground waiting to get a picture. The camera is likely focused on the bird's nest or some other spot that the bird is known to frequent. For the bird to return, it must be convinced that that the camera setup poses no threat. Thus, the photographer must be prepared to spend a long time waiting. It would appear that the blind is divided in two in order to minimize the obstruction near the nest and hasten the bird's return. The camera is hidden in its own blind. The resulting image will thus be separated from the viewpoint of photographer; it will not represent what he saw.[57] The compound blind is the beginning of the separation within the photographic image of the animal and photographer.

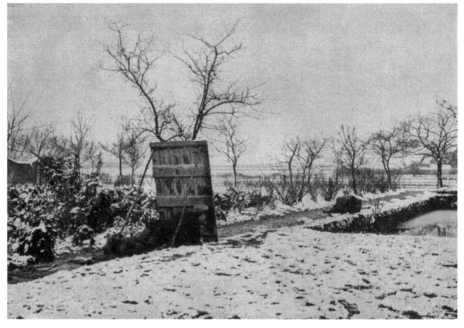

FIGURE 23. Cherry Kearton, *Photographing a Kingfisher*, 1898.

Later, the Keartons developed more complicated and elabo-
rate photographic blinds, the first and most famous of which was
their artificial cow. The Keartons built a hollow cow within which
Cherry could hide and photograph animals. One of their most
famous photographs shows Cherry stuck in the upside down cow
(Figure 24). The cow lies on its back in a field with its legs straight
up in the air; Cherry's legs can be seen sticking up in the middle.
The cow is lying on a slight downslope and is shot from below,
so that it appears silhouetted against the sky. Like a turtle on its
back, Cherry was unable to right himself without Richard's help.
This was not the only misadventure with the fake cow; there is
also a probably apocryphal story that the cow once attracted the
unwanted attentions of a bull. Together, both episodes suggest
there are real disadvantages in trying to disappear as something
specific in the landscape. Yet, there may also be advantages to

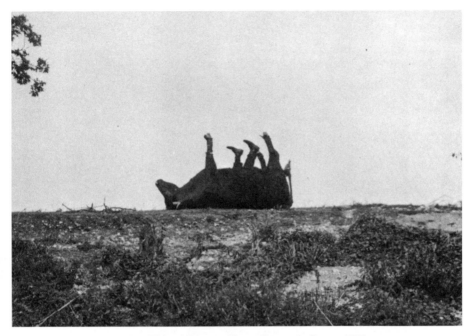

FIGURE 24. Richard Kearton, *Cherry Kearton in Cow*, ca. 1900.

appearing as something else; the story of the bull can also be read as a verification of the disguise's effectiveness. As in Pliny's famous story of the contest between Zeuxis and Parrhasius, deceiving the animal is a credit to the artist. In a collapse of the two figures, in this case the deception of the animal convinces us that the illusion is complete. Birds must be fooled by the blind because bulls are fooled. Fooling the animal is also fooling the human.

It was in their 1898 book *Wildlife at Home: How to Study and Photograph It* that the brothers significantly developed the photographic blind beyond the parameters of the traditional hunting blind.[58] Among their other experimental photographic blinds the Keartons built an *Artificial Rubbish Heap*.[59] This was a wagon piled high with grass creating a frame within which Cherry could hide with the camera. As a wheeled vehicle, the rubbish heap had the

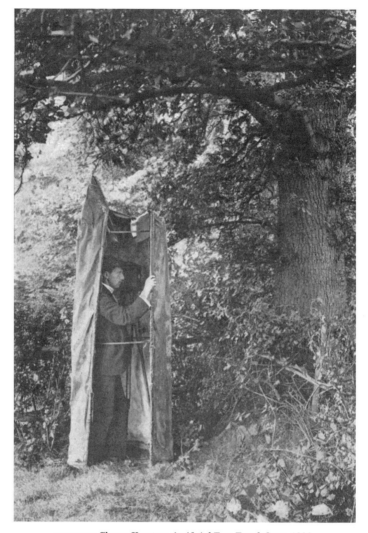

FIGURE 25. Cherry Kearton, *Artificial Tree Trunk Open*, 1899.

advantage of a certain degree of mobility. However, its design lim-
ited it to operating on flat terrain or near roads; it could not enter
into anything approaching a forest. The rubbish heap blind would
appear to be limited to photographing around the farm. However,
the blind does appear to be indistinguishable from a real rubbish

FIGURE 26. Cherry Kearton, *Artificial Tree Trunk Closed*, 1899.

heap and thus acts as further evidence for the effectiveness of the photographic blind.

The Keartons' most important invention for the further development of the photographic blind was their artificial tree trunk. As Richard described, the brothers developed "an imitation tree-

trunk of sufficient internal capacity to accommodate my brother and his camera."[60] The tree trunk is illustrated in two images in *Wildlife at Home*. The first, *Artificial Tree Trunk Open,* shows Cherry in a narrow tent before a large tree (Figure 25).[61] He is dressed in a suit and holding the tent flap open to show the camera and tripod in the structure with him. It is paired with a second image, *Artificial Tree Trunk Closed* (Figure 26).[62] The second photograph shows the structure in the same position as the first, now with the flap closed and the exterior covered with vegetation. The tree trunk blind was lightweight, portable, and appropriate for most situations.[63] This was the least "realistic" of the Keartons' blinds. There was no attempt to represent the texture of tree bark, and the use of ivy, to disguise the exterior, was minimal.

The Keartons' photographic blinds were intended to allow close observation of birds by making the observer invisible to them. They were designed for long-term occupation, creating the possibility for multiple shots of the same animal. The blinds no longer needed to be reset after each picture of the animal. Fully enclosed blinds allowed photographers to refocus and change film without disturbing the animals, as they hid all of the photographer's movements. It is important that the Keartons' blinds are well enough camouflaged to deceive humans. This is not because we can be assured that animals will also be deceived; it is unclear that animals will see things the same way as we do. What it does do is help convince us that the humans inside these blinds are well hidden. The use of the apparatus slides from simply enabling the taking of the picture to allowing the observation of birds in a way that would not otherwise be possible. The pictures of the apparatus assure us that the photographs we see are of birds observed close-up from life.

FRANCIS HERRICK AND THE OBSERVATIONAL BLIND

The photographic blind's potential to allow long-term observation was further developed in the early twentieth century by Francis

Hobart Herrick, Ph.D. (1858–1940). Herrick was the first professor of biology at Adelbert Western Reserve University, later Case Western Reserve, and wrote the definitive natural history of the lobster.[64] Herrick was also the first to study the life of the bald eagle and wrote the first major biography of Audubon.[65] C. A. W. Guggisberg suggests Herrick "was probably the first photographer to use as a hide or blind a plain, uncamouflaged tent."[66]

Herrick's work marks the incorporation of the photographic blind into the discourse of ornithology. This incorporation was part of the growing importance of photography to the practice of ornithology. As Alfred O. Gross notes in his 1933 history of bird photography in America, "By the beginning of the twentieth century bird photography was no longer a mere novelty and a fad. Bird pictures were not considered an end in themselves merely to please the eye but as important records of bird life and bird behavior."[67] Thus, in the early twentieth century bird photographs were no longer simply trophies or aesthetic objects; they were in the process of becoming disciplinary objects.

Herrick presented his findings on the use of the photographic blind for observing and documenting birds in his article "A New Method of Bird Study and Photography."[68] In this essay, Herrick presented the photographic blind as an essential tool for studying and documenting birds. He argued that the photographic blind enabled photographers to see birds in a manner that was previously not possible. It was now possible to create a series of photographs of birds on the nest. The photographic blind was thus central to the essay. From an unmarked technique in the Wallihans' work the photographic blind had in Herrick's work come to occupy center stage in the thinking of animal photographers. Herrick contrasted his new method of bird photography with what he described as the old-fashioned techniques of stalking animals (i.e., the practices associated with camera hunting).

> In the new method of the study and photography of birds, the conditions ... are completely changed. . . . instead of attempt-

ing to go to the observer—nest, young, branch, and all. The nest, whatever its original position, is moved with its supports to a favorable place for study. A green tent is then pitched beside it, and under this perfect screen the observer can watch by the hour and accurately record the shifting panoramic of nest life.[69]

Thus, in contrast to the stalking methods associated with camera hunting, Herrick proposed to use the photographic blind and its ability to obscure the photographer to conduct prolonged up close observation and photography of birds. Merely obtaining an image of an animal was no longer enough. Herrick sought characteristic images of birds.

There were two keys to Herrick's method: "(1) The control of the nesting site, and (2) The concealment of the observer."[70] For concealment of the observer, Herrick used a tent blind:

> For an observatory I have adopted a green tent which effectually conceals the student, together with his camera and entire outfit. The tent is pitched beside the nest, and when in operation is open only from one point, marked by a small square window, in line with the photographic lens and the nest. (427)

Herrick described a fairly simple blind, a canvas tent with a single hole for the lens. The article included three images of the photographic blind. The first, *The Author's Tent in a Field*, shows the blind set up in a farmer's field (Figure 27).[71] The blind, a tall, thin canvas tent, is set up in the lower right-hand corner of the image. In the middle distance is a dry stone fence beyond which is a road. The window in the side of the tent is not visible in the photograph. The tent is held up with stakes and guy wires; thus while portable, it is by no means quick and straightforward to erect. The second image of the tent, *The Tools of Bird-Photography: The Tent Rolled Up in Portable Form at Night*, shows the tent alongside the rest of Herrick's photographic equipment (Figure 28).[72] Leaning up against a tree, the blind is now tightly wrapped in

a bundle around the tent poles. While packaged to be compact and portable, the blind is still relatively bulky. Yet, as the third image shows, the blind is capable of being transported and set up in fairly dense brush (Figure 29). The image, *Tent in Bushy Pasture beside Nest of Chestnut-Sided Warbler,* shows the blind peeking through the foliage.[73] The blind has been taken into the woods and set up next to the nest. Yet, as the essay made clear, moving the blind into the woods to set up next to the nest was not typical of Herrick's method. This becomes obvious when we understand Herrick's first criterion for bird photography: controlling the nesting site. Rather than climb into the tops of trees, like the Keartons, Herrick's solution was to bring the nest down to the

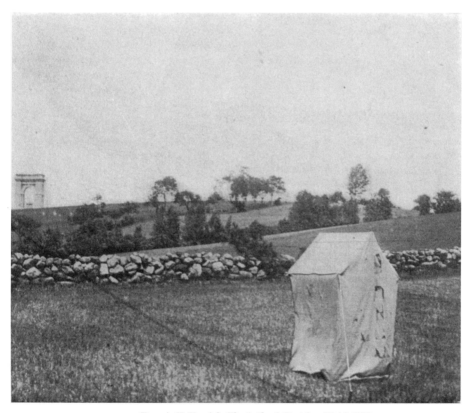

FIGURE 27. Francis H. Herrick, *The Author's Tent in a Field,* 1901.

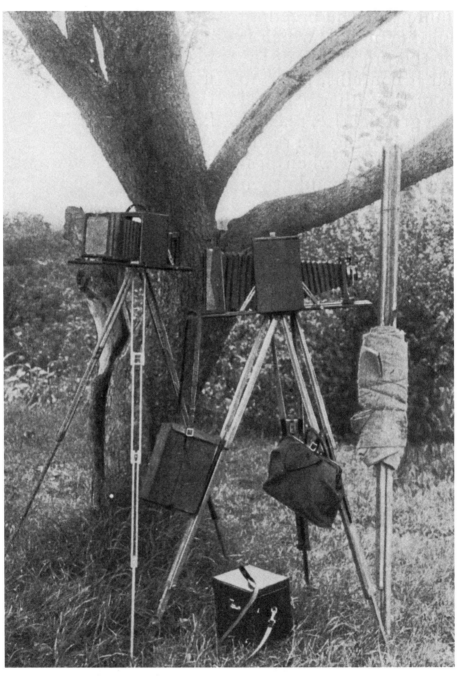

FIGURE 28. Francis H. Herrick, *The Tools of Bird-Photography: The Tent Rolled Up in Portable Form at Night*, 1901.

FIGURE 29. Francis H. Herrick, *Tent in Bushy Pasture beside Nest of Chestnut-Sided Warbler*, 1901.

camera.[74] However, he insisted that in so doing he was not in any way disturbing the nest.[75]

Thus, while Herrick supported moving nests to enable easy and prolonged observation, he did so out of a belief that in so doing he did not alter anything essential. Although, he had some sense that the site of the nest was important, he believed that only the immediate surrounding was necessary. Yet, despite not conceiving of nest and animal as inviolate, not seeing animal and human as truly separate, Herrick's work was the beginning of the photographic blind as the erasure of the photographer's presence. The photographic blind instantiated a new way of seeing animals;

the blind allowed its viewers to see and document the daily life of birds:

> With note-book in hand you can sit in your tent, and see and record everything which transpires at the nest,—the mode of approach, the kind of food brought, the varied activities of the old and young, the visits of intruders and their combats with the owners of the nest, the capture of prey which sometimes goes on under your eye. No better position could be chosen for hearing the songs, responsive calls, and alarm notes of the birds. You can thus gather materials for an exact and minute history of life at the nest, and of the behavior of birds during this important period. More than this, you can photograph the birds at will, under the most perfect conditions, recording what no naturalist has ever seen, and what no artist could ever hope to portray. The birds come and go close to your eye, but unconscious of being observed. (430)

According to Herrick, the birds he photographed were unaware of being observed (despite his movement of their nests). This was the beginning of the sense of the photographic blind as conferring invisibility. Because the blind made the observer's presence unobservable to the birds, the photographs show us the birds acting as if we were not there (because for them we are not).[76] What we see is what we would see if we were not there. The photographic blind presents these photographs to us as photographs taken as if we did not exist. The photographic blind allows its occupant to conduct an unprecedented observation of animals. It also produces series of photographs documenting the behavior of birds. These are very different images than those produced by stalking. With Herrick the photographic blind comes to be marked as significant for its ability to produce new kinds of animal images. These images are no longer thought of in terms of a connection to the photographer. The observer or photographer in the blind has become an interchangeable element in a larger

disciplinary structure. They fulfill a professional role document-ing the bird's behavior. Herrick's work marks the beginning of the photographic blind's engagement with ornithology.[77] Its absorp-tion by the disciplinary formation is the key to its new function. The photographs the blind produces now count as knowledge of the animal; they provide access to its truth.

With Herrick the photographic blind came to be understood as conferring invisibility on its occupant. This understanding of the photographic blind's invisibility was not yet accompanied by a sense of nonintervention. While Herrick's work was an important stage in the development of the blind, it was not widely adopted. As Gross writes, "not many naturalists have approved of Prof. Herrick's methods of involving the disturbance of birds by the removal of the nest."[78] Herrick's disturbance of the birds did not conform to the ideal of nonintervention at the heart of mechani-cal objectivity.[79] Thus, Gross adds that Herrick's method not only raises the "possibility of harm to the young birds" through its intervention, but, more importantly, "it does not show the bird in its real environment" (166). While Herrick's method allowed the documentation of birds on the nest, its disturbance of the nest came to be seen as inauthentic in comparison to the images produced by the further development of the photographic blind.

FRANK MICHLER CHAPMAN AND THE FORMALIZATION OF THE PHOTOGRAPHIC BLIND

Frank Michler Chapman (1864–1945) was a key figure in both American ornithology and the popularization of bird-watching.[80] His official involvement with ornithology began in 1888 when he took up a position as Joel Asaph Allen's (1838–1921) assistant at the American Museum of Natural History. Chapman became the museum's Associate Curator of Mammals and Birds in 1901, the Curator of Birds in 1908, and the first Chairman of the Depart-ment of Birds in 1920. He was the founding editor of the official journal of the second Audubon Society, *Bird Lore*, and was the

inventor of the habitat diorama as a form of museal display.[81] He also originated the practice of Christmas counts in ornithology. Chapman was a key figure in integrating photography into the practice of ornithology and was responsible for formalizing the photographic blind.

Chapman first discussed the use of the photographic blind in his 1900 book on bird photography *Bird Studies with a Camera*.[82] The book was a how-to manual of bird photography for the general public. In the book Chapman described the Keartons' use of blinds and their connection to the hunting blind. "As the sportsman constructs blinds in which he may conceal himself from his prey, so the bird photographer may employ various means of hiding from his subjects" (23). However, at this point Chapman failed to see the importance of the blind to the practice of animal photography. Chapman argued that whatever benefit the blind might confer was outweighed by its inconvenience: "It is difficult to carry one of these blinds in addition to a camera, etc., without assistance, and I fear that the inconvenience attending their use will restrict them to the few enthusiasts who count neither time, labor, nor cost in attaining a desired end" (24). For this reason, Chapman noted, he preferred "to conceal my camera and make exposures from a distance rather than weight myself with a portable blind and endure the discomforts of being confined within it" (24). Thus, in 1900 Chapman saw no special value in the photographic blind for producing images and no significant difference in the images it produced.

However, in 1901 Chapman invented his own version of the photographic blind (Figure 30). Gross describes Chapman's "umbrella" blind:

> This blind was merely a large leaf-green "sign" umbrella which was opened within a bag large enough to fall to the ground. There was a large hole in the center of the umbrella for purposes of ventilation. The stick of the umbrella was supported by adjustable brass rods the lower one of which was driven into the ground. This blind had the valuable feature of being easily

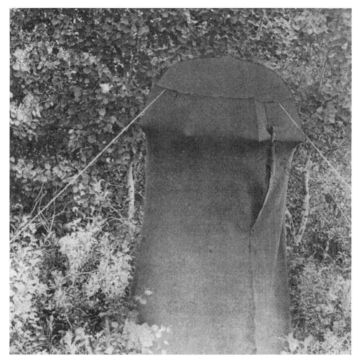

FIGURE 30. Frank M. Chapman, *Umbrella Blind*, 1908.

erected and when collapsed and folded made a very small and light bundle.[83]

Chapman's umbrella blind simplified the construction and use of the blind and is the model for contemporary tent blinds. Chapman used the blind in his ornithological photography to document birds on the nest.

Chapman's use of the photographic blind to study nesting behavior is exemplified by his 1908 article "The Fish Hawks of Gardiner's Island."[84] His studies "were conducted from the umbrella blind which [he found] indispensable to success in any effort to gain an insight into the home life of birds" (158). The blind was necessary because of the openness of the beach (Figure 31). As Chapman noted, "Both nests and blinds were conspicuous objects

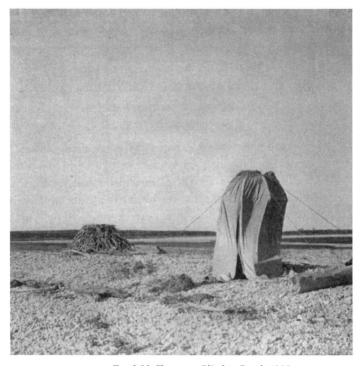

FIGURE 31. Frank M. Chapman, *Blind on Beach*, 1908.

on the beach" (158). Because of this conspicuousness, it was nec-
essary not only for the photographer to use a blind but to divest
it of human presence. The blind was dehumanized by having "a
coöperator whose departure, after [Chapman] had entered the
blind, apparently reassured the owners of the nest" that the blind
was now empty (158). This form of bird photography was a great
distance from the stalking photography emphasized by camera
hunting. The image of the bird was obtained not by sneaking up
on it but by convincing or deluding it that the blind was empty.

Chapman cited his use of the blind in the "Fish Hawks"
article as exemplary when he presented a formal description of
the blind's operation in 1908.[85] Chapman's article, "The Use of
a Blind in the Study of Bird-Life," placed the blind at the center

of bird study. He argued that the blind was the solution to the central problem in bird study. As Chapman noted, "If one would study the habits of birds under natural conditions it is of the first importance that they be unalarmed by one's presence" (250). The problem, he argued, was that "man's presence is always a more or less disturbing element, if not to the bird in question, at least to other species with which it may chance to become associated" (250). Human presence was disturbing because "with bird as with man, the consciousness of being under observation induces more or less artificiality of manner" (250). If birds were aware of human presence, they would not behave "naturally." We would instead see an unnatural bird that reflects our presence. Thus, Chapman argued that if we wanted to "gain true insight into either bird life or human life, one's subject should be unaware that they are the objects of scrutiny" (250). The truth of the animal, like that of the human, was only accessible when the animal believed itself to be unobserved. Otherwise, the animal, like the human, would compose itself for the viewer and would not be natural. For this reason Chapman argued that in order to capture the truth of the natural animal it was "necessary to employ an artificial blind" to erase the observer's presence (250). As the historian of science Helen MacDonald explains,

> Hides create a disembodied observer with no consequential pres-
> ence, attempting to guarantee the epistemological reliability and
> truth of behavioural data through an assurance that the scien-
> tist in no way affects the behaviour of the animals observed. In
> a related sense, the hide literalises and concretises that ascetic
> withdrawal from the immediacy of the observed phenomena
> which is at the heart of the positivist-pragmatist ethos—translat-
> ing a methodological, cognitive freeing from subjective involve-
> ment to a *literal* freeing from involvement.[86]

The blind performs a double erasure of the observer. It separates the observer from the animal both literally and conceptually and

thus guarantees the objectivity of the observations. In its production of observations of the animal the blind is forming a disciplinary object, a "natural" animal that is inaccessible outside of the apparatus of the blind.

Chapman confessed that he originally "did not appreciate the necessity for a hiding place which not only permitted one to photograph but to see" (250). However, he now argued that "a blind will be found to be of the greatest assistance in securing the proper point of view" (250). That is, the blind acted as a "'cloak of invisibility' from the shelter of which one may see unseen" (252). Thus, in this article, Chapman linked the production of the truth of animals with the ability to see them while remaining unseen.

Chapman clarified the operation of the blind and framed its contemporary understanding. He disavowed his earlier attempts to create a blind that mimicked a tree trunk as an example of "how far one may be carried on the wrong road by a false premise" (250). He suggested that his "fundamental error" was "the belief that the blind must be like some object in nature" (250). Instead Chapman argued that the blind's "chief virtue is its immobility" (250). The blind's immobility overcomes the suspicions of the birds and ultimately it becomes for them "a part of the landscape to be perched on if convenient" (250).

Chapman described the experience of being in the blind more poetically in his 1908 autobiography *Camps and Cruises of an Ornithologist*. In it he related the pleasure he felt while watching birds from "the shelter of this 'cloak of invisibility'" that is the photographic blind.[87] Chapman indicated that

> there is a supreme and wholesome pleasure in feeling that one
> has reached a point of vantage from which the drama of ani-
> mal life may be studied without the performers knowing that
> they are under observation. Wholly aside from the often thrilling
> novelty of the experience and the thought that, even if uncon-
> sciously, one has been accepted as a part of the surroundings,
> there is a well-founded satisfaction in realizing that one is mak-

ing an actual contribution to our knowledge of animal life, not based on the study of creatures in captivity, or of those placed under greater or less restraint by fear, but of animals in their native haunts, living their lives under absolutely natural conditions. (xv–xvi)

Chapman conceived of the blind as allowing access to animals in their "absolutely natural conditions" in a way that produced knowledge about their lives. Thus, the blind enabled the production of new forms of knowledge about animals and in so doing produced a new understanding of what constituted a "natural" animal.

THE PHOTOGRAPHIC BLIND AS AN ABSTRACT MACHINE

As formalized by Chapman, the photographic blind is an abstract machine for producing effects of power. In describing the photographic blind as an abstract machine I am drawing on Foucault's analysis of the panopticon. Like the panopticon, the photographic blind is a "machine for dissociating the see/being seen dyad."[88] However, the photographic blind dissociates seeing and being seen in a different manner than the panopticon. Designed by Jeremy Bentham as a prison, the panopticon is a hollow cylindrical structure in which inmates are isolated in illuminated cells that open onto the central courtyard and control tower. The structure displays its inmates to the central tower. As Foucault argues, the major effect of this display is "to induce in the inmate a state of conscious and permanent visibility that ensures the constant functioning of power" (201). However, what interests Foucault is not the specific configuration of the panopticon as a prison but the panopticon as "a generalizable model of functioning; a way of defining power relations in terms of the everyday life of men" (205). We must distinguish between the panopticon as an architectural structure and panopticism as "a diagram of a mechanism of power reduced to its ideal form; its functioning, abstracted

from any obstacle, resistance or friction, must be represented as a pure architectural and optical system: it is in fact a figure of political technology that may and must be detached from any specific use" (204–5). Thus, panopticism describes the internalizing of discipline through the consciousness of observation and display.

In contrast, the photographic blind as an abstract machine inverts the relation to visibility at work in the panopticon by inducing in the observer a state of conscious and permanent invisibility while preventing the observed from realizing they are on display. Rather than inducing the observed to internalize the disciplinary effects of observation, the photographic blind induces the observer to externalize their relation to the observed. By disciplining the observer it promises access to the truth of the observed. It is both an inversion and an intensification of the panopticon. Panopticism fosters an awareness of the internalization of the other when being seen. The corollary of this awareness of our internalization of the other is the sense that unless we are unobserved when viewing the other, all we see is a reflection of ourselves. Thus, within the panoptic framework, the only way to see the truth of the other is to see them without their knowledge of our presence. The photographic blind is instrumental in creating the category of the natural animal whose existence it guarantees. The photographic blind is a disciplinary apparatus producing specific relations to nature and animals. It produces a regime of animal truth.

The photographic blind is a discursive formation regulating the appearance of animals. The apparatus produces images that are marked as candid shots of wild animals. So marked, these images produce normal animals; as White put it, the blind shows us the animal's "normal activity." That is to say, the blind allows us to see how animals behave when we are not around, which we take as revealing their true nature. The blind presents its function as the regulation of the animal body by erasing the observer. However, its central operation is not the control of the animal

body but its disciplining of the observer. I claim that the central operation of the blind and its images is to induce in the observer a state of conscious invisibility. Thus, the blind produces natural animals by erecting a conceptual separation between animals and humans.

THE PHOTOGRAPHIC BLIND AND THE DEVELOPMENT OF ANIMAL PHOTOGRAPHY

Although the development of the photographic blind began to influence animal photography, it did not change animal photography overnight. Photographers continued to speak of their photography as camera hunting well after the photographic blind was in common use. Photographers even described waiting in the blind to photograph animals as a sport, although they conceded that it was not an equivalent to hunting.[89] However, as the following quote from 1909 indicates, after its formalization the photographic blind was understood as central to animal photography:

> Shyer woodland species were stalked by these indefatigable men disguised as moss-grown pollards; and dippers, wheatears, and others were outwitted by means of stage rocks that gradually appeared in their haunts and contained the crouching naturalist and his apparatus. The hollow sheep and Trojan bullock were invented for benefit of the curlew, plover, and other shy birds that nest in the open plain. If our naturalists had been given the magic gift of fernseed, they could scarcely have outwitted more completely the creatures of the wild that we formerly "studied" by means of the scatter-gun and the rifle. Science has given us, it is true, the shoulder camera with which the very skilled can take flying shots, and the artillery of the telephoto lens, by means of which a good sitter can be taken at the distance of half-a-mile or more, but all the great triumphs of animal photography have been won by means of infinite patience and the stealthy approach of the artist within actual camera range.[90]

As the passage indicates, while the photographic blind was not the only new technique used in animal photography, it was the central one. Both the photographic blind and the telephoto lens enabled photographers to take candid pictures of animals. The two techniques can work in conjunction and combine to make animal photography easier. Yet I, like the passage, concentrate on the photographic blind. While the telephoto lens is part of the technical possibility of animal photography, the photographic blind is central to its conceptual understanding.

The passage also suggests another reason for the breakdown in the rhetoric of camera hunting. The invisibility conferred by the photographic blind changes the relation between photographer and animal. Animal photography is no longer a test of wits between animal and photographer but rather the photographer's outwitting of the animal. It is not the photographer's skill at woodcraft but rather the bird's blithe obliviousness to human presence that is the key to photographing the animal.

The resulting images, unmarked by human presence, no longer support a reading as trophies; images that are unconnected to humans cannot easily be grounded in the photographer. They no longer function as evidence of the photographer's prowess and are at best linked to the photographer as an oeuvre. The photographic blind's rhetoric of interiority marks the images with a radical separation between human and animal. These new images come to shape our understanding of animals and appropriate animal imagery. Things that were impossible to see before the development of animal photography have become the standard for judging the truth of nature. Images that do not conform to these expectations become unreadable.

The photographic blind emerged from the hunting blind. It was initially one technique among many for taking photographs of live animals in their natural habitats. As photographers adapted the blind to animal photography, it opened up new possibilities for seeing and documenting animals. The enclosure of

the blind came to be understood as marking a conceptual separation between the photographer and the natural world. This separation altered the relation to the animal figured by animal photography. The animals represented were no longer available to the viewer as a potential conquest. Instead, the images offered unprecedented access to the private lives of animals. Yet, the price for this access was images that assert that the rest of our interactions with animals are necessarily partial or false. Contra Berger, it was not industrialization that made human-animal relations impossible. It was wildlife photography that convinced us that traditional methods of representing and relating to animals were not up to its standard.

The Appearance of Animals: Abbott Thayer, Theodore Roosevelt, and Concealing-Coloration

Nineteenth-century animal photography was characterized by the attempt to make animals visible. This effort can be seen in the development of photographic technology by Eadweard Muybridge, Étienne-Jules Marey, and Ottomar Anschütz to capture mobile animal bodies; the adaptation of hunting techniques to make uncooperative animal bodies photographable; and the development of the photographic blind. These practices and events all contributed to making animals visible and photographable. For example, as was discussed in the previous chapter, the photographic blind was used to make animals fully available to sight. In the rhetoric of the blind, seeing more of animals equaled knowing more about them. The blind thus presupposed that animals' relation to visuality was such that to appear was to be knowable. Yet, as Jonathan Burt cautions, "It is important not to conflate the scientific project of knowing more about animals with the visual project of seeing more."[1] Seeing more of animals is not necessarily the same as knowing more about them. Burt's caution raises the

question of whether photography's emphasis on the visibility of the animal, its stress on making the animal appear, can obscure the animal's visual relation to the world. This question of the separability of visibility and knowledge is at the heart of the American painter Abbott Thayer's work on concealing-coloration in animals.

In this chapter I examine the role of photography in Thayer's work on animal coloration. Thayer used photography to examine the visuality of animals—the visual relation of animal appearance to the world. Thayer's work on animal coloration sparked considerable scientific debate.[2] His theory that all animal appearance was protective was rigorously challenged, most notably by Theodore Roosevelt. Reading the scientific debate illuminates the changing understanding of animal photography at the turn of the century and clarifies the limitations of Thayer's theories of animal coloration. The photographs Thayer used are unusual in that they do not strive to maximize the visibility of their subjects. Instead, the animals photographed tend toward imperceptibility, and the images toward unreadability. The photographs open up the question of animal visuality and hence the relation of animals to photography. The images go against photography's bias toward visibility and in so doing reveal the extent to which that bias constrains animal photography. They thus help illuminate the limits of animal photography by showing how its operations need to be articulated through the visible. I argue that the photographs in Thayer's natural history work mark a separation within photography between the visual project of seeing animals and the scientific project of knowing animals.

THAYER, PHOTOGRAPHY, AND COUNTERSHADING

Abbott Handerson Thayer (1849–1921) was one of the most significant painters of late-nineteenth-century America.[3] Born in Boston, he grew up in the New England countryside. He trained as an artist in Boston and started his artistic career in 1867 as an animalier painting pet portraits in Brooklyn. In the late 1870s he studied in

Paris under the Academic painter Jean Léon Gérôme (1824–1904). After his return to America in 1879, Thayer became nationally known for his paintings of angelic women and children and was elected president of the Society of American Artists in 1883.

In the early 1890s Thayer began to focus on the function of animal coloration.[4] An avid collector of bird skins since childhood, Thayer began investigating the patterns of their markings. In his investigations, Thayer began to explore whether bird coloration was functional rather than simply decorative. He argued that bird markings evolved through natural selection to respond to the bird's environment. Thayer took a bird's appearance as a representation of the species' evolutionary environment that protected the bird from predation by obscuring it from view.

In 1896, Thayer published a series of animal photographs in the journal of the American Ornithological Association, *The Auk*.[5] The photographs accompanied Thayer's article "The Law Which Underlies Protective Coloration." The series of photographs documented Thayer's experiments positioning taxidermic objects in nature to demonstrate his theory that protective coloration in animals was based on countershading.[6] The photographs and accompanying text occupy equal space in the journal. There are five pages of text and nine photographs on five pages of plates. The photographs in *The Auk* were Thayer's first attempt to make animal invisibility visible and reveal its source. It was with these photographs that Thayer formulated his representational strategies for revealing the function of animal coloration.[7]

COUNTERSHADING

The article in *The Auk* explained Thayer's theory of protective coloration in animals based on countershading, which it presented to the public for the first time. Thayer sought to explain why certain animals were difficult to see in nature. Arguing against earlier explanations for inconspicuousness based on drab coloration, he suggested that the key to protective coloration was countershad-

ing.[8] The coloration of countershaded animals fades from dark on top to white underneath, erasing their appearance of solidity. This gradation made animals *"cease to appear to exist at all"* (125). Protectively colored animals were not simply nondescript but were colored to erase their appearance.

Countershading balances the effects of sunlight and eliminates the effect of relief produced by shading. Thayer illustrated the principle in a line drawing accompanying the article (Figure 32). The diagram illustrates the abstract mechanism of countershading that the accompanying photographs show at work in nature.[9] The diagram consists of three equal-sized circles arranged in a line against a dark background. The first circle represents how countershaded animals are colored in nature; it is dark on top fading to white on the bottom. The contrast of light and dark makes the circle appear solid and three-dimensional.[10] The second circle represents how sunlight falls on an object; it is light on top shading to dark on the bottom. It also appears solid and three-dimensional. The third circle represents how the two effects combine; the circle is the color of the background and appears flat and insubstantial. As the diagram shows, when countershading opposes the direction of light (i.e., countershades), the countershaded object loses the appearance of solidity. However, while countershading was important and underlay protective coloration, Thayer insisted that the relation between animal and environment went beyond the erasure of solidity effected by countershading. He argued, "the markings on the animal become a picture of such background as one might see if the animal were transparent. They help the animal to coalesce, in appearance, with the background which is visible when the observer looks past him" (128). In other words, not only are protectively colored animals countershaded, but they also bear a composite image of their surroundings. For Thayer, a protectively colored animal is an image of its environment. Thus, the principle of countershading suggests that an animal's relation to the world is, in important

FIGURE 32. Abbott H. Thayer, *Diagram of Countershading*, 1896.

ways, structured by the visible and argues for the centrality of vision to apprehending the world.

STUFFED ANIMAL PICTURES

The photographs accompanying the article show two stuffed birds posed in a variety of situations. The nine photographs break down into two sequences. The first sequence consists of five images of a stuffed grouse in a series of poses. The second sequence repeats the final four poses of the first sequence using a stuffed woodcock.[11] The photographs assert a relation between the birds and their environment based in appearance such that when the birds are positioned "normally," it is difficult to distinguish between bird and environment.[12] To demonstrate this relation's grounding in countershading, Thayer needed to show not only the normal invisibility of the countershaded bird but also the failure of the animal's camouflage when not countershaded and when not normally positioned. Thus, I argue the photographs had four tasks to accomplish. First, the photographs needed to show that the bird was countershaded. Second, the photographs

needed to show that the countershaded bird was invisible (or at least hard to see) under its normal conditions in nature. Third, the photographs needed to show that the bird would not be invisible in nature if it were not countershaded. Fourth, the photographs needed to show that if the countershading was not properly oriented against the light, the bird would remain visible. Thayer's solution was to construct a series of photographs showing the bird in different poses to demonstrate how changes in position affected its visibility. Given the difficulty (if not impossibility) of posing live birds as needed, Thayer used stuffed animals for his subjects. Thus, in order to demonstrate his theory, Thayer put taxidermic specimens in representations of their environment in order to make visible the animal's invisibility. He constructs, in other words, a form of diorama.

The photographs accompanying the article document Thayer's anti-dioramas. I call Thayer's taxidermic installations anti-dioramas because the logic of their construction goes against the dominant aim of taxidermy and dioramas at the time, as described by the feminist anthropologist of science Donna Haraway and the historian of science Karen Wonders: the desire for a transparent image of nature.[13] In his installations, Thayer situated stuffed birds in nature so that they disappeared. The birds were displayed not to construct a visual "morality play on the stage of nature,"[14] but to demonstrate the birds' visual relation to their environment, their visuality. In contrast to the habitat diorama's illusion of transparency, Thayer's anti-dioramas highlighted their staging through their serial format. As Haraway argues, in the habitat diorama "what is so painfully constructed appears effortlessly, spontaneously found, discovered, simply there if one will only look. Realism does not appear to be a point of view, but appears to be a 'peephole in the jungle' where peace may be witnessed" (34). Rather than presenting the illusion of a discovered scene, Thayer's series of photographs highlighted his manipulations of the displayed birds. The birds were not displayed to high-

light their lifelikeness but rather in a manner that emphasized their dead nature.

In not striving for lifelikeness Thayer's birds differed from other taxidermic objects of the time. They went against what Jane Desmond has identified as the dominant vector in taxidermy: the progressive search for liveliness.[15] The reason for this difference was that, for Thayer, the most lifelike bird was the least visible. Thayer's work developed into a representational program that opposed traditional ways of representing animals, including habitat dioramas, as misleading. He felt that any representation that highlighted the animal's visibility misrepresented their visuality.

In 1896, photographs of stuffed birds were not uncommon in ornithological journals. While, as Alfred O. Gross argues, in the 1890s ornithologists were beginning to see photographs as "important records of bird life and bird behavior," it was only after the turn of the century that photographs of live birds became standard ornithological practice.[16] At this time, ornithologists used photographs of stuffed birds largely for identification purposes. Their photographs documented the surface and markings of birds in order to distinguish them as separate species. Thayer's photographs of stuffed birds differ in treating the surface and markings of the animal as functional and not simply identificatory.

As was discussed in chapter 1, photographs of stuffed animals present a controlled image of nature. Taxidermic animals are passive, docile, and dead nature whose display re-creates nature in a human image. Taxidermic animals must be posed, and their photographs must be composed; as James Ryan notes, these processes mark nineteenth-century colonial photographs of taxidermic objects as vehicles for particular cultural values including nationalism, imperialism, and masculine prowess.[17] Nineteenth-century American ornithological photographs connected to nationalism less directly. They presented stuffed birds as specimens. Ornithological photographs treated their subjects as typical or representative figures rather than exemplary ones.[18] They connected to

nationalism through identifying and classifying native species. As Harriet Ritvo has demonstrated, nineteenth-century American taxonomy participated in a larger nationalist project of symbolically claiming ownership over the North American continent by naming and mapping its contents.[19] This was a project of self-knowing in which the American naming of nature was asserted against European naming as a form of identity construction that transformed "unmarked" space into place.[20] Nineteenth-century ornithological photographs are a subset of that project. Thayer's photographs had similarities to ornithological identification photographs. However, rather than displaying the animal for taxonomic classification, they depicted the function of the bird's appearance. They thus had the potential to work against the nationalist project by positing the indistinguishability of animal and environment for a human observer. The intensive belonging between animal and environment this suggested undercut the human connection grounded in identification and naming.

THE AUK PHOTOGRAPHS

Plate 1 from Thayer's article on countershading is a full-body shot of a dead grouse. The grouse lies on its side on top of a crate (Figure 33). Thayer's first name, Abbott, is written behind it. The bird lies diagonally across the image from top left to bottom right. While dead grouse are a traditional subject in sporting art, the bird was not displayed in a traditional manner. Yet the casual display was also not typical of a scientific specimen posed for identification. The viewer was not looking at the bird to determine species but to verify it as the bearer of a specific type of marking. The grouse is displayed to reveal its markings, not to identify the bird as a grouse, nor distinguish grouse as a species, but to treat the grouse as an example of a pattern of coloration. Thayer's caption for the image instructed the viewer to see the grouse in terms of its countershaded gradation:

> Fig. 1 of a Ruffed Grouse shows this arrangement of color and
> light. This bird belongs to the class in which the arrangement is

FIGURE 33. Abbott H. Thayer, *Side View of Grouse to Show Coloration*, 1896.

found in its simplest form, the color making a complete grada-
tion from brown above to silvery white beneath, and conforming
to every slightest modeling; for instance, it grows light under the

FIGURE 34. Abbott H. Thayer, *Grouse Placed on the Ground as in Life*, 1896.

shelving eyebrows, and darker again on the projecting cheek. (126)

The bird is on its side against a neutral background so that viewers can see its coloration. The bird is displayed to show its gradation; viewers can clearly see the transition of its coloration from pure white underneath to dark on its back. The photograph was meant to let viewers see the grouse differently—to see aspects of its appearance that they would normally miss.

Plate 2 shows the "grouse posed on the ground as in life" (Figure 34).[21] Yet, on first glance there does not appear to be a grouse in the image. The image shows a patch of underbrush at the edge of a forest. A wedge of low ground-cover plants in the foreground of the image runs from halfway up the left side of the image to the bottom right corner. Behind these plants is a line of low brush and fallen saplings running parallel to the line of the wedge. These plants are in shade and are darker than the foreground. There are a number of strong horizontal lines in the low brush

FIGURE 35. Abbott H. Thayer, *Woodcock on Nest*, 1896.

FIGURE 36. Abbott H. Thayer, *Woodcock on Nest, Color Gradation Painted Out,*
1896.

directing the viewer's eye across the image. Behind the brush is a lighter area broken up by the strong verticals of tree trunks. There is a tree trunk in the center of the image that is flanked by two additional trunks: one that is an inch and a half from the left side, and one that is an inch from the right side. Below and slightly to the left of the central trunk, at the point where the ground cover meets the brush, lies the stuffed grouse.

The grouse itself is difficult to distinguish from the background. The mottled sides of the grouse blend into the leaves, causing the eye to sweep across the bird without registering its outline. The eyes and the beak are the most discernible parts of the grouse.[22] By recognizing them, viewers can resolve the grouse from the background. However, if they did not already know that the grouse is in the picture, they might not see it. The photograph demonstrates the difficulty of seeing the grouse in its "natural" habitat (the woods).[23] The comparable woodcock picture appears to be an unbroken field of vegetation (Figure 35). The woodcock photograph is much more difficult to resolve, and it is only by comparing the photo to the next in the series that viewers can with any confidence indicate where the bird is in the image (Figure 36).

Plate 3 shows the grouse with its countershading painted out (Figure 37). In this image, the grouse is insistently visible. Its belly is in deep shadow, marking the grouse as a three-dimensional object and separating it from the background. Thayer darkened the grouse's belly to reduce the bird to a uniform shade. The grouse is in a similar position to the one it occupied in plate 2, but the camera has been moved to the left; the trees in the background of the image are now right of center. The camera has been placed slightly higher and farther back from the grouse, as can be seen from the change in the size of the grouse relative to the frame. The image shows the visibility of the noncountershaded grouse. The contrast between plates 2 and 3 is striking. The countershaded grouse is difficult to see, while the nonshaded grouse is

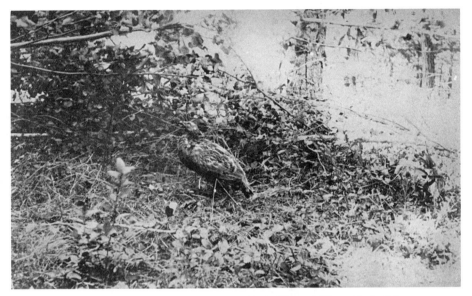

FIGURE 37. Abbott H. Thayer, *Grouse Posed as in [Figure 34] but with the Color Gradation Painted Out*, 1896.

highly visible, highlighting the role of countershading in controlling visibility.

However, Thayer's failure to control the position of either the camera or the grouse undermines the effectiveness of the images as scientific evidence. Because both the camera and grouse were moved between the taking of the two photographs, the photographs cannot be mapped onto each other and can only be taken as rough analogues of each other.[24] While it seems likely that the differences between the photographs were due to inattention on Thayer's part, a skeptic could argue that the differing viewpoints were, at least in part, responsible for the differing degrees of visibility. The persuasiveness of the striking contrast between the images was potentially undercut by the lack of rigor in their staging.[25] This lack of rigor was based in Thayer's understanding of precisely what the images were demonstrating. Thayer's conception of the grouse as a generalized image of underbrush obviated

for him the need for precise placement. The grouse functioned for Thayer as a stand-in for the class of countershaded animals rather than as a representative of grouse behavior. His argument in the article was about the principle of countershading, not grouse coloration. Thus, the image was constructed to demonstrate that countershaded animals blend into the surrounding foliage and not necessarily to show a typical manner and location for a grouse to exploit its coloration for defensive purposes.

Plates 4 and 5 show the grouse in nature placed in nonstandard poses (Figures 38 and 39). They demonstrate how visible the grouse was when its countershading did not oppose the direction of the light. Plate 4 shows the grouse placed on its side, belly exposed, against roughly the same background as in plates 2 and 3. The white of its belly contrasts strongly with the background, making the bird highly visible. Plate 5 shows the grouse lying on its side from the back. While the grouse's back is not as distinctive as its belly, it is still more visible than the grouse posed as in life. This image has a different background from the others in the series. The background of the photograph shows a house and yard. This suggests that rather than repositioning the grouse from plate 4, the photographer simply moved the camera to the other side of the grouse. The house in the background suggests that the pictures were taken at the edge of Thayer's yard. This indicates that Thayer selected his photographic site for convenience rather than for the representativeness of the location as a typical habitat for grouse. Again, this raises the question of the specificity of the background required in order for the photographs to act as evidence for the function of countershading in nature. For Thayer, the grouse, like any countershaded animal, was a picture of its background. Thus, when he found a background that the grouse disappeared into, the similarity between animal and environment was enough to establish their connection.

Thayer's photos are striking in their presentation of the contrast between countershaded and noncountershaded animals.

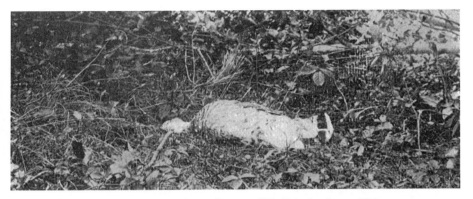

FIGURE 38. Abbott H. Thayer, *Grouse on Side, Exposing Breast*, 1896.

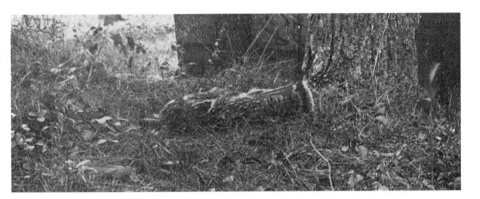

FIGURE 39. Abbott H. Thayer, *Grouse on Side, Exposing Back*, 1896.

They demonstrate that noncountershaded animals are more con-
spicuous than countershaded animals, indicating that counter-
shading caused the animals' inconspicuousness.[26] However, in
1896 Thayer did not fully trust the photographs' ability to convey
his discoveries.[27] He worried that readers would not believe that
the stuffed birds in plates 3 and 9 had been reduced to an even
tone rather than being darkened and deliberately made conspicu-
ous (see Figures 36 and 37). To counter this doubt, Thayer sug-
gested that "the reader ... must try these experiments for himself
before he can believe that in [the images with the countershading
painted out] I tinted the under surfaces exactly as dark as the

FIGURE 40. *Parliament Street from Trafalgar Square*, Photo de St. Croix. Daguerreotype. England, 1839. V & A Images / Art Resource, NY.

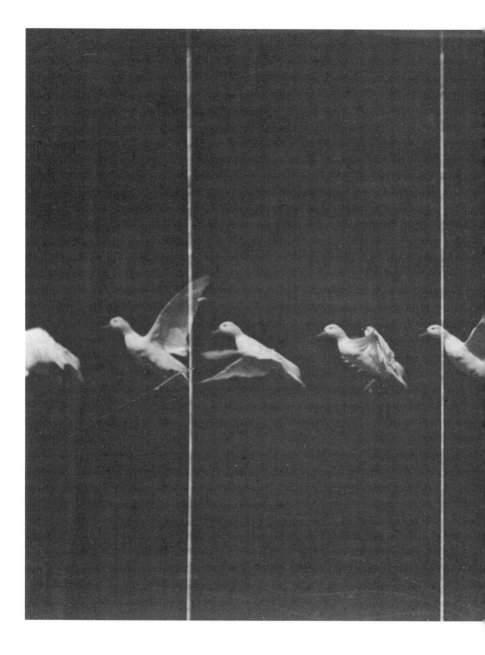

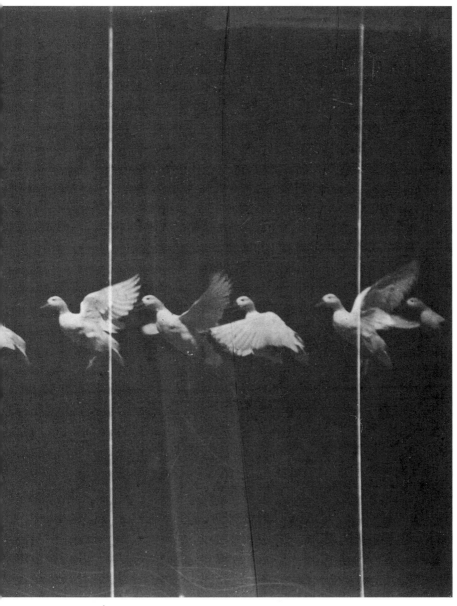

FIGURE 41. Étienne-Jules Marey, *Chronophotography of a Flying Bird*, ca. 1885–90. Adoc-photos / Art Resource, NY.

upper, and no darker" (127). This suggestion indicates that Thayer doubted photography's ability to represent animal appearance. What he was trying to show went against photography's emphasis on visibility. While the camera could easily show conspicuousness, it had difficulty revealing inconspicuousness. The problem is that the more transparently photography captures indistinctness, the more illegible the resulting photographs will be. *The Auk* photographs confronted the problem of revealing that something was visually indistinct without suggesting that the difficulty in resolving the object was the fault of either the photographer or the camera.[28] What can a viewer make of a photograph, purportedly of an animal, in which they cannot distinguish the animal from the background? The photographs in *The Auk* required additional testimony before their failure to reveal the animal's presence could be taken as evidence for the animal's invisibility. This was because photographing invisibility runs up against photography's bias toward visibility.

PHOTOGRAPHING INVISIBILITY

As Nigel Warburton explains, there is a cultural bias toward thinking photography in terms of visibility.[29] Photography tends to be thought of as a means of capturing and preserving visible traces, and photographs are generally taken as evidence of how things look.[30] The attempt to photograph invisibility raises a number of questions about photography's ability to function as evidence. Is the animal's failure to appear in the photograph the fault of the animal or of the means of representation? For example, photography in the 1830s and 1840s had difficulty registering movement and produced haunting street scenes with humans registering as only vague blurry presences as a result (Figure 40). In that case, the failure of humans and animals to appear in the image was clearly due to the limits of photography.

In contrast, *The Auk* photographs strove to reveal the "normal invisibility" of the animals depicted *and* demonstrate its

cause—countershading. They offered visual evidence for Thayer's assertion that white bellies make their bearer inconspicuous or invisible. They were thus attempts to photograph invisibility. Photographing invisibility is a separate problem from the task of photographing the invisible. As pieces of scientific evidence, *The Auk* photographs do not make the shift from image to graphical trace exemplified by the work of the French scientist Étienne-Jules Marey (1830–1904).[31] Marey's physiological photography represented the invisible and nonvisible functions of the animal body. His photographs provided graphic evidence of processes unavailable to human sight (Figure 41).[32] Marey's photographs used the camera to go beyond the limits of human sight rather than as a stand-in for it.[33] Thayer's photographs sought instead to document the operations of normal vision.

Joel Snyder provides one model for thinking the relation of photography and invisibility.[34] Snyder argues that chronophotographs, instantaneous photographs of movement such as those produced by Marey, extend the visible beyond the limit of human sight; by showing the "unseeable," the instantaneous photograph takes over from the eye as the standard of visibility. However, while *The Auk* photographs are photographs of invisibility, they differ in the kind of invisibility they represent from the instantaneous photographs of movement discussed by Snyder. They do not represent invisibility by going beyond the limits of human sight. Instead, *The Auk* photographs are visual object lessons in which the camera stands in for the eye. Within these photographs the equation of the camera and eye is not an extension of visibility but the recording of its conditions. The objectivity of the camera eye does not guarantee access to the truth but reveals the limits of visibility or visuality. *The Auk* photographs also construct the relation between animal, environment, and viewer differently than do the images produced by the photographic blind. As was demonstrated in the previous chapter, the photographic blind linked animal and nature by excluding the human. The photo-

graphic blind made animals visible by erasing human presence thereby erasing the connection between human and animal. The rhetoric of the blind, as formalized by Frank Michler Chapman (1864–1953), indicated that "natural" animals were only accessible when humans were not present, positioning the animals depicted from the blind in a realm outside the human.[35] Within the concept of the "natural" animal promulgated by the photographic blind, animal visibility depends on human absence or invisibility. In contrast, *The Auk* photographs argue that the visibility of animals is independent of human presence. They position visibility as a relation between animal and environment. *The Auk* photographs present a different conception of the "natural" animal to that propagated by the photographic blind. Thus, *The Auk* photographs represent a fourth kind of invisibility in animal photography; the kinds are photographic (the early daguerreotype), instantaneous (Marey), rhetorical (Chapman), and camouflage (Thayer).

Thayer's photographs resist identity for both photograph and subject. We cannot discern the subject and thus have difficulty locating ourselves in relation to the image. In this, the photographs are marked by the ambiguity of their relation between animal and viewer. Rather than offering images of animals rhetorically unmarked by human presence, Thayer sought images of animals in which the animal becomes imperceptible. They position the viewer within a visual economy in which appearing is always a potential threat; the evolutionary pressure that animal appearance responded to was predation. They refuse the possibility of a detached observer, offering instead an always already implicated spectator. The photographs postulate a visual economy in which visibility is detached from any particular viewer and is instead an effect of a generalized (evolutionary) field of the other. Thayer's photographs thus provide a model for rethinking what it means to look at animals, and animal photographs, by introducing a concept of the visual as an immersive field of the other.

READING THAYER

PHOTOGRAPHY AND THE CONCEALING-COLORATION DEBATE

Thayer's theory of countershading was initially well received by the scientific community.[36] As a result of his first paper, the American Ornithological Association invited Thayer to demonstrate his theory of countershading at their annual meeting in November 1896.[37] Thayer showed his audience a series of decoys at a slight distance, some countershaded and some not, and asked them to identify the number of decoys displayed. Initially, the audience only identified the noncountershaded decoys.[38] He then had them approach until they could discern the additional countershaded decoys. The ornithologist and bird photographer F. M. Chapman described the strong effect of the demonstrations on an audience: "One had only to see it become convinced of its truth and application to the coloration of animals."[39] Chapman suggested that the observer's failure to discern the countershaded decoys enabled them to see the truth of Thayer's principle. However, the founding editor of *The Auk*, ornithologist Joel Asaph Allen (1838–1921), would come to argue that Thayer's demonstration was too convincing and that the power of the demonstrations prevented ornithologists from thinking through countershading's relation to bird life.[40]

Thayer published several articles on concealing-coloration and mounted public demonstrations to prove his theory that animal coloration was protective.[41] Thayer's work on natural history attracted a number of scientific supporters including the eminent Darwinian Alfred Russel Wallace (1823–1913) and the Cambridge biologist Edward Poulton (1856–1943). Poulton, the author of the major work on animal coloration at the time, became a key proponent of Thayer's work.[42] Poulton favorably reviewed Thayer's theories in *Nature* in 1902 and wrote a commentary on Thayer's 1903 article in the *Transactions of the Entomological Society of London*.[43] The article marked the beginning of Thayer's interest in the broader problem of the use value of animal coloration rather than

the specific mechanism behind one form of concealing-coloration. In the article Thayer extended his theory of protective coloration by introducing the idea of ruptive coloration. Ruptive coloration disrupts an animal's outline by breaking it into sections. According to Thayer, this conceals the animal by making it difficult to discern where the animal begins and the background ends.[44]

Thayer continued to revise and extend his theories, culminating in the publication in 1909 of *Concealing-Coloration in the Animal Kingdom*, which was written by Thayer's son Gerald under his direction.[45] The book was lavishly illustrated and contained 16 full-color reproductions and 140 black-and-white images. Included among the many photographs were the series of woodcock photos from Thayer's first article and two of the grouse photos.[46] This continuity of imagery indicates the fundamental continuity of Thayer's visual strategies despite the evolution of his theories of animal coloration. Thayer saw his later work on concealing-coloration as an extension of his work on countershading rather than a radical revision of it. Countershading became a subset of the larger field of concealing-coloration. *Concealing-Coloration* proposed a general theory of animal coloration. The book argued that all animal coloration was adaptive and protected animals from predators by obscuring them from vision at key moments. All animal coloration was defensive.[47] All animal coloration was a picture of the animal's background at the moment of its greatest vulnerability—when the evolutionary pressures facing it were greatest. Because Thayer saw animal coloration as a picture, he was also concerned with the depiction of animals.

THAYER'S THEORY OF ANIMAL PHOTOGRAPHY

In *Concealing-Coloration*, Thayer argued that only photography and his paintings truthfully represented animals as they are in nature—difficult to see. Photography allowed the production of images of animals in their natural environment, exposing the limitations of traditional illustration. According to Thayer,

> Pictures of protectively colored wild birds and mammals *in situ* cannot be really true to Nature if they represent them as having the light-and-shade of normal solid objects—a fault usually committed by illustrators, who study them in unnatural situations, such as cages of a menagerie, or other places where the illumination fails to coöperate with their counter shading. These paintings of ours (grouse, rabbit, snake, caterpillars, etc.) are intended as examples (outside the field of photography) of *true* animal illustration—rendering instead of defeating the wonderful obliterative effects of their counter shading. (28)

Thayer argued that most natural history illustrations presented images of animals in unnatural situations, obscuring the connection between their coloration and their environment. Up until this point, natural history illustration had been based on dead or captured animals in artificial situations. Thus, Thayer thought his photographs and paintings were more true to the animal than most scientific illustrations.

However, Thayer thought the value of his images went beyond scientific evidence and intended his work as a representational program. He believed the truth and power of his images would undercut other styles of animal representation, leaving his work as the standard for depicting animals. It was photography that enabled his work to obtain this standard:

> Photography, indeed, is the great ally of those who would expound the laws of obliterative coloration; and it is destined— more swiftly now that the underlying principles of that beautiful phenomenon have been disclosed and analyzed—to effect a fundamental change in men's knowledge of the looks of animals in nature; and, by the same token, in the drawings and paintings men make of these wild animals. The world has had enough, or must soon have had enough, of pictures of birds and beasts with their light-and-shade falsified to make them show. Outdoor nature as it really is, in the matter of the marvelous and exquisite

visual correlations between animal and environment, offers to
art, in this late age, an almost boundless virgin field. (128)

Thayer felt his work would lead to a reformation of animal rep-
resentation. Photographs of concealingly colored animals in
nature would change the representation of animals just as Muy-
bridge's horse photographs had. To viewers familiar with Thayer's
images, highly visible animals would come to seem as outdated
as "hobby-horse" pictures of splay-legged horses. Thus, animal
representation would move away from images of highlighted
and prominently displayed animals standing out from their back-
ground, which he saw as falsifying nature, toward images that
unified animal and environment.

However, as should be apparent from a quick perusal of
twentieth-century animal imagery, Thayer's images did not trans-
form animal representation. Highly visible animals continue to
populate contemporary wildlife photography. It appears Western
culture is uncomfortable with indistinct images.[48] Our thinking
of photography is generally limited to a narrow range of well-
exposed images. We tend not to think of blurred, out of focus,
over- or underexposed images as proper photographs.[49]

Throughout his work, Thayer remained more committed
to using animals to illustrate the optical principles involved in
protective coloration than to showing how the coloration was
deployed by animals in life, precisely, I suggest, because of his
conception of the animal as a picture. Thayer claimed that being
able to pose an animal so that it disappeared and finding its typi-
cal habitat amounted to the same thing. Defending his methods
in 1911, Thayer suggested that his practice of "tak[ing] a bird and
spend[ing] an hour in finding a type of vegetation, situation and
view-point in which he is absolutely indistinguishable" can be
interpreted in two ways.[50] He argued that "to the superficial
and unreceptive observer it represents merely my ingenuity. To
the eye of science it is the ascertaining whether the background
against which the bird can disappear is typically such a one as

that against which he would commonly be looked at by his enemy or prey" (460–61). Because Thayer took as his starting point the idea that animals are a picture of their environment, finding an area of similarity between animal and environment was for him enough to ground a claim for typicality. His failure to realize that this relation between animal and environment was what needed to be demonstrated, rather than presumed, limited his work and ultimately prejudiced its reception.

THE RECEPTION OF CONCEALING-COLORATION

In many ways, Thayer represented the last of the American tradition of artist-naturalists. His work has affinities with that of Mark Catesby (1679–1749), Alexander Wilson (1766–1813), and John James Audubon (1785–1851).[51] Like the earlier artist-naturalists, Thayer depicted animals in order to increase our knowledge of them. However, this tradition was no longer viable in its own terms at the end of the nineteenth century. Because the structure of scientific practice had changed, the space that the artist-naturalist had occupied in American science was no longer available. Zoologists no longer saw depicting animals as producing knowledge. As Ann Shelby Blum describes, over the latter half of the nineteenth century the American ornithological community professionalized its practices of illustration and by the 1890s saw natural history images as documenting and illustrating scientific work rather than producing knowledge.[52] Ornithological illustration moved from Audubon's depiction of birds in their environment to the formalized depiction of fragmented body parts for comparative anatomy.[53] The development of a standardized representational isolation of the birds depicted militated against reading images, like Thayer's, that focused on the connection between figure and ground. Thus, the ornithological community was predisposed against reading Thayer's images as scientific evidence because the images' assertion of an essential connection between animal and environment violated the community's new understanding of the role of scientific animal representation.

FIG. 90. Cardboard 'zebra' without stripes, against light straws as in Fig. 91.
Photograph, retouched.

FIG. 92. Cardboard zebra among imitation reeds 'relieving' dark, as against the sky.
Photograph, retouched.

FIG. 91. Cardboard zebra among straws 'relieving' light, like reeds or grasses against dark ground.

Photograph, retouched.

FIG. 93. Chipmunk (*Tamias striatus*) among dead leaves, its stripes picturing sticks or leaf-edges and shadows. (These picture-patterns are, of course, based on perfect obliterative shading.)

Photographed from life, outdoors. (Captive chipmunk.)

FIGURE 42. Abbott H. Thayer, Plates 90–93 from *Concealing-Coloration in the Animal Kingdom*, 1908.

Despite these difficulties, *Concealing-Coloration* was initially well received. J. A. Allen gave the book a favorable review and called it "by far the most important contribution yet made to the subject of animal coloration."[54] However, the book soon sparked considerable controversy, much of which centered on the use of photography to represent animals.

Concealing-Coloration included a series of photographs of a posed cardboard cutout, representing a zebra, against a reed background (Figure 42).[55] The first photograph shows a stripeless "zebra" against "reeds" (upper left). The second shows the striped zebra against a dark reed background in which the dark stripes appear as background and the light stripes appear as reeds (upper right). The third photograph shows the "zebra" among reeds against a light background representing sky (lower left). In this photograph the white stripes read as sky, and the dark stripes appear as reeds. The photos documented Thayer's claim that the zebra's stripes obscured its form from predators when it approached a watering hole. This claim provoked Theodore Roosevelt, who attacked Thayer's work in an appendix to his 1910 book documenting his post-presidential African safari, *African Game Trails.*[56] Roosevelt argued that his experience as a hunter observing animals in nature gainsaid Thayer's armchair speculations on animal appearance. He denied that coloration was adaptive, preferring to see it as the result of environmental effects.[57]

Roosevelt's criticism altered the scientific reception of Thayer's book. J. A. Allen retracted his favorable review of Thayer's book, citing Roosevelt's criticisms.[58] Roosevelt and his chief supporters, the American herpetologist Thomas Barbour (1884–1946) and the doctor and conservationist John C. Phillips (1876–1938), criticized Thayer for basing his theories on experiments with fake animals at home rather than observation of real animals in the field.[59] The historian of science Sharon Kingsland summarizes their objections as follows:

Roosevelt, Barbour, and Phillips together advocated a "common-

sense" approach to coloration, which essentially meant that the judgment of an animal's conspicuousness should be based on field observation. Thus Roosevelt refuted Thayer's claims of concealment in animals like the zebra, flamingo, and many others, because he had frequently observed them in the wild and they had appeared highly conspicuous.[60]

As Kingsland indicates, Roosevelt took himself as the standard for biological significance; his experience in the woods was sufficient to dismiss concealing-coloration. In fact, he argued that belief in concealing-coloration stemmed from a lack of woodsmanship. When looking at animals, Roosevelt cautioned,

We must remember that to the untrained eyes of civilized man they often appear inconspicuous, or as concealingly colored, when in the eyes of a savage hunter or a beast or bird of prey they do not seem inconspicuous at all. An ordinary man, even an ordinary scientific man of the closet variety, who is only acquainted with a zebra or a tanager in a museum, when he visits the wilds unconsciously expects to see the creatures loom up as conspicuously as in show cases; just exactly as a city man when first out after deer cannot see a buck when it is pointed out. In consequence, instead of realizing that it is his own vision and attitude of mind which are at fault, he thinks there is some peculiar attribute of invisibility in the animal itself.[61]

Roosevelt agreed with Thayer that images of conspicuous animals shaped the expectations of their viewers. However, he disagreed with Thayer that the difficulty viewers had in seeing animals in nature indicated the animals' concealment rather than the viewers' weakness. As was discussed in chapter 2, Roosevelt saw a lack of woodsmanship as a lack of manliness. Roosevelt's argument thus implies that modern men are unable to properly perceive animals in nature because they are overcivilized. Roosevelt argued that only experience in the field as a hunter counted in the

discussion of animal appearance. Thayer responded to this criticism by arguing that seeing a few instances in which an animal appeared conspicuous said nothing about all the times Roosevelt had failed to notice inconspicuous animals.[62]

However, the heart of Roosevelt and his allies' criticism of Thayer was their argument that what animals *do* in nature was more biologically significant than what Thayer could make decoys or stuffed animals do. The paleontologist and historian of science Stephen Jay Gould suggests that these critics found the fatal flaw in Thayer's method; his theory was not falsifiable and hence not scientific.[63] Because Thayer claimed animals resembled the background at their moment of greatest need rather than resembling their typical habitat, it was impossible to refute his theory by proving empirically that animals in nature did not enter the environment in question.[64] Thayer's insistence that the animal was a picture caused him to presume the connection between animal and background that he needed to prove in order to ground a claim for biological significance. However, despite the flaws in Thayer's method and the overstatement of his position, much of his work has been shown to be correct. Countershading, known in biology as Thayer's principle, remains a valuable contribution to the understanding of animal coloration. Thayer's critics were also wrong in their dismissal of natural selection, and their argument that the existence of differently colored animals in the same habitat means that at least one of them must be conspicuous indicates a failure to understand speciation; different species occupy different environmental niches within the same habitat.

Neither of the two main protagonists in the debate were scientists. Roosevelt claimed his authority as a hunter-naturalist, while Thayer claimed his as an artist-naturalist. Kingsland suggests that the backgrounds of the two main protagonists in the debate account for the fact that "from a scientific point of view, the arguments were unsophisticated and centered more on the problem of method and interpretation of data than on the under-

lying mechanisms that governed evolution."[65] In other words, Kingsland argues that rather than focusing on biological issues, the debate focused on questions of representation, most of which turned on the role of animal photography.

The importance of photography to the concealing-coloration debate has largely passed unremarked. Only the art historian Alexander Nemerov has commented on the key role photography played in the debate.[66] While Nemerov stresses the importance of photography to the controversy, he brackets off any consideration of the substance of the debate, preferring to read it symptomatically. As Nemerov indicates, his interest "is not who was right or wrong, but the sheer intensity of the debate between Thayer and Roosevelt, suggesting that the issues concerned more than just animal camouflage."[67] Nemerov argues, "Roosevelt's disagreement centered on Thayer's use of visual representation. Indeed, turn-of-the-century discourse about visual display—in particular the social and educational purposes of visual display—lay at the core of their debate" (72). As Nemerov notes, "The beginning of Roosevelt's initial review of *Concealing-Coloration* significantly overlooks Thayer's book per se and focuses instead on the relative insignificance of photographs and paintings compared to written text" (72). Roosevelt began his attack on Thayer's book with a disquisition on the need for imagery to be subordinate to text in any serious work of natural history. While Roosevelt thought that "the photographer plays an exceedingly valuable part in nature study," he argued that

> our appreciation of the great value of this part must never lead
> us into forgetting that as a rule even the best photograph renders
> its highest service when treated as material for the best picture,
> instead of as a substitute for the best picture; and that the best
> picture itself, important as it is, comes entirely secondary to the
> text in any book worthy of serious consideration either from the
> stand-point of science or the stand-point of literature.[68]

Roosevelt framed his criticism by arguing for the subordination of photography to text. While he acknowledged the importance of photographs, he stressed "the *relative* values of the photograph, the picture, and the text" (552). For Roosevelt, photography's value to natural history was only as illustration. Roosevelt was thus enforcing the distinction that had developed in American science that images documented knowledge and did not produce it. Nemerov summarizes Roosevelt's position by arguing, "Imagery, for Roosevelt, was by nature obscure. Only through textual explication could imagery be made morally useful" (72).

In 1911, Roosevelt strengthened his cautions on the use of animal photography. Responding to Thayer's criticisms of his first piece, Roosevelt wrote,

> The first thing to realize in discussing concealing coloration is that to any but trained hunter's eyes, all birds and mammals out of doors seem far more inconspicuous than previous acquaintance with them in the museum or menagerie or in book pictures leads the observer to expect; and moreover when the mammal or bird is small, or is seen against the light, as must be the case where it is in the tree tops, the difficulty of making it out is immeasurable increased.[69]

He linked this difficulty in seeing animals to photographing them and suggested this difficulty was "one of the reasons, but by no means the only reason, why photographs, if not taken by men especially fitted to understand not only the uses but the limitations of their instrument, are so often unsatisfactory and misleading as representations of natural objects" (210). While Roosevelt admitted that "admirable work" had been done by naturalists with the camera, he argued that "unless used by a very conscientious, and also very capable, observer, photographs may be a positive hindrance to knowledge" (210). Roosevelt saw animal photography as potentially misleading and argued that great care must be taken in photographing animals or else the resulting images would give

a false impression of them. For this reason, he wanted to limit animal photography to expert naturalists; animal photography was not for everyone. This was a radical shift from Roosevelt's earlier claims that animal photography, in the form of camera hunting, was potentially the salvation of the nation and should be widely adopted. Discussing Allen Grant Wallihan's photographs in the context of declining game populations in 1901, Roosevelt said that he "hope[d] that the camera [would] largely supplant the rifle."[70] As was discussed at length in chapter 2, Roosevelt had hoped that animal photography would become a widespread practice. In 1901, he saw it as a way of promoting woodsmanship and developing virility while preserving nature. However, given the sustained thrust of Roosevelt's attack on Thayer and his use of visual representation, clearly his new position was not simply a strategic disavowal of animal photography. Thus, there was a shift in Roosevelt's thinking of animal photography from a concern with conservation and the practice of woodsmanship to ensuring the adequate representation of nature for the moral education of the nation's youth. His opinion of animal photography changed as his thinking shifted from a focus on its production to a concern with its consumption and circulation.

What intervened between 1901 and 1909 was the nature fakers debate.[71] The debate was a campaign waged by Roosevelt and his ally the naturalist John Burroughs (1837–1921) against what they saw as the morally corrupting effects on children of the falsified nature in wildlife stories. The campaign opened in 1903 with Burroughs's assault in the *Atlantic Monthly* on the reputations of three famous nature writers: Ernest Thompson Seton (1860–1946), Jack London (1876–1916), and Rev. William J. Long (1857–1952).[72] Burroughs accused these writers of falsifying nature in their stories. Roosevelt consulted with Burroughs throughout the debate and became officially involved in June 1907.[73] After a contentious debate, the controversy ended with the publication of a special issue of *Everybody's Magazine* in Septem-

ber 1907, which presented the scientific consensus on the topic as supporting Roosevelt and Burroughs's position.[74] After the debate, Roosevelt no longer saw nature as transparently available to representation. Instead, he believed its representation needed to be carefully policed to prevent false moralizing from corrupting it. This was especially problematic given Roosevelt's belief in the centrality of nature to the formation of American character. If children received a false impression of nature from falsified representations, they would be unable to reap the character-forming benefits nature could bestow.

The nature fakers debate shaped the reception of Thayer's work in another way. Although not formally part of the concealing-coloration debate, Burroughs's 1905 *Atlantic Monthly* essay "Gay Plumes and Dull" was the first published criticism of Thayer's work.[75] Critics have ignored Burroughs's essay and its role in the debate over Thayer's natural history work. However, Burroughs's essay rehearses many of the later criticisms of Thayer's work made by Roosevelt. This is significant, as Burroughs was Roosevelt's alter ego in the nature fakers' controversy. London described the relation between the two men as follows: "In this alliance there is no difference of opinion. That Roosevelt can do no wrong is Burroughs's opinion; and that Burroughs is always right is Roosevelt's opinion."[76] Given the similarities between Burroughs's argument and Roosevelt's, it seems clear that Burroughs's essay helped shape Roosevelt's.

Like Roosevelt's *African Game Trails* argument, Burroughs's starts with the question of photographic evidence. He begins by discussing a photograph that was presented to him as evidence of protective coloration. Burroughs wrote:

> Not long since, one of our younger naturalists sent me a photograph of a fawn in a field of daisies, and said that he took the picture to show what he considered the protective value of the spots. The white spots of the fawn did blend in with the daisies, and certainly rendered the fawn less conspicuous than it would have

been without them, but I am slow to believe that the fawn has spots that it may better hide in a daisy field, or, in fact, anywhere else, or that the spots have ever been sufficiently protective to have materially aided in the perpetuity of the deer species. (721)

Burroughs denied the value of the photograph as evidence of protective coloration. He further denied the existence and value of most protective coloration, criticizing countershading in particular. While Burroughs accepted that the photograph showed that the fawn was hidden by the daisies, he denied that this had any evolutionary value. Thus, the photograph could not be taken as evidence for the effect of the animal's coloration.

Burroughs presented a number of arguments that would later be made by Roosevelt. He argued that the variety of animal coloration among animals sharing the same habitat argued against the protective value of animal coloration.[77] Similarly, he also argued that only one type of coloration could be concealing in a particular environment:

> If dull colors are protective, then bright colors are non-protective or dangerous, and one wonders why all birds of gay feather have not been cut off and the species exterminated: or why, in cases where the males are bright-colored and the females of neutral tints, as with our scarlet tanager, and indigo bird, the females are not greatly in excess of the males, which does not seem to be the case. (723)

He also argued against the protective value of countershading, suggesting that the white bellies of animals are simply the result of the action of sunlight (727).

More importantly, Burroughs linked the bright coloration of male animals to display and masculine pride:

> Cut off the ugly bull's horns, and you have tamed him. Castration tames him still more, and changes his whole growth and development, making him approximate in form and disposi-

tion to the female. I fancy that the same treatment would have the same effect upon the peacock, or the bird of paradise, or any other bird of fantastic plumage and high color. Destroy the power of reproduction, and the whole masculine fabric of pride, prowess, weapons and badges, gay plumes, and decorations, falls into ruins. (735)

Burroughs claimed display was central to masculinity. Without conspicuous display, males revert to femininity. Burroughs thus implies that Thayer's theory of concealing-coloration is equivalent to castration. Burroughs's argument provides a different shading on the fierceness of Roosevelt's opposition to Thayer's work. It was not simply that he saw Thayer's work as false and therefore morally suspect. It was that Thayer's work threatened to undermine the status of masculine display underlying Roosevelt's advocacy of trophies and big-game hunting. Roosevelt believed in the importance of trophy display. His denial of Thayer's position on animal coloration was connected to a gendered politics of the masculine display of prowess and virility; for Roosevelt, masculinity meant standing out from the background.

Standing out from the background was precisely what Thayer's work denied. As Nemerov notes, animal representation in the period often presented animals as "heroic specimens of a thinly disguised human masculinity."[78] Thayer's animal imagery was problematic because it "fail[ed] to conform to period constructions of heroic masculinity" (79). This failure to conform threatened the kind of construction of masculine identity at work in the trophy relation.[79] For this reason, Nemerov reads Thayer's work as threatening American manhood and argues that "given the context in which he was writing, Thayer's camouflage suggested the loss of an Anglo-Saxon masculine identity. What could be more unmanly, after all, among a race proud of its martial virtues, than failing to show up?" (79). Suggesting that animals disappeared went against the grain of a culture that emphasized masculine display.

THE LIMITS OF PHOTOGRAPHY FOR CAPTURING ANIMALS

The question of animal photography also emerged in the side debate that developed between the ornithologists Francis Henry Allen (1866–1953) and F. M. Chapman on the role of scientific photography. Chapman had been an early supporter of Thayer but felt *Concealing-Coloration* had gone too far in its universalizing of protective coloration. As Kingsland notes, Allen was the only naturalist to voice support for Thayer once the debate was under way.[80] Allen challenged the manner in which Roosevelt and his allies had attacked Thayer, suggesting that their arguments were unfair and unscientific.[81]

In his first essay on the topic, Allen made two arguments that I want to highlight. In relation to the general argument over concealing-coloration, Allen suggested that part of the difficulty was naturalists' interest in the absolute animal rather than the particular. He suggested that ornithologists were prone "to see what we *know* is there rather than what actually appears to the eye" (501). He linked this miss-seeing to their focus on *"absolute* color,—color that is such by virtue of pigmentation and structure, not color as seen out of doors in varying lights and subject to the influence of countless neighboring colors" (501). Ornithologists "see a bird's under parts as white, sometimes doubtless because we *know* they are white, and sometimes by the eye's unconsciously making allowance for the effect of shade" (502). With unrecognized birds, ornithologists "are constantly translating its apparent colors into terms of the absolute colors that [they] know or suspect them to represent," because "that is the only way that we can identify an unfamiliar bird,—without having it in the hand, where no such translation is necessary" (502). Allen suggested that naturalists' knowledge of animals prevented them from seeing animals as they appeared. He thus argued for a gap between seeing and knowing. Allen's argument sums up what I take as the central issues that prevented Thayer's arguments from receiving a full hearing. This is not to suggest that Thayer's arrogance and tendency for overstatement did not also contribute.

However, while I think Allen's statement is important as a diagnosis of the limitations turn-of-the-century ornithology placed on thinking animals, I want to focus on a second statement of his on the role of photography.

In his analysis of what he saw as Roosevelt's unfair argumentation, Allen commented on Roosevelt's citation of photography. Roosevelt had made reference to other photographers who he saw as honest portrayers of animals in contrast to Thayer's active deceptions. Allen criticized Roosevelt by arguing that he had ignored the photographer's efforts to ensure the animal's visibility:

> In two places ... he instances the photographs of certain birds taken by Messrs. Job, Finley, and Chapman as showing the conspicuousness of those species in a state of nature, quite overlooking the obvious facts that the photographers naturally chose the conspicuous subjects, avoiding those that were at all obscured and getting their cameras into positions where the birds would come out most clearly, and thus made the birds as conspicuous as they possibly could, which was the end and aim of their work. I take it that the birds in most photographs do not appear at all as they would under average conditions in their natural surroundings. (492)

Here Allen raises the question of how accurate photography is in its representation of animals. How does the photographer's general desire for crisp, clean images structure the images we see? The photographer's desire for a clean exposure to highlight the animal's appearance (to present it as a typical specimen) may obscure the atypicality of this exposure.

Allen's argument that birds in photographs do not appear as they would "under average conditions in their natural settings" provoked a response from Chapman. Chapman wrote a letter to *The Auk* seeking to defend bird photography from this assault on its credibility. Chapman conceded, "Many bird photographs are made with the object of displaying their subject to their best

advantage."[82] However, he continued by arguing, "it does not follow that for this reason most bird photographs are lacking in scientific value, or that they do not faithfully portray nature" (148). Chapman maintained that the photographs cited by Roosevelt (which included his own work) showed:

> (1) that the photographer does *not* avoid subjects that "are at all obscured" (witness so-called puzzle pictures of Grouse, Woodcock, Whip-poor-will, etc.), (2) that he does *not* always make the bird as "conspicuous" as possible, (3) that to make birds conspicuous is *not* "the end and aim" of bird photography, and (4) that many bird photographs *do* represent birds as they appear "in their natural surroundings." (148)

Chapman defended bird photography by noting that there were many photographs of birds everyone conceded were camouflaged in which the birds were not easy to see. Thus, Chapman noted, there was at least a subset of bird photography that did not make the birds it depicted completely conspicuous. However, the rest of Chapman's assertions act as a corrective to Allen's overstatement without fundamentally addressing the broader question he raises about photography's structuring of animal representation. Allen's assertion that photography strives to make animals conspicuous and thus was not an accurate representation of them in nature was overstated and untenable. However, restated as the question of how photography's bias, as a visual medium, toward visibility shapes animal photographs, the question still has force. The question of how photography both opens the possibility of depicting animals and at the same time constrains that depiction cannot be dismissed by Chapman's assertions of good intentions.

This was the position that Allen took in his reply to Chapman.[83] Allen conceded that his position was overstated, and he indicated that he had not meant to "charge photographers with doing violence in nature in order to prove a point or make a pretty picture" (314). He stressed his respect for the scientific

value of photography and argued "that bird photographs are of inestimable value to the student, since they show him some things which he could not possibly learn without them" (314). He thus acknowledged photography's ability to provide access to otherwise inaccessible aspects of animal life.

However, while Allen accepted the correction, he reiterated his underlying point. He continued, "It needs no extended argument, however, to prove that a bird in a picture, where the observer's eye is inevitably directed toward it, is in the nature of things much more easy to be seen than in the landscape out of doors" (314). Allen's point here is straightforward; framed in an image the animal is much more visible than it is as part of the manifold of sense experience we encounter in the world. Allen argued, "while some birds that are inconspicuous (as the woodcock) may be inconspicuous even under the disadvantage of occupying a comparatively large proportion of the field of view in a photograph, it is not sound reasoning to assert that all birds which are conspicuous in photographs are conspicuous in nature" (315). In fact, Allen suggested the problem was not that an overemphasis on visibility meant that bird photographs lack scientific value, but rather that "their scientific value depends in great measure on their clearness in detail" (314). Thus, when dealing with the question of protective coloration, photography's strength as a scientific tool for studying animals, its ability to make visible otherwise unavailable aspects of their existence, worked against the understanding of coloration.

Allen's argument that photography's tendency to the visible made it less than ideal for the subject of protective coloration appears to conflict with Thayer's assertion that photography was "the great ally of those who would expound the laws of concealing coloration."[84] Yet what the two positions reveal is the complexity of photography. Thayer's position emphasized photography's ability to reduce the animal and its environment to a single plane of consistency. In so doing, it makes apparent the

visual links between animal and environment central to protective coloration.[85] However, as Allen indicated, at the same time as photography reveals the visual connection between animal and environment, it also highlights the animal by framing it in isolation from its broader surrounds. These positions mark out the tensions in animal photography between visibility and invisibility.

Allen's reply marked the closing of the protective coloration debate. With the publication of Allen's response, the editor of *The Auk*, Witmer Stone, declared the debate closed. Stone argued, "As the discussion on Concealing Coloration has already been unduly prolonged it seems desirable to close it at this point."[86] While both Roosevelt and Thayer continued to raise the subject, the scientific community moved on to the business of investigating and testing the function of animal coloration. Thayer's increasingly strident calls for the proper testing and approval of his theories led both him and his theories to be considered something of an embarrassment. As Kingsland concludes, "The debate itself did not solve any of the biological issues, but it did help to elucidate some of the problems that had to be solved, problems centering on the role of natural selection and the meaning of biological significance."[87]

Thus, despite the initial warm reception for his work on animal coloration, Thayer's work fell out of favor, and by the mid-twentieth century biologists treated Thayer as a cautionary footnote.[88] Gould argues that by extending his investigations to the general field of animal coloration, Thayer overextended his theory.[89] According to Gould, it was this overextension that led Thayer's otherwise valuable work into disrepute. In contrast, Blum suggests that Thayer's difficulties were the result of the professionalization of science and his support for natural selection.[90] Thayer misunderstood the changed structure of American biology and failed to understand how to marshal evidence in the new argumentative environment. Kingsland concurs, arguing that Thayer "simply did not understand how to deal with the issue

of biological significance in a scientific manner."[91] There were a combination of factors prejudicing Thayer's reception; these included the overextension of his theories, a widespread hostility to natural selection in American natural history, Thayer's inability to grasp biological significance, and, as is suggested by Nemerov, his theory's conflict with period notions of nationalism and masculinity.[92]

THE DISAPPEARANCE OF ANIMALS

Nemerov sees Thayer's images as featuring "pointless prominence," in which the animals are displayed "for no other reason than for the fascination of the viewer" (74). He continues,

> Even those photographs and paintings in Thayer's book in which the sublimation is more successful—that is, where the pictured prey disappears so dramatically as to make the image unreadable—also constituted a kind of representation unredeemable by any educational program. How can one write about a picture of nothing at all? (74)

For Nemerov, the photographs in Thayer's work are not discursive and are essentially about nothing; they offer no purchase on the animals depicted to their viewers.[93] Nemerov sees Thayer's photographs as fundamentally improper. He argues that the photographs are either oversignified and unscientific, or undersignified and about nothing at all. Nemerov's aesthetic reading of Thayer's natural history images leads him to dismiss their content. Instead, he reads the photographs as sublimated representations of Thayer's disgust with sexual display. As Nemerov indicates, Thayer thought "display for display's sake" was "an immoral indulgence" (60). Nemerov situates the animal photographs as part of what he describes as "Thayer's larger mission of making desirable bodies disappear" (60). Nemerov proceeds psychoanalytically and reads the images as the expression of Thayer's underlying disgust with displayed bodies. While Nemerov is the only critic to seriously

discuss Thayer's use of photographs, he reads them in terms of their scopophilic excess rather than their depiction of animals. He correctly identifies that Thayer's images separate seeing animals from knowing them. However, for Nemerov, because they do so by making the animals disappear, they cannot be said to produce knowledge.

I agree with Nemerov that Thayer's preoccupation with the immorality of display shaped and limited his natural history work. Nemerov's analysis of Thayer's obsession with the immorality of display provides a convincing explanation for Thayer's rejection of any role for display in animal coloration and helps to explain the reception of Thayer's work on animal coloration. However, because he brackets the content of Thayer's work, he does not address its implications for thinking human-animal relations. Although my reading is indebted to Nemerov's, I differ from him in my interpretation of Thayer's camouflage images and argue that the photographs speak to the limits and potentials of photography and the separability of seeing and knowing. While Thayer's theory that all coloration is defensive was flawed, his images make a contribution to our understanding of animals' relation to visuality and hence to what it means to look at them.

ANIMAL APPEARANCE

For Nemerov, an animal's "protective disappearance into the woods prompts associations with the investigations of Roger Caillois, who studied insect camouflage for what it might reveal about a human loss of self" (79). In his 1935 essay "Mimicry and Legendary Psychasthenia," the French theorist Caillois (1913–78) argued that disappearing into the background threatens the distinctness of insects by blurring their physical and psychical boundaries.[94] Caillois treated the function of mimicry as equivalent to the symptomatic expressions of legendary synesthesia and argued that both entailed a "depersonalization by assimilation to space."[95] In this reading, mimicry, defined as an insect's imitation

of an aspect of its environment, places the insect's sense of self outside the boundaries of its body. The background becomes part of the insect's appearance, and the external becomes internalized as a component of (non)identity.[96] Caillois saw mimicry as a dangerous excess. As in the psychic disorder legendary psychasthenia, mimetic insects lose their ability to locate themselves; they can no longer situate themselves in space and instead become captivated by it.[97] They, like the animals in Thayer's images, become unlocatable.

Nemerov uses Caillois's reading to link the blurring of animals' boundaries in mimicry to a blurring of national and masculine identities in Thayer's work. He argues that Thayer's natural history paintings suggest "a comparable loss of identity—a dispersal of the self into the world around."[98] Yet, there is a gap between Caillois's discussion of animals' experience of identity and Nemerov's discussion of early-twentieth-century American viewers' inability to projectively identify with the animals in Thayer's work. It is not immediately clear why looking at an image of an animal with confused boundaries between itself and the world should threaten to undermine the conceptual frameworks of its viewers. However, as Nemerov argues, Roosevelt's vehement opposition to Thayer's work demonstrates that it did do so. To clarify this relation, I want to situate Thayer's work against Caillois's later rethinking of the topic of mimicry, in which he formulated animal appearance as an engagement with the visual as a field of the other.

Caillois was trained as a sociologist and became an autodidact of science. In the late 1930s, Caillois was a cofounder, with the renegade surrealist Georges Bataille (1897–1962) and the writer Michel Leiris (1901–90), of the *Collège de sociologie*, which explored the question of the sacred in modern life.[99] Caillois's works on the sacred and on play continue to have an impact on the thinking of these topics.[100] He has been compared to Lévi-Strauss, due to his range and breadth of interests, and has been called a true

naturalist.[101] Throughout his life, Caillois focused his attention on the appearance and behavior of insects and the meaning of display with specific emphasis on the question of mimicry.[102]

In his 1958 book *Man, Play, and Games,* Caillois rethought the analysis in "Mimicry and Legendary Psychasthenia."[103] Caillois moved his analysis of mimicry from "a disturbance of space perception and a tendency to return to the inanimate" to "the insect equivalent of human games of simulation" (178n5). Caillois expanded this analysis of mimicry in his 1960 work *The Mask of Medusa.*[104] His analysis divided mimicry into three aspects, disguise (appearing as another creature), camouflage (disappearing into the background), and intimidation (appearing as something frightening or hypnotic), based on the function of the creature's appearance.[105] This categorization was not exclusive, and he argued that in many cases "camouflage prepares the way for intimidation and the invisibility is only there to secure the success of frightening and sudden appearance" (88). He thus situated concealment in relation to display, suggesting that "concealment is not the only purpose of disguise. One may just as well use it to attract attention, to appear, in borrowed plumes, spectacular and striking, confusing or deceptive" (109-10). Caillois argued that mimicry had multiple functions in nature. Unlike Thayer's argument, Caillois's analysis was grounded in the biological function of mimicry, not optical principles.

DISPLAY, NATURAL SELECTION, AND USE VALUE

As Adolph Portman notes, "Examples of mimicry abound in elementary textbooks, mimicry being a stock argument in favor of evolution."[106] Biologists subsume imitative coloration, including camouflage, under the heading of mimicry.[107] Their analyses emphasize the centrality of vision in mimicry.[108] For example, in his 1980 book on animal coloration, biologist Denis Owen suggests that mimicry "is a process in which one animal (called the operator) is unable to distinguish a second organism (the mimic) from

either another organism or from part of the physical environment (the models), the consequence of which is to increase the chances of survival of the mimic."[109] As a visual characteristic, camouflage requires a viewer. For camouflage, or any other form of mimicry, to be effective, the signal has to be received. Thus, for biologists, mimicry functions as a kind of Peircean semiotics in which an animal's failure to appear as itself acts as a sign for another animal.[110] However, in this sign system the use value of the sign only operates for the sender. The receivers who "correctly" read the sign receives nothing for their trouble.[111]

Insect coloration provided one of the most important early confirmations of Darwin's theories. Henry Wallace Bates's (1825–92) 1863 work on Amazonian butterflies offered a set of facts that he claimed only natural selection could explain.[112] Bates's work, while controversial at the time, continues to frame the standard biological interpretation of conspicuous coloration. Bates theorized that the close resemblance he discovered between unrelated species of butterflies was due to palatable butterflies mimicking a conspicuous nonpalatable butterfly for protection. Bates proposed that natural selection was the mechanism by which these nonrelated butterflies edged ever closer to the appearance of their model. Thus, Bates provided a framework through which insect coloration could be considered useful. The consideration of use has continued to shape biological discussions of insect coloration. Those who oppose the mimicry hypothesis have denied its usefulness and thus its existence, the operating consideration being that if mimicry is not useful, then it is simply an epiphenomenon that appears only to the human eye and does not actually exist for the animals involved. Against such criticism biologists who support the mimicry hypothesis have continually striven to demonstrate its use value. It was against the understanding of mimicry in terms of use value that Caillois attempted to work.[113]

Caillois condemned what he saw as the presupposition of utility by biologists.[114] He argued that the existence of mimicry

between species of palatable butterflies undercut claims for mimicry's grounding in utility. In doing so he opened up the possibility of comparing humans and animals in the space cleared by utility's rejection.[115] Caillois acknowledged that his arguments opened him to an accusation of anthropomorphism. He defended himself by arguing that it is a thinking of utility that is truly blinded by anthropomorphism:

> However, if we stop projecting our human reactions on to the non-human part of nature we find an immense squandering of resources is the rule there. It is a world where there is nothing, absolutely nothing, to indicate that an ostentatious outpouring of resources, with no intelligible end, may not be a wider and more universal law than the strict vital interest, the imperative of the survival of the species. (40)

Nature, Caillois argued, is excessive. Yet we continue to assert that it is governed by a principle of strict utility; we remain "convinced that nature does nothing in vain" (40-41). Not only was this presumption dangerous but also illegitimate. What, he wondered, would be a legitimate criterion to give "a clearly defined meaning for the expression 'in vain'" (40-41). Presuming that nature is always constrained by utility was, he thought, "the final anthropomorphic error" (40-41). In his opening of a space to think biology outside strict utility, Liz Grosz argues that Caillois's work anticipates "what might be considered a 'philosophy' or perhaps even an 'anthropology' of the post human."[116] As Grosz highlights, thinking about mimicry and display has implications for our understanding of humanity.

The condemnation of utility opens the possibility of rethinking what Nemerov described as the nondiscursive quality of Thayer's photographs. It is not that they are "about nothing at all." Instead, the photographs' failure to be constrained by Roosevelt's narrow, moralized educational program is linked to their opening up of the question of animal appearance beyond utility. In this open-

ness, Thayer's photographs go beyond his arguments that constrained their depiction of animal appearance in their positing of it as always defensively concealing. Instead, Thayer's photographs escape strict utility by depicting what Caillois posited as the visual as the field of the other.

THE VISUAL AS THE FIELD OF THE OTHER

While he categorized mimicry by the function it was used for, an animal's use of its appearance was not based on utility for Caillois; he argued instead that "in the world of living things there is a law of pure disguise."[117] He defined this as "a leaning toward the act of passing oneself off as something or someone else" that cannot be "accounted for by any biological necessity connected with the struggle for existence or natural selection" (75). Appearing as something else was not for protection; it was a response to a tendency or desire for disguise. In positing a biological desire for disguise, Caillois rethought mimicry, shifting his analysis from an individual insect's psychic experience to the species' relation to the Other. Mimicry indicates that animal appearance orients toward visibility. Because it operates at the level of the species, this orientation is not aimed at any particular observer but to a generalized other in the field of vision. Caillois described this as "a fascination with the Other, suggesting this as the reason for mimicry and the adoption, for no practical reason, of the appearance and behavior of other creatures," and suggested this desire was also present in humans as "correspond[ing] in man to his irrepressible love of disguise" (86). As Chris Venner describes, "Caillois wants to foreground the possibility that insect behavior is predicated on a social Other rather than on an instinctual self."[118] Katherine Arens concurs with Venner's analysis, arguing, "Caillois ties biological behaviour not to biological structure, but rather to functional relationships with the Other of a particular population or community."[119] Caillois tied insects into social relations by defining their coloration as a mask. As Arens explains,

this is what "Caillois calls the 'sorcery' of the insect. In a functional sense, then, he believes that the insect is using a mask, just as primitive societies do, to assert a power that it has through its use of symbols (masks, signs)" (233). It is the insect's exploitation of its coloration that forces Caillois to consider it a mask.

Caillois based his rethinking of mimicry on ocelli, the circular spots on insects and animals that resemble a vertebrate eye.[120] Ocelli are generally found on camouflaged insects, which display them both to warn off predators and, as in the case of some mantises, to hunt by paralyzing their prey.[121] Caillois argued that "the whole point of ocelli and a condition for their success is precisely for them to be enormous—out of proportion. It is not a question of looking exactly like the model but of creating an aura of terror" (87). Ocelli provoke fear by suddenly making their target feel exposed to the field of vision. Ocelli, thus, are something in nature that insects and animals take to be looking at them but that cannot in fact see them (91). They demonstrate the possibility of detaching the experience of being seen, and becoming consciously visible, from the eye of a beholder. They demonstrate, in other words, the existence of the gaze as the visual field of the other.

Caillois's interpretation of ocelli and his posit from them of a visual field of the other not based in any particular observer were the basis of the French psychoanalyst Jacques Lacan's (1901-81) formulation of the concept of the gaze.[122] Lacan incorporated Caillois's work on mimicry into his analysis of visibility but did so in a way that emphasized the role of representation in vision in the concept of the screen.[123] Kaja Silverman has undertaken the most extensive investigation of the gaze as a structural, rather than human, "'Otherness' within the field of vision" that I see as central to Caillois's formulation.[124] Silverman's analysis of this aspect of the gaze is shaped by her engagement with Caillois. She began her investigation, in *Male Subjectivity at the Margins,* by reading Caillois as an influence on Lacan to clarify the subject's

immersion in the field of the gaze.[125] As Silverman notes, the gaze is central to Lacan's understanding of the formation of the subject.[126] While the problematics of the Lacanian subject are not my concern here, Silverman's reading does offer an explanation for why Thayer's images challenged Roosevelt's sense of masculinity.[127]

Silverman introduces the concept of the look to clarify the operations of the gaze from the action of the eye. The look of an individual (the action of the eye) is separate from the gaze (the condition of being seeable). The look can be a support for the gaze, but the two are distinct; while someone's look can make us aware of our visibility, this awareness can also be provoked by other means, such as a camera or a sudden sound.[128] We are immersed in the visible yet see from only one point; our look always is exceeded by the field of vision. The experience of the excessive nature of the gaze has the potential to remind us of the gap between our desired self-image and our appearance in the world. In other words, the gaze reminds us of what Silverman calls our lack—our necessary and inevitable distance from the cultural models we desire to see ourselves as. These cultural models are situated in Silverman's reading as a screen that intervenes between a subject and its seeing of the world.

In this model, images gaze back at us as we look at them; images thus have the power to make us aware of our lack.[129] However, the alignment of the look and the gaze in images gives their viewers a sense of mastery and an impression of control covering up the gap between self-image and actuality. When viewers are situated as what the image proposes as its ideal vantage point, they are given the illusion that they are the master of the gaze. The Western perspectival tradition conflates eye and gaze and, in so doing, offers its viewers a position of mastery, which Silverman argues is figured as masculinity.[130] Silverman expanded her analysis in *Threshold of the Visible World*, providing a much more nuanced and detailed account of the relation between the look

and the gaze through the figure of the screen.[131] As part of her exploration of the screen as the historical and cultural space of ideology within vision, she suggests that since the nineteenth century, photography has been the central figure for apprehending the gaze. We now imagine the ideal appearance of things photographically (135). This supports Francis Allen's contention, during the concealing-coloration debate, that there is a desire to produce crisp, clear photographs of animals, images that in Silverman's terms align the look and the gaze.

Thayer's work refuses the conflation of look and gaze by suggesting there is no ideal vantage point from which the truth of the animal can be seen. In doing so, the work further suggests that the conflation of the look and the gaze is impossible in nature. There is no master position outside nature from which to look; we too are immersed in the field of vision. Silverman's argument thus provides a model to explain the vehemence of Roosevelt's attack on Thayer; Thayer's images separate look and gaze, disrupting the illusion of the control and mastery of nature central to Roosevelt's conception of virile masculinity. It also suggests why Thayer's work failed to become a model for representing animals; rather than confirm viewers in their sense of self, it did not conform to the cultural desire to either master or commune with nature.

Silverman's continued engagement with the implications of Caillois's thinking for the understanding of visuality ultimately leads her to break with Caillois. I want to examine Silverman's rethinking of the gaze to clarify the implications of Caillois's formulation to the thinking of animal appearance. She returns the theorization of the gaze to the question of insect mimicry in the last chapter of her 2000 book *World Spectators*.[132] Silverman's larger argument in the book proposes the experience of beauty as a corporeal engagement with the world's opening to the visible in appearance (145–46). In this rethinking of the visible, she draws on Caillois but differs from him in downplaying the dangers of appearance, arguing instead that the world opens up to

us in appearance as love (131–36). Silverman argues against both Caillois and Lacan as she thinks through animal appearance in relation to the visibility of the world.

Silverman reads Caillois's description of disguise, by which he means the form of mimicry in which an animal appears as another species, as a morphological, or bodily, fashion as implying that mimicking animals are inauthentic. She suggests that "to argue both that insect mimicry is existential and a fashion or disguise, as Caillois does, is to suggest that certain natural creatures are inauthentic in their very being" (134). Silverman disagrees and suggests that "when an insect or animal assumes another bodily form, it does not falsify or depart from its essence" (135). Silverman interprets Caillois's characterization of disguise as fashion as treating disguise as frivolous and inessential. In contrast, I read the comparison in terms of what I see as Caillois's deep anthropological comparison of human and animal behavior.[133] I base this reading on Caillois's conclusion that mimicry is a mask. For Caillois, the use of ocelli to provoke fear is central. Caillois argued that "if there were no ocelli," he would accept that animal markings "are simple caprices of nature." But he argued, not only are there ocelli, but there are also the effective uses of ocelli to hypnotize and provoke fear. In these cases, "the insect definitely behaves like a spell-binder, a sorcerer, the wearer of a mask who knows how to use it."[134] Insect mimicry is thus for Caillois not an inessentiality but a morphological engagement with the gaze. Caillois's argument is that the gaze is a generalized phenomenon that precedes the human. The difference is that while insects can exploit their appearance, humans can play with theirs. Where Silverman argues against Caillois in her desire to read the world as opening onto appearance as beauty, I follow Caillois in suggesting that the appearance of animals indicates openness to both beauty and fear.

For Caillois, the visual is a field of power relations. Nature, in Caillois's analysis, is never innocent, it is always excessive.[135]

Thus, for Caillois, the field of the visual is saturated with power that can hypnotize and provoke fear. His thinking of visuality resembles Thayer's in positing the visual field as fraught with danger. Yet, the violence Caillois locates in the visual field is different from that postulated by Thayer; it is not simply an assertion of the dangers of appearing but also an acknowledgment of the power of display. Caillois's analysis of mimicry allows us to articulate what Thayer's photographs reveal about photography's limits for capturing animals.

CONCLUSION: THE APPEARANCE OF ANIMAL PHOTOGRAPHY

Thayer's natural history work sought to transform both the understanding of animals and the standards for animal representation by convincing viewers of the truth of his theories of concealing-coloration. Yet, as this chapter has shown, his work failed in this attempt; while his work on animal coloration was initially well received, it provoked controversy and was ultimately ridiculed. His images did not transform animal representation, and they failed to convince their intended audience of the truth of Thayer's revelations. Highly visible animals continue to populate contemporary representations of animals, particularly in wildlife photographs, films, and videos. Indeed, a major emphasis in the expansion of wildlife representation in the twentieth and twenty-first centuries has been to find new ways to make animals visible.[136] Thayer's writings on natural history foundered on his refusal to consider the role of display in animal coloration. However, his images go beyond his writing in their presentation of the logics of camouflage. The serial form of the images with their alternation between the visibility and invisibility of the animals depicted indicates that the images situated camouflage in relation to display.[137] The images thus evinced a deeper understanding of the visual economy of animal coloration than Thayer's writing. Yet, despite this sophistication, the images also failed to con-

vince their audience. The failure of Thayer's images is significant. My analysis of Caillois's work suggests that the images failed not because they were incorrect, but because they refused to privilege their viewers. The images refused to play to the cultural reassurance of human mastery that accompanies the sense of separation from nature put forward by wildlife representations. Thayer's images ran up against cultural resistance, in the form Roosevelt and his allies, and the bias of photographic technology to the visual.

Thayer's work highlighted the relation between an animal's appearance and its environment. In so doing, it opened up the question of the field of visuality to which the animal's appearance is addressed. Some of Thayer's natural history photographs attempted to capture the animal's appearance to a generalized field of the other.[138] His photography highlighted the importance of the gaze to animal representation and confronted photography's bias toward visibility. The thrust of animal photography had been (and largely continues to be) to capture images of animals and make them visible. As Francis Allen argued, most "photographers" made animals "as conspicuous as they possibly could, which was the end and aim of their work."[139] This was in part, as Allen suggested, because photographs' "scientific value depends in great measure on their clearness in detail."[140] Thayer's images revealed that photography is a poor medium for depicting invisibility; the failure of something to appear in a photograph generally reads as a failure of the photographer, not a success. Animal photography is biased toward making animals visible and tends to obscure the gap between seeing animals and knowing them.

Thayer's work on animal appearance treated animals as pictures of their environment and thus as representations. Within Thayer's reading of appearance, to appear was to be under threat; animals were representations aimed at a generalized field of visuality constituted as a threat. However, in their situating camouflage in relation to display, his images opened the possibility

of a more nuanced understanding of animals as representations in a field of visual power relations. Thayer's images implied that animals and humans exist within a field of visuality of which humans are not the privileged part. The images argue for the separation of seeing and knowing in understanding animals while at the same time acknowledging that the ability to produce knowledge of animals is to assert power over them; what his work denies is that knowledge of animals is mastery of them. If animals are representations intended to control their appearing, there can be no innocent representation of them and no unmediated encounter with them.

In positing animals as representations, Thayer's work undercuts the fiction of the direct encounter between human and animal presented by John Berger in "Why Look at Animals?"[141] Berger criticizes modern human-animal relations based on their distance from earlier conditions of human-animal looking. Berger contends that we can no longer see animals because they have been so completely marginalized that they are unable to look back at us. He suggests that prior to modernity and capitalism a different regime of looking at animals held sway in which humans were part of an economy of animal looks. According to Berger,

> The eyes of the animal when they consider a man are attentive and wary. The same animal may well look at other species in the same way. He does not reserve a special look for man. But by no other species except man will the animal's look be recognised as familiar. Other animals are held by the look. Man becomes aware of himself returning the look. (2–3)

Berger suggests humans looked back at animals and thereby recognized themselves. Instead, Thayer's images point to the importance of our immersion in the visual to thinking animal appearance and representation. This concept implicates both humans and animals in a field of visuality in which humans are not privileged. Against Berger's postulation of the exchange of

glances between human and animal that confirms the human, I argue that Caillois's work and Thayer's photographs indicate an irreducible play of power relations in visuality. What Thayer's photographs reveal is a potential within photography to capture a field of visuality not founded on an exchange of looks but on our immersion in the field of the other. This potential suggests that photography can picture animals without positioning the photographer or the viewer in a privileged position of knowledge or mastery over them but instead bringing an awareness of our mutual immersion in a visual field. In this, Thayer's strategies of representation anticipate postmodern strategies for ethical animal representation. In this operation, the violence of the photograph is not directed at the object photographed but rather reveals our own exposure to the field of the other.

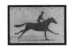

CONCLUSION

Developing Animals

Since the announcement of photography in 1839, there have been an ever-increasing number of cameras pointed at animals in nature. The resulting photographs bear, in varying degrees, the traces of the animals in front of the lens and the humans behind them. The photographs produced by a camera pointed at an animal in nature are shaped by the social and technical context of the image's production and circulation. This includes the immediate situation of animal and camera in nature, the broader social and cultural situation of the photographer, and the technological capabilities (and constraints) of the equipment. Simply put, cameras do not naturally produce wildlife photographs, nor, it should be stressed, any other kind of photographs. The regular production of any kind of image, which I call a practice of photography, requires a supporting social context. Focusing on American photographic practices, this book has explored what I see as the key moments in the discursive construction of animal photography.

Contemporary photographs of animals in nature are largely

produced through the framework of wildlife photography that conceptually separates humans and animals. However, as the history of animal photography discussed in this book shows, wildlife photography is only one of the possible forms for the photography of animals in nature. The earliest animal photography operated differently and cannot be understood in terms of wildlife photography. Thus, in the 1840s and 1850s photographers produced a variety of images of animals that depicted animals as pets, transportation, and game. Those images from the time, like Llewelyn's, which resemble wildlife photographs, operated according to different logics. In the 1870s and 1880s, Muybridge, Marey, and Anschütz developed new forms of photographic technology in order to capture images of animals. These developments helped make it technically feasible to photograph animals in nature. Photography of animals in nature emerged as a practice in the 1890s, when American photographers began hunting animals with their cameras. The camera hunters understood their photography as hunting, and their photographs as trophies. These claims for their practice made sense in the social and technical context of late-nineteenth- and early-twentieth-century America. However, as photographic technology continued to develop (making animal photography easier), as American attitudes to hunting changed (challenging sport hunting's preeminence), and as the images began to circulate outside their original contexts (moving into scientific publications and general interest magazines), the "naturalness" of camera hunting broke down. In contrast, the understanding of animal photography that developed with the photographic blind has been more durable. Adapted to photography from a hunting technique, the photographic blind introduced a separation of human and animal into the practice of animal photography. The blind made animals visible at the price of conceptually erasing human-animal contact from the photographs. The resulting images of "deep" nature provided the framework for the development of the genre of wildlife photography. Yet not

all animal photographers sought to make animals visible; Abbott Thayer's images sought to capture the relation between animal and environment in a way that did not privilege the human viewer. However, Thayer's work failed to develop into a practice, in large part because his photographs of indistinct animals encountered fierce hostility from the American establishment.

The history of animal photography *Developing Animals* has detailed is characterized, with the notable exception of Thayer, by an emphasis on making animals accessible to sight. This emphasis has continued through the expansion of camera-based animal images in the twentieth and twenty-first centuries. The twentieth century saw an explosion of animal images and the development of wildlife photography, film, and video.[1] The late twentieth century saw the development of satellite TV channels devoted to various forms of wildlife representations, and the twenty-first century has seen the development of twenty-four-hour animal webcams. Photographs, and other camera-based media (film and video), have helped structure our understandings of animals and our understandings of the human. As Jonathan Burt suggests, "the position of the animal as a visual object is a key component in the structuring of human responses towards animals, particularly emotional responses."[2] Wildlife photographs construct their viewers as unnatural. That is to say, wildlife photographs frame our relation to nature in terms of authenticity and suggest that our presence makes nature inauthentic. The compensation for this unnaturalness is a reassurance of human identity that accompanies our separation from nature.

Developing Animals thus provides a historical account of construction of the separation of animal and human that scholars of animal representation argue continues to be an important component of wildlife representation. For example, Cynthia Chris suggests that "the wildlife genre provides an illusory picture of a pleasurably ordered, harmonious, resilient natural world; that is, the comforting image of an eternal, 'natural,' depoliticized and

heterotopically whole world."[3] Gregg Mitman links the spread
of wildlife films to increased awareness of conservation and
environmentalism but suggests that wildlife representations also
separate us from nature and animals. "By making animals into
spectacle, rather than beings we engage with in work and play,
nature films and other recreations of nature reinforce this dichot-
omy of human and nature. In nature as spectacle, the animal
kingdom exists solely to be observed, objectified, and enjoyed."[4]
Derek Bousé's history of the genre, *Wildlife Films*, concurs, sug-
gesting that the conventions of nature films distort animal life.[5]
More broadly, Akira Lippit's *Electric Animal* argues that all com-
munications technology, including film and video, is a site for
mourning our separation from animals.[6] While Burt acknowl-
edges the separation, he argues it is also important to recognize
the "transformative potential of the animal film, as a counterbal-
ance to analyses that restrict themselves to the implications of
the objectification of the animal (both as truth-telling and as a
process of detachment and domination)."[7] Burt suggests that the
ethical and affective impact of animal representation can work
against this separation, motivating viewers to take action in sup-
port of animals.

Images of animals in nature help frame our understanding
of nature. For this reason, understanding the effects of animal
imagery is crucial to understanding human-animal relations in
contemporary Western culture. In contemporary culture animals
are most often encountered through imagery. Many "familiar"
species, like moose and beaver, are only encountered in repre-
sentations or in zoos. In fact, the spectacular images of animals
that wildlife representations provide can seem more real than ani-
mals in nature.[8] As Chris suggests, within the spectacular logic
of wildlife representation "animals on film are even better than
animals in zoo enclosures, and surely better than animals in the
wild: they are not only captive and visible at our whim, not their
own, but they are at their very best."[9] Similarly, Donna Haraway

argues that in wildlife representations "the critters of the world
... are assayed by the standard of the visually convincing and,
at least as important, the visually new and exciting."[10] Wildlife
representations have become the standard for thinking animals.
Animals that fail to live up to their spectacular images can seem
false in comparison.

However, wildlife representations not only frame the under-
standing of animals, they also frame the conception of the human.
As Chris demonstrates, we now use that construction of nature to
also make arguments about the limits and possibilities of human
behavior. Her history of wildlife representations traces a shift in
how animals are figured "from a framework in which the ani-
mal appears as *object* of human action (and in which the animal
is targeted as *game*), to an *anthropomorphic* framework, in which
human characteristics are mapped onto animal subjects, to a *zoo-
morphic* framework, in which knowledge about animals is used
to explain the human."[11] Some wildlife representations encour-
age us to think about the full spectrum of life, death, reproduc-
tion, and the interconnection of species. Others present charming
fables that moralize the difficulties of existence or try to use a
limited depiction of animal life to present a restricted image of
the biological limits of human society. Ultimately, I want to insist
that human beings are part of nature and that, while we may
be extraordinarily disruptive of habitats and ecosystems, it is a
conceptual mistake (with, as Haraway suggests, potentially lethal
consequences) to accept the framing of wildlife representations
that nature is something we can only authentically encounter
from the outside. Yet the persistence of this viewpoint suggests
that the camera has been a key instrument in structuring human-
animal relations; our thinking about animals takes place in a
space defined by wildlife representations. The difficulty is that
animal imagery is not transparent. It does not provide unmedi-
ated access to the animals depicted but rather structures its view-
ers' understandings of animals in particular ways. The centrality

of photography to contemporary discourse of animality suggests that we will only be able to think our relation to animals differently when we begin to grapple with the seductive force of the world picture that wildlife representations put forward. For this reason, it is important to trace not just why we look at animals but also how.

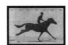

NOTES

PREFACE

1. "Millennial Animals: Theorizing and Understanding the Importance of Animals," University of Sheffield, Sheffield, England, July 29-30, 2000; and "Animal Arenas: Spaces, Performances, and Exhibitions," Annual Conference of the International Society for Anthrozoology, University College, London, August 20-21, 2002.

2. See, for example, Jacques Derrida, *The Animal That Therefore I Am*, ed. Marie-Louise Mallet, trans. David Wills (New York: Fordham University Press, 2008); Donna Haraway, *When Species Meet* (Minneapolis: University of Minnesota Press, 2008); Cary Wolfe, ed., *Zoontologies: The Question of the Animal* (Minneapolis: University of Minnesota Press, 2003); Cary Wolfe, *Animal Rites: American Culture, the Discourse of Species, and Posthumanist Theory* (Chicago: University of Chicago Press, 2003); and Steve Baker, *The Postmodern Animal* (London: Reaktion Books, 2000).

3. Matthew Brower, "Robert Bateman's Natural Worlds," *Journal of Canadian Studies* 33, 2 (Summer 1998): 66-77.

4. I think the closest American parallel to Bateman would be Norman Rockwell, a popular representational painter whose images often circulated in collectable formats and who was generally seen as epitomizing kitsch.

5. I should make clear that I don't think this comparison is fair to Bateman.

6. The reference was to the practice known as stashing. Because planters were paid per tree and spent their days wandering unsupervised (with random spot checks) in clear-cuts, there was a constant temptation to bury trees and count them as planted.

7. The relaxing of standards of cleanliness, dress, and sexual morality were often celebrated as core elements of tree-planting culture. The loosening of standards in regards to fairness, excrement, safety, and basic living conditions were, unfortunately, also sometimes part of the package.

8. This was often expressed normatively as "harden up—you're in the bush!"

9. John Berger, "Why Look at Animals?" in *About Looking* (New York: Vantage, 1980), 1–28.

10. "Images and Values," Association of Art Historians Twenty-fifth Annual Conference, University of Southampton, Southampton, April 9–11, 1999. The session was on the representation of animals in art and also included a contribution by Steve Baker.

INTRODUCTION

1. For an argument against this contemporary understanding of nature, which also acknowledges its seductive appeal, see William Cronon, "Getting Back to the Wrong Nature," in *Uncommon Ground,* ed. William Cronon (New York: W. W. Norton, 1995), 69–90.

2. On the political implications of this myth, see Donna Haraway, "A Cyborg Manifesto: Science, Technology, and Socialist Feminism in the 1980s," in *The Haraway Reader* (New York: Routledge, 2004), 7–45.

3. The fifth day of creation is, of course, the day animals were created in Genesis, chapter 1. It is the day before humans enter the garden. Genesis, chapter 2, reverses this order and has humans created before the animals and responsible for naming them.

4. John Berger, "Why Look at Animals?" in *About Looking* (New York: Pantheon, 1980), 1–28.

5. There is no position in the image's internal economy for the viewer to locate themselves in relation to the depicted animals. The camera's position does not present itself as an embodied human viewer.

6. The logic of animal imagery discussed by Berger parallels the logic of the spectacle articulated by Guy Debord in *The Society of the Spectacle.* The spectacle offers a commodified image in the place of a now inaccessible real relation. Guy Debord, *The Society of the Spectacle,* trans. Fredy Perlman and John Supak (Detroit: Red and Black Books, 1977).

7. Akira Mizuta Lippit, *Electric Animal: Toward a Rhetoric of Wildlife* (Minneapolis: University of Minnesota Press, 2000), 2–3.

8. Haraway, "A Cyborg Manifesto," 13.

9. Jonathan Burt, *Animals in Film* (London: Reaktion Books, 2002), 30.

10. Bill McKibben, "Curbing Nature's Paparazzi," *Harper's* 295, 1770 (November 1997): 19–24. See also Peter Friederici, ed., *Nature Photography: A Focus on the Issues* (Jamestown, N.Y.: Roger Tory Peterson Institute of Natural History, 1993).

11. James Elkins, *The Object Stares Back: On the Nature of Seeing* (San Diego: Harcourt, 1996), 33.

12. Bears that become accustomed to humans are either moved or killed as a prophylactic measure.

13. Derek Bousé has suggested that such behavior stems from the inappropriate conception of animals promulgated by wildlife representations. Derek Bousé,

"False Intimacy: Close-ups and Viewer Involvement in Wildlife Film," *Visual Studies* 18, 2 (2003): 123-32.

14. There were earlier photographs of animals in nature taken. These were mainly of birds on the nest (i.e., in a situation of limited mobility).

15. There were a number of technological developments necessary for photographing of animals in nature to become a regular pursuit. These include the development of dry plates, focal plane shutters, and fast lenses.

16. Berger, "Why Look at Animals?"

17. Jonathan Burt, "'Why Look at Animals?': A Close Reading," *Worldviews* 9, 2 (2005): 203-8.

18. Burt, *Animals in Film*.

19. Bousé, "False Intimacy."

20. While the focus of this book is on American animal photography, not all of the practices investigated are so easily geographically localized. For example, the development of the photographic blind involved English photographers as well as Americans. Consequently, while I focus on American photography, I also discuss other practices.

21. C. A. W. Guggisberg, *Early Wildlife Photographers* (London: David and Charles, 1977). Guggisberg's work approaches the topic from a largely British perspective, as does Margaret Harker's catalog essay on nineteenth-century animal photography. Margaret Harker, "Nineteenth Century Animal Photography," in *The Animal in Photography, 1893-1945*, ed. Alexandra Noble (London: The Photographers' Gallery, 1985), 24-35.

22. Guggisberg, *Early Wildlife Photographers*. See also Derek Bousé, *Wildlife Films* (Philadelphia: University of Pennsylvania Press, 2000), 195-222, which includes an appendix, "Chronological Highlights from the History of Wildlife and Natural History Films," that breaks down the history of wildlife film and photography in terms of firsts.

23. Bousé suggests that with the *Challenger* photographs "at last were images of real behavior in a natural setting." Bousé, *Wildlife Films*, 40. In the footnote accompanying this statement, he highlights his claims to precedence: "These dates are considerably earlier than the 1882 photograph of gannets in the Gulf of St. Lawrence, which are elsewhere said to be the earliest successful wildlife photographs taken in the field" (228n10). See Alan C. Jenkins, *The Naturalists: Pioneers of Natural History* (New York: Mayflower, 1978), 181.

24. The image circulated as a wood engraving. Guggisberg, *Early Wildlife Photographers*, 14.

25. Berger, "Why Look at Animals?"

26. Erica Fudge, "A Left-Handed Blow: Writing the History of Animals," in *Representing Animals*, ed. Nigel Rothfels (Bloomington and Indianapolis: Indiana University Press, 2002), 3-18.

27. Finis Dunaway and Gregg Mitman have discussed the American practice of camera hunting. Dunaway examines the practice in order to bring together environmental and cultural history. Finis Dunaway, "Hunting with the Camera: Nature Photography, Manliness, and Modern Memory, 1890-1930," *Journal of American Studies* 34 (2000): 207-30. Mitman examines the idea of hunting with a camera as it gets used in early-twentieth-century nature films. Gregg Mitman, *Reel Nature: America's Romance with Wildlife on Film* (Cambridge, Mass.: Harvard University Press, 1999). James Ryan has written incisively on the role of camera hunting in Africa. See James Ryan, "'Hunt-

ing with the Camera': Photography, Wildlife, and Colonialism in Africa," in *Animal Spaces, Beastly Places,* ed. Chris Philo and Chris Wilbert (London: Routledge, 2000), 203–21; and James Ryan, *Picturing Empire: Photography and the Visualization of the British Empire* (Chicago: University of Chicago Press, 1998). I argue in chapter 2 that the separate invention of camera hunting in North America operates differently than the European colonial practice he describes. The photographic blind, the enclosure used to take pictures of animals without their knowledge, is discussed only in how-to manuals. However, Helen MacDonald has written on the ethologist's blind and the production of objectivity. Helen MacDonald, "Covert Naturalists, or How Ethologists Hunt for Objectivity," paper presented at "The Practice of Objectivity in the Natural and Social Sciences," CPNSS/Max Planck Institute for the History of Science, London School of Economics, October 8–9, 2003. Although there have been several articles written about Abbott Thayer's attempt to construct a unified theory of animal coloration, little has been written on his use of photography. For an analysis that examines Thayer's photography, see Alexander Nemerov, "Vanishing Americans: Abbott Thayer, Theodore Roosevelt, and the Attraction of Camouflage," *American Art* 11, 2 (Summer 1997): 50–81.

28. Steve Baker, *The Postmodern Animal* (London: Reaktion Books, 2000).

29. Bill Nichols, "The Work of Culture in the Age of Cybernetic Systems," in *The New Media Reader,* ed. Noah Wardrip-Fruin and Nick Montfort (Cambridge, Mass.: MIT Press, 2003), 627–41.

30. Hilda Kean, *Animal Rights: Political and Social Change in Britain since 1800* (London: Reaktion Books, 1998); Burt, *Animals in Film;* Baker, *The Postmodern Animal.* I argue for the importance of Burt's work in Matthew Brower, "Jonathan Burt, *Animals in Film,*" *Society and Animals* 11, 3 (2003): 299–301.

31. See, for example, John Tagg, *The Burden of Representation* (Amherst: University of Massachusetts Press, 1988).

32. Tagg, *The Burden of Representation.*

33. Anne McCauley, "Writing Photography's History before Newhall," *History of Photography* 21, 2 (Summer 1997): 87–101, 87.

34. Compare Ted Cohen's insistence on the importance of photographic technique to the understanding of photographs. Ted Cohen, "What's Special about Photography?" *Monist* 71, 2 (1988): 292–305.

35. Similarly, Nigel Warburton argues against the reduction of photographic representation to a single kind. "My aim here is to point to one source of inadequacy in what most philosophers have written about photography: their fundamental mistake in grouping all photography together, as if all photography used the same mode of representation." Nigel Warburton, "Varieties of Photographic Representation: Documentary, Pictorial and Quasi-documentary," *History of Photography* 15, 3 (Autumn 1991): 203–10, 203.

36. Douglas Nickel, "History of Photography: The State of Research," *Art Bulletin* 83, 3 (September 2001): 548–58.

37. Marita Sturken and Lisa Cartwright, *Practices of Looking* (New York: Oxford University Press, 2001).

38. Geoffrey Batchen, *Burning with Desire: The Conception of Photography* (Cambridge, Mass.: MIT Press, 1997), 189.

39. Batchen, *Burning with Desire,* 182–83. See also Rosalind Krauss's equation of photography and deconstruction. "As I have said, at a certain point photogra-

phy in its precarious position as the false copy—the image that is resemblant only by mechanical circumstances and not by internal, essential connection to the model—served to deconstruct the whole system of model and copy, original and fake, first- and second-degree replication. For certain artists and critics, photography opened the closed unities of aesthetic discourse to the severest possible scrutiny turning them inside out. Given its power to do this—to put into question the whole concept of the uniqueness of the art object, the originality of its author, the coherence of the oeuvre within which it is made, and the individuality of so-called self-expression—given this power, it is clear that, with all due respect to Bourdieu, there is a discourse proper to photography; only, we would have to add, it is not an aesthetic discourse. It is a project of deconstruction in which art is distanced and separated from itself." Rosalind Krauss, "A Note on Photography and the Simulacral," in *The Critical Image: Essays on Contemporary Photography*, ed. Carol Squiers (Seattle: Bay Press, 1990), 15-27, 24.

40. To be fair, Batchen is aware of this difficulty. He acknowledges Foucault and Derrida's differences but argues that their public disagreements have "tended to obscure the many sources, aspirations, and practices that the two philosophers share." Batchen, *Burning with Desire*, 260-61n38. I do not disagree that these two thinkers share sources, but I do disagree with Batchen's conclusion that this shared set of influences is enough to allow the two discourses to easily translate into each other's concerns.

41. See Jacques Derrida, *Of Grammatology*, trans. Gayatri Chakravorty Spivak (Baltimore: Johns Hopkins, 1976). This attempt to align a larger logic with a specific process is paralleled by some versions of apparatus theory's attempt to treat the broader psychoanalytic process of suture as something specific to the operations of film.

42. Batchen, *Burning with Desire*, 185

43. Walter Benjamin, "The Work of Art in the Age of Mechanical Reproduction," in *Illuminations*, ed. Hannah Arendt, trans. Harry Zohn (New York: Schocken Books, 1968), 217-51; Rosalind Krauss, "Photography's Discursive Spaces" in *The Originality of the Avant-Garde and Other Modernist Myths* (Cambridge, Mass.: MIT Press, 1989), 131-50; Jonathan Crary, *Techniques of the Observer: On Vision and Modernity in the Nineteenth Century* (Cambridge, Mass.: MIT Press, 1996).

44. Pierre Bourdieu, Luc Boltanski, Robert Castel, and Jean Claude Chamboredon, *Un Art Moyen: Essai sur les Usages Sociaux se la Photographie* (Paris: Les Éditions de Minuit, 1965). Rosalind Krauss summarizes Bourdieu's position thusly: "But the notion that there is really an art photography as opposed to a primitive photography of common usage is, for Bourdieu, merely the extension of the expression of social distinctions. His feeling that art photography's difference is a sociological effect rather than an aesthetic reality stems from his conviction that photography has no aesthetic norms proper to itself; that it borrows its caché from the art movements with which various serious photographers associate themselves; that it borrows certain aesthetic notions from the other arts as well—notions like expressiveness, originality, singularity, and so forth—but that these notions are incoherent within what purports to be the critical discourse of photography; and that, finally, most photographic discourse is not inherently different from the judgment of the common man with his Instamatic. They reduce, on the one hand, to a set of

technical rules about framing, focus, tonal values, and so on, that are in the end purely arbitrary, and on the other hand, to a discussion of genre, which is to say the judgment 'it's an *x* or a *y*.'" Krauss, "A Note on Photography and the Simulacral," 20–21.

45. "But, of course, a judgment of genre is completely transparent to the photograph's represented objects. If a photograph belongs to the type landscape or portrait, that is because the reading of its contents allows it to be recognized and classed by type. And it is the nature of these types—according to Bourdieu's assessment of photographic practice—to be ruled by the rigid constraints of the stereotype." Krauss, "A Note on Photography and the Simulacral," 19. Cf. Warburton's embedding of judgments of genre in convention. Warburton argues against "the assumption that photographic representation is all the same sort of thing, and that it is relatively simple to say what a photograph is *of*: it is simply of whatever caused the image. I reject this view: you cannot make sense of the expression 'photograph of' without making an appeal to some kind of background of conventions and implicit intentions which are made apparent by the way the photograph is used." Warburton, "Varieties of Photographic Representation," 204.

46. This is not something specific to photographs. Discourses on nature almost always attempt to naturalize themselves as a way hiding their cultural construction. On the naturalization of nature photographs, see, for example, Estelle Jussim and Elizabeth Lindquist-Cock, *Landscape as Photograph* (New Haven, Conn.: Yale University Press, 1985).

47. See Berger, "Why Look at Animals?"

48. Roger Caillois, *Mask of Medusa*, trans. George Ordish (New York: Clarkson Potter, 1964); Kaja Silverman, *Male Subjectivity at the Margins* (New York: Routledge, 1992), 125–56; Kaja Silverman, *Threshold of the Visible World* (New York: Routledge, 1996), 125–227; and Kaja Silverman, *World Spectators* (Palo Alto, Calif.: Stanford University Press, 2000), 130–40.

1. A RED HERRING

1. The epigram is by Thomas Hood.

2. On Llewelyn's family history, see David Painting, "J. D. Llewelyn and His Family Circle," *History of Photography* 15, 3 (Autumn 1991): 180–85. On Llewelyn's photography, see Richard Morris, *John Dillwyn Llewelyn, 1810–1882: The First Photographer in Wales* (Cardiff: Welsh Arts Council, 1980).

3. On the history of the estate, see Richard Morris, *Penllergare: A Victorian Paradise* (Llandeilo: Friends of Penllergare, 1999).

4. On the temporality of the wildlife photograph, see John Berger, "Why Look at Animals?" in *About Looking* (New York: Vantage, 1980), 1–28.

5. Estelle Jussim and Elizabeth Lindquist-Cock, *Landscape as Photograph* (New Haven, Conn.: Yale University Press, 1985), 31. Jussim and Lindquist-Cock also suggest that this reading may be the result of "some intense human desire typical of the alienated, overcrowded twentieth century," implying that, at the very least, a particular kind of historical consciousness is necessary for such a reading.

6. On deep time and its relation to visual representation, see Martin J. Rudwick, *Scenes from Deep Time* (Chicago: University of Chicago Press, 1992).

7. On the inhuman quality of scientific time scales, see Jean-François Lyotard,

The Inhuman, trans. Geoffrey Bennington and Rachel Bowlby (Palo Alto, Calif.: Stanford University Press, 1992).

8. Bruno Latour, *We Have Never Been Modern*, trans. Catherine Porter (Cambridge, Mass.: Harvard University Press, 1997).

9. On deep nature and its predication on human absence, see Peter van Wyck, *Primitives in the Wilderness: Deep Ecology and the Absent Human Subject* (Albany: SUNY Press, 1994).

10. This is related to the untrue but prevalent view that animals do not undergo cultural changes in habit or style except when impacted by natural disaster or human intervention (suburbanization, fire, deforestation). I owe this insight to Lisa Cartwright.

11. It should be noted that the materiality of the photograph will provide some historicity. For example, the use of sepia tone provides a dated quality to the image regardless of what it represents.

12. Carol Freeman, "Imaging Extinction: Disclosure and Revision in Photographs of the Thylacine (Tasmanian Tiger)," *Society and Animals* 15, 3 (2007): 241–56.

13. Charles Millard, "Images of Nature: A Photo Essay," in *Nature and the Victorian Imagination*, ed. U. C. Knoepflmacher and G. B. Tennyson (Berkeley: University of California Press, 1977), 14–31.

14. Live, that is, at the time of the photo, the heron being certainly dead now. On the relation between the temporality of the photograph and death, see Roland Barthes *Camera Lucida: Reflections on Photography*, trans. R. Howard (New York: Hill and Wang, 1981).

15. Edmund White, "Animals, Vegetables and Minerals: The Lure and Lore of Nature Photography," in *Photographing Nature* (New York: Time-Life Books, 1971), 13–16, 13.

16. The depiction of live animals continues to be a problem for wildlife artists. See Matthew Brower, "Robert Bateman's Natural Worlds," *Journal of Canadian Studies* 33, 2 (Summer 1998): 98–128.

17. See Nicholas Hammond, *Twentieth-Century Wildlife Artists* (London: Croom Helm Ltd., 1986), 18; and Christopher Hume, *From the Wild* (Toronto: Summerhill Press, 1986), 15.

18. Hammond, *Twentieth Century Wildlife Artists*, 14. Audubon was simply the most programmatic example of this phenomenon. He killed his subjects, wired them to grids for accurate depiction, and then would often eat them when done. Hammond, *Twentieth Century Wildlife Artists*, 19. See also Hume, *From the Wild*, 15.

19. Andrew Lanyon, "Frontispiece: Deer Parking," *History of Photography* 8, 3 (July–September 1984): 168.

20. It is only post-ecology that the live animal comes to be a marker for the health (reality) of nature. We might position Rachel Carson's *Silent Spring* as the origin of a North American mass consciousness of the animal as the marker of ecological health. Rachel Carson, *Silent Spring* (Boston: Houghton Mifflin, 2002).

21. U. C. Knoepflmacher and G. B. Tennyson, introduction to *Nature and the Victorian Imagination*, ed. U. C. Knoepflmacher and G. B. Tennyson, xvii–xxiii (Berkeley: University of California Press, 1977), xxi.

22. On the conceptual role played by prehuman nature in contemporary ecological thought, see van Wyck, *Primitives in the Wilderness*.

23. Bill Readings discusses the manner in which Wordsworth's inscription of meaning into the landscape underwrote its capitalistic exploitation through tourism. Bill Readings, *The University in Ruins* (Cambridge, Mass.: Harvard University Press, 1996), 96. I discuss the implications of Readings's argument for thinking animal imagery's charging of the wild animal with symbolic meaning in Brower, "Robert Bateman's *Natural Worlds.*"

24. On the use of animals as elements of the picturesque, see also Basil Taylor, *Animal Painting in England: From Barlow to Landseer* (Harmondsworth, Middlesex: Penguin Books, 1955).

25. The image is reproduced in Lanyon, "Frontispiece: Deer Parking," 168.

26. The calotype photographic process was patented by Talbot in 1841.

27. Steve Baker, *The Postmodern Animal* (London: Reaktion Books, 2000), 62.

28. Harriet Ritvo, *The Animal Estate* (Cambridge, Mass: Harvard University Press, 1987), 205-88.

29. Miles Orvell, *The Real Thing: Imitation and Authenticity in American Culture, 1880-1940* (Chapel Hill: University of North Carolina Press, 1989), 77.

30. Orvell's caution in many ways parallels John Tagg's arguments on the historically constructed nature of photographic meaning. John Tagg, *The Burden of Representation* (Amherst: University of Massachusetts Press, 1988).

31. Among Llewelyn's images is a photograph of a sporting print that may be by Landseer. John Dillwyn Llewelyn, *Stag Hunters*, ca. 1850. The image is in the Swansea Museum: item # SWASM:SM1987.844.4, www.swanseaheritage.net.

32. The aim of emphasizing the deer's nobility could perhaps be ascribed to the taxidermist, but Llewelyn's composition of the photograph with its emphasis on the deer's head and antlers indicates his complicity in this construction.

33. The difference in the function between Landseer's and Llewelyn's deer could also be because Llewelyn's deer is dead. However, what is decisive is the shift in the image's function. The deer fails to perform as an evocation of an idealized nature. Treating this failure as productive, I argue that the image presents a different conception of the animal and of nature. I would further add that it is due to the changed conception of the animal and nature that Landseer's deer are so often referred to as sentimental and anthropomorphic.

34. Berger, "Why Look at Animals?"

35. James R. Ryan, "'Hunting with the Camera': Photography, Wildlife, and Colonialism in Africa," in *Animal Spaces, Beastly Places*, ed. Chris Wilbert and Chris Philo, 203-21 (London: Routledge, 2000), 214.

36. Kitty Hauser, "Coming Apart at the Seams: Taxidermy and Contemporary Photography," *Make: The Magazine of Women's Art* 82 (December 1998-January 1999): 8-11, 8.

37. In locating the relationship between photography and taxidermy as being between *animal* photography and taxidermy, Ryan backs off of Hauser's larger claims. Hauser's arguments operate on the level of photography and taxidermy's structure of representation—that both are "non-consensual" appropriations of surfaces from the world intimately related to death. Hauser, "Coming Apart at the Seams."

38. John MacKenzie, *The Empire of Nature: Hunting, Conservation, and British Imperialism* (Manchester: Manchester University Press, 1988).

39. On the depiction of landscape as an imperial form, see W. J. T. Mitchell, "Landscape and Imperial Power," in *Landscape and Power*, ed. W. J. T. Mitchell (Chicago: University of Chicago Press, 1992), 5-34.

40. Llewelyn made this operation explicit in his 1857 photograph *Still Life of Pheasant and Fern*. The image is in the Swansea Museum: item # SWASM: SM1987.846.104, www.swanseaheritage.net.

41. Millard suggests that picturesque photography was localized in England and ended by the mid-1880s as the development of photographic technology made the practice of photography widespread.

42. C. A. W. Guggisberg, *Early Wildlife Photographers* (London: David and Charles, 1977); Margaret Harker, "Animal Photography in the Nineteenth Century," in *The Animal in Photography, 1843–1985*, ed. Alexandra Noble (London: The Photographers' Gallery, 1986), 24–35. Cynthia Chris makes a similar argument: "Staging such scenes with dead animals must have seemed like the next best thing to actually photographing a live animal in the out-of-doors, and it demonstrated fine craftsmanship in several technologies at once." Cynthia Chris, *Watching Wildlife* (Minneapolis: University of Minnesota Press, 2006), 5.

43. The process was based on Talbot's earlier method of photogenic drawing.

44. Talbot's insistence on patenting and licensing his process also contributed to its lesser adoption. Daguerre's invention was purchased by the French government and made a gift to the world.

45. Collodion remained the standard photographic process until the introduction of effective dry plates in 1878.

46. Despite these seeming advantages, the oxymel process was not widely adopted.

47. On the development of taxidermy, see Karen Wonders, *Habitat Dioramas: Illusions of Wilderness in Museums of Natural History* (Upsala: Acta Universitatis Upsaliensis, 1993). On the taxidermist's pursuit of the illusion of lifelikeness, see Jane Desmond, "Displaying Death, Animating Life: Changing Fictions of 'Liveness' from Taxidermy to Animatronics," in *Representing Animals*, ed. Nigel Rothfels (Bloomington: Indiana University Press, 2002), 159–79.

48. See Geoffrey Batchen, *Burning with Desire: The Conception of Photography* (Cambridge, Mass.: MIT Press, 1997) on thinking photography as a non-psychoanalytic social desire.

49. However, photographs of stuffed animals were a key component of Llewelyn's practice in a way that they were not for other photographers.

50. Graham Smith, *Disciples of Light: Photographs from the Brewster Album* (Los Angeles: J. Paul Getty Museum, 1993). For information on the Adamson brothers and their practice of photography, see A. D. Morrison-Low, "Brewster, Talbot, and the Adamsons: The Arrival of Photography in St. Andrews," *History of Photography* 25, 2 (Summer 2001): 130–41.

51. David Bruce, *Sun Pictures: The Hill-Adamson Calotypes* (Greenwich, Conn.: New York Graphic Society, 1973); J. Paul Getty Museum, *In Focus: Hill and Adamson* (Los Angeles: J. Paul Getty Museum, 1999).

52. According to Harker, the negative is in the Talbot Museum in Lacock. "Animal Photography in the Nineteenth Century," 24.

53. The image is in the Swansea Museum: item # SWASM:SM1987.845.4, www.swanseaheritage.net.

54. The image is in the Swansea Museum: item # SWASM:SM1987.845.40, www.swanseaheritage.net.

55. Llewelyn, *The Great Horned Owl—Clifton Zoological Gardens, Bristol*, March 1854, Swansea Museum: item # SWASM:SM1987.846.9; Llewelyn, *Lion Cubs at the*

Zoological Gardens, Clifton, March 16, 1854, Swansea Museum item: # SWASM: SM1987.846.5, www.swanseaheritage.net.

56. Guggisberg, *Early Wildlife Photographers*, 13.

57. Fenton is perhaps best known for his photographs of the Crimean War. Roger Fenton, Helmut Gernsheim, and Alison Gernsheim, *Roger Fenton, Photographer of the Crimean War: His Photographs and His Letters from the Crimea, with an Essay on His Life and Work* (London: Secker and Warburg, 1954).

58. Guggisberg, *Early Wildlife Photographers*, 12–13. James Chapman, *Travels in the Interior of South Africa*, 1868.

59. Carol Armstrong, *Scenes in a Library: Reading the Photograph in the Book, 1843–1875* (Cambridge, Mass.: MIT Press, 1998). See also Douglas Nickel, *Francis Frith in Egypt and Palestine: A Victorian Photographer Abroad* (Princeton, N.J.: Princeton University Press, 2003).

60. Elaine A. Evans, "In the Sandals of Pharoah: James Henry Breasted and the Stereoscope," McClung Museum Occasional Paper, http://mcclungmuseum. utk.edu/.

61. Harker, "Nineteenth Century Animal Photography," 25.

62. Elizabeth Anne McCauley, *A. A. E. Disdéri and the Carte de Visite Portrait Photograph* (New Haven, Conn.: Yale University Press, 1985); Geoffrey Batchens, "Dreams of Ordinary Life: Cartes-de-visite and the Bourgeois Imagination," in *Image and Imagination*, ed. Martha Langford (Montreal: McGill-Queens University Press, 2005).

63. Harker, "Nineteenth Century Animal Photography," 27–28.

64. Léon Cremière, *La Venerie Francaise* (Paris: J. Rothschild, 1865). *Venerie*, which uses dogs to hunt down animals without firearms, is similar to the English foxhunt. On the human-animal relation in the foxhunt, see Garry Marvin, "Research, Representations and Responsibilities: An Anthropologist in the Contested World of Foxhunting," in *Applications of Anthropology: Professional Anthropology in the Twenty-First Century*, ed. Sarah Pink (Oxford: Berghahn Books, 2006), 191–208.

65. Guggisberg, *Early Wildlife Photographers*, 14–15. Derek Bousé, *Wildlife Films* (Philadelphia: University of Pennsylvania Press, 2000).

66. Guggisberg, *Early Wildlife Photographers*, 17–18.

67. Lodge published a number of books on bird life in the early twentieth century.

68. Richard Kearton, *British Birds' Nests: How, Where and When to Find and Identify Them* (London: Cassell, 1895).

69. Jonathan Burt, "The Wheel of Nature: Animals in Early Films from the Lumière Brothers to Charles Urban's '*Evolution,*'" "Representing Animals," University of Wisconsin, Milwaukee, April 13–15, 2000. See also Jonathan Burt, *Animals in Film* (London: Reaktion Books, 2002).

70. On Marey and historical structures of visualization, see Marta Braun, *Picturing Time: The Work of Etienne-Jules Marey (1830–1904)* (Chicago: University of Chicago Press, 1992); and Lisa Cartwright, *Screening the Body: Tracing Medicine's Visual Culture* (Minneapolis: University of Minnesota Press, 1995). On Muybridge and visualization, see Marta Braun, "The Expanded Present: Photographing Movement" in *Beauty of Another Order: Photography in Science*, ed. Ann Thomas (New Haven, Conn.: Yale University Press, 1997). On the historically specific nature of vision and its relation to the camera, see Jonathan Crary, *Techniques of the Observer* (Cambridge, Mass.: MIT Press,

1990); and Martin Jay, "Photo-unrealism: The Contribution of the Camera to the Crisis of Ocularcentrism," in *Vision and Textuality*, ed. Stephen Melville and Bill Readings (Durham, N.C.: Duke University Press, 1995), 344–60. For an oddly dissenting view on the relation between photography (specifically Marey and Muybridge) and vision, see James Elkins, *The Object Stares Back: On the Nature of Seeing* (San Diego: Harcourt, 1996).

71. Braun, *Picturing Time*, 45.

72. Ibid., 45.

73. Lewis S. Brown, "Eadweard Muybridge and His Work," in *Eadweard Muybridge, Animals in Motion* (Mineola, N.Y.: Dover Publications, 1957), 9–11, 10.

74. Deac Rossell, *Ottomar Anschütz and His Electrical Wonder* (Hastings: The Projection Box, 1997); Helmut Kummer, *Ottomar Anschütz, Ein deutscher Photopionier* (Munich: Institut für Photogeschichte, 1983).

75. Copies of the roe deer photographs are in the collection of the National Gallery of Australia. See, for example, Ottomar Anschütz, *Side View with Two Faun on Right*, 1886, Accn No: NGA 2004.7.18.

76. Beaumont Newhall, "Photography and the Development of Kinetic Visualization," *Journal of the Warburg and Courtauld Institutes* 7 (1944): 40–45.

77. Jonathan Crary, *Suspensions of Perception: Attention, Spectacle, and Modern Culture* (Cambridge, Mass.: MIT Press, 2001), 138–48. Joel Snyder, "Visualization and Visibility," in *Picturing Science, Producing Art*, ed. Caroline A. Jones and Peter Galison (London: Routledge, 1998), 379–97, 394–96.

78. Burt, *Animals in Film*, 105.

79. Unlike humans, who could be made to sit still for the camera, animals were the quintessential "life in motion" because they were not domestic; they could not be easily captured.

2. CAMERA HUNTING IN AMERICA

1. James B. Carrington, "In the Open," *Book Buyer* (July 1900): 455–59, 455.

2. The advocates of camera hunting often stressed their bona fides as hunters, arguing that their preference for the camera was not a product of squeamishness on their part.

3. Susan Sontag, *On Photography* (New York: Anchor Books, 1977).

4. On contemporary wildlife photography, see John Berger, "Why Look at Animals?" in *About Looking* (New York: Pantheon, 1980), 1–28; and Peter Friederici, ed., *Nature Photography: A Focus on the Issues* (Jamestown, N.Y.: Roger Tory Peterson Institute of Natural History, 1993).

5. See C. A. W. Guggisberg, *Early Wildlife Photographers* (London: David and Charles, 1977).

6. Worth Mathewson, *William L. Finley: Pioneer Wildlife Photographer* (Corvallis: Oregon State University Press, 1986), 2.

7. The collodion wet-plate process was invented in 1851. It used glass plates coated with a mixture of ether and gun cotton for the negative. The plates needed to be exposed and developed before the mixture dried; hence the name wet plate.

8. Philip Stokes, "Trails of Topographic Notions: Expeditionary Photography in the American West," in *Views of American Landscapes*, ed. Mick Gidley and Robert Lawson-Peebles (Cambridge: Cambridge University Press, 1989), 64–80, 66.

9. Ibid., 74.

10. Estelle Jussim, *Visual Communication and the Graphic Arts: Photographic Technologies in the Nineteenth Century* (New York: R. R. Bowker Company, 1974), 8.

11. See Weston Naef's description of the labor involved in developing images in the 1860s. Weston J. Naef, *Era of Exploration* (Buffalo: Buffalo Fine Arts Academy, 1975), 71.

12. Some mid-nineteenth-century books were illustrated by photographs, but it was necessary to glue them into specially inserted pages within the text as they could not be printed from the same plate as the text.

13. Jonathan Crary, *Suspensions of Perception: Attention, Spectacle, and Modern Culture* (Cambridge, Mass.: MIT Press, 2001), 117. The classic work on this topic is Walter Benjamin, "The Work of Art in the Age of Mechanical Reproduction," in *Illuminations*, ed. Hannah Arendt, trans. Harry Zohn (New York: Schocken Books, 1968), 217–51.

14. John Tagg, *The Burden of Representation* (Amherst: University of Massachusetts Press, 1988), 56.

15. Peter B. Hales, *William Henry Jackson and the Transformation of the American Landscape* (Philadelphia: Temple University Press, 1988), 198.

16. Paul Sternberger, *Between Amateur and Aesthete: The Legitimization of Photography as an Art in America, 1880–1900* (Albuquerque: University of New Mexico Press, 2001).

17. Rosalind Krauss, "Photography's Discursive Spaces: Landscape/View," in *The Originality of the Avant-Garde and Other Modernist Myths* (Cambridge, Mass.: MIT Press, 1989), 131–50.

18. Michel Foucault, *The Archeology of Knowledge*, trans. A. M. Sheridan (New York: Harper and Row, 1976). However, Andrew Hershberger convincingly argues that Krauss misinterprets Foucault's concept of a discursive formation. Andrew Hershberger, "Krauss's Foucault and the Foundations of Postmodern History of Photography," *History of Photography* 30, 1 (Spring 2006): 55–67. Rather than following Hershberger's implied suggestion of abandoning Krauss's formulation as fatally flawed, my aim here is rearticulate Krauss's concept to preserve its usefulness for the history of photography.

19. Krauss, "Photography's Discursive Spaces," 150.

20. Joel Snyder, "Territorial Photography," in *Landscape and Power*, ed. W. J. T. Mitchell (Chicago: University of Chicago Press, 1994), 175–202.

21. Robin Kelsey, "Viewing the Archive: Timothy O'Sullivan's Photographs for the Wheeler Survey," *Art Bulletin* 85, 4 (December 2003): 702–23.

22. Estelle Jussim and Elizabeth Lindquist-Cock, *Landscape as Photograph* (New Haven, Conn.: Yale University Press, 1985).

23. François Brunet, "Revisiting the Enigmas of Timothy O'Sullivan: Notes on the William Ashburner Collection of King Survey Photography at the Bancroft Library," *History of Photography* 31 (Summer 2007): 97–133.

24. This limitation was overcome by the late 1890s.

25. The difficulty of obtaining exposures varied by species. Some, like the shorebirds photographed by Carlton Watkins in the 1870s, adjusted easily to human presence and allowed a relatively straightforward approach. Others, like deer, remained skittish and were difficult to photograph.

26. See chapter 3, this volume.

27. For a discussion of this method of wildlife photography, see E. C. Park, *The*

Use of the Set Camera as a Technique in Wildlife Photography (master's thesis, Oregon State College, 1959).

28. Anon., "A Wild Deer Takes Its Own Portrait," *Scientific American*, May 8, 1897, 296.

29. Bernard Meiklejohn, "Adventures in Wildlife Photography: The Story of Mr. W. E. Carlin's Successful Camera-hunting for Big Game in Idaho and Florida," *World's Work*, May 4, 1902, 2080–88, 2083.

30. Berger, "Why Look at Animals?" 14. For a discussion of the ideology of invisibility in animal photographs presented from the viewpoint of practicing photographers, see the roundtable discussion by George Lepp, Helen Longest-Slaughter, Arthur Morris, and Townsend Dickinson, "Are We Governed by a Code of Ethics?" in Friederici, *Nature Photography*, 7–10.

31. The use of the pronoun *his* is intended to mark the connection between hunting and masculinity in this period. For a period argument against women and hunting, see M. G. Fawcett, "How Men Make Women Unwomanly: Attitude toward Hunting," *Review of Reviews*, August 8, 1893, 208. However, there is *no* intrinsic or necessary connection between hunting and masculinity. For a compelling argument against the simple equation of hunting with men, see Mary Zeiss Stange, *Woman the Hunter* (Boston: Beacon Press, 1997). For an argument against the deeply embedded anthropological theory of man the hunter (and woman the gatherer), see Melanie G. Wiber, *Erect Men and Undulating Women* (Waterloo, Ont.: Wilfrid Laurier University Press, 1998), 17–46.

32. Stringing up the deer is not solely done for display. The deer's throat must be cut and the animal hung in order for the blood to drain. This prevents the meat from spoiling.

33. George Shiras 3d, *Hunting Wildlife with Camera and Flashlight: A Record of Sixty-Five Years' Visits to the Woods and Wilds of North America* (Washington, D.C.: National Geographic Society, 1935, 1936), 2 vols., vol. 1, 18.

34. Linda Kalof and Amy Fitzgerald, "Reading the Trophy: Exploring the Display of Dead Animals in Hunting Magazines," *Visual Studies* 18, 2 (Spring 2003): 112–22.

35. On photographic captions, see Roland Barthes, "The Photographic Message," in *Image Music Text*, trans. Stephen Heath (New York: Hill and Wang, 1977), 15–31.

36. On restricted and general economies, see Georges Bataille, *The Accursed Share: Volume I*, trans. Robert Hurley (Cambridge: Zone Books, 1991).

37. James R. Ryan, "'Hunting with the Camera': Photography, Wildlife and Colonialism in Africa," in *Animal Spaces, Beastly Places*, ed. Chris Philo and Chris Wilbert (London: Routledge, 2000), 203–21, 206.

38. Mary Wallihan provides the following description of the photograph: "In the fall of 1891 my husband told me I must get the winter's meat while he took photographs of the deer. So we commenced in the usual way by saddling our ponies and starting out with rifle to kill the deer and camera to take the photos. The first day I got nothing. The second I lost a fine buck because I had to shoot past my husband, as I thought, too close for safety. Then I moved a hundred yards or more from him. I had hardly got ready before I saw two fine bucks and a number of does and fawns. I confess I was a little selfish—I wanted both bucks very much. As I had lost the large one I thought two with one shot would please my husband very much. So

quicker than I can tell it I fired and killed them both at 130 yards with one shot." A. G. Wallihan and Mary A. Wallihan, *Hoofs, Claws and Antlers of the Rocky Mountains* (Denver: Thayer, 1902), unpaginated.

39. In some cases the animal represents through the hunter's prowess that of a larger group that they embody. Ryan, "'Hunting with the Camera.'"

40. David Toews clarified this distinction for me in a personal communication.

41. Some sporting trophies do contain an indexical relation to past greatness— this is particularly the case when it is the same trophy that continues to circulate. However, there is still no indexical connection between, for example, the activity of playing hockey and the production of the Stanley Cup.

42. Interestingly, one of the strategies employed against the use of animal parts in fashion has been to reassert the indexical link between the displayed body part and a dead animal. This strategy was successfully used in the Audubon Society's campaign against millinery feathers and continues to be deployed in PETA's campaigns against fur. Animal bodies and parts also circulate within ritual economies. A contemporary example would be the use of eagle feathers in Native American ceremonies. However, in ritual circulation the animal parts participate more in what Benjamin calls "cult value" than they do in economies of display.

43. Thus the notorious status of fish stories, in which, absent evidence, the fish is free to grow in stature.

44. Ryan, "'Hunting with the Camera.'"

45. Daniel Justin Herman, *Hunting and the American Imagination* (Washington, D.C.: Smithsonian Institution Press, 2001).

46. As an indication of hunting's conceptual and practical importance to early Americans, we might note that the right to hunt was enshrined in the state constitutions of Vermont and Pennsylvania. Thomas A. Lund, "Early American Wildlife Law," *New York University Law Review* 51, 5 (November 1976): 703–30, 712–13.

47. In England tenants had no right to game and could be hanged for harming a deer that was eating their crops. Lund, "Early American Wildlife Law," 703. In contrast, the United States embraced a policy of free taking in which game belonged to all and could be taken by anyone on any piece of unfenced property. Peter Mathiessen notes, however, that despite the embrace of the principle of free taking, every colony but Georgia had established a hunting season for deer by the time of the Revolution. Peter Mathiessen, *Wildlife in America* (New York: Viking Press, 1987), 65. For a discussion of the legal and policy decisions surrounding the public's right to game and the government's right to regulate their access, see James A. Tober, *Who Owns the Wildlife: The Political Economy of Conservation in Nineteenth-Century America* (Westport, Conn.: Greenwood Press, 1981). This access was gradually limited by the enactment of game laws confining shooting to a set hunting season and banning certain methods of hunting (like jacklighting). For a discussion of early New York game laws, see Hugh C. MacDougall, "The Pioneers and New York Game Laws," *James Fennimore Cooper Society Newsletter* 6, 3 (December 1995): 5–6. For a broader discussion of American game laws, see Karl Jacoby, *Crimes against Nature: Squatters, Poachers, Thieves, and the Hidden History of American Conservation* (Berkeley: University of California Press, 2001); and Louis Warren, *The Hunter's Game: Poachers and Conservationists in Twentieth-Century America* (New Haven, Conn.: Yale University Press, 1997).

For a discussion of hunting in the United Kingdom, see Gavin Sprott, "From Fowling to Poaching," in *Tools and Traditions: Studies in European Ethnography*, ed. Hugh Cheape (Edinburgh: National Museum of Scotland, 1993), 125–31; and Roger Manning, "Unlawful Hunting in England, 1500–1640," *Forest and Conservation History* 38, 1 (1994): 16–23.

48. Tober, *Who Owns the Wildlife*, 43.

49. Herman, *Hunting and the American Imagination*.

50. Frederick Jackson Turner, "The Significance of the Frontier in American History," in *Frontier and Section: Selected Essays of Frederick Jackson Turner* (New York: Prentice-Hall, 1961), 199–227.

51. These practices were adduced as a model for American hunting practices in the second half of the nineteenth century, most notably by Henry William Herbert. John Reiger, "The Merging of Sport, Art, and Conservation in Late Nineteenth-Century America," in *Value in American Wildlife Art*, ed. William V. Mealy and Peter Friederici (Jamestown, N.Y.: Roger Tory Peterson Institute of Natural History), 44–51, 45. See also John Reiger, *American Sportsmen and the Origins of Conservation* (New York: Winchester Press, 1975), 11–45.

52. On the celebration of massive kills as the epitome of the English "sportsman's" prowess and its late-nineteenth-century revision in terms of contest, see Harriet Ritvo, *The Animal Estate: The English and Other Creatures in the Victorian Age* (Cambridge, Mass.: Harvard University Press, 1987), 243–88.

53. Reiger, "The Merging of Sport," 45.

54. Reiger acknowledges that not all middle-class hunters conformed to the code of the sportsman. Ibid., 46.

55. Matt Cartmill, *A View to a Death in the Morning: Hunting and Nature through History* (Cambridge, Mass.: Harvard University Press, 1993), 232.

56. Reiger, *American Sportsmen*, 51–77.

57. Reiger, "The Merging of Sport," 45.

58. Cartmill, *A View to a Death*, 233.

59. On the rise of animal protection societies in America, see Lisa Mighetto, *Wild Animals in American Thought and Culture, 1870s–1930s* (Ph.D. diss., University of Washington, 1986). On the British origins of animal protection societies, see Ritvo, *The Animal Estate*, 125–66; and Hilda Kean, *Animal Rights: Political and Social Change in Britain since 1800* (London: Reaktion Books, 1998). On the early history of the conservation movement, see Reiger, *American Sportsmen*, 51–72.

60. Matt Cartmill describes the conflict as between a Darwinian camp who value nature because it is healthy and a Romantic who value nature because it is holy. Cartmill, *A View to a Death*, 149–50.

61. Ralph H. Lutts, *The Nature Fakers: Wildlife, Science, and Sentiment* (Golden, Colo.: Fulcrum Publishing, 1990), 23.

62. On the slow evolution of American attitudes toward predators, see Mighetto, *Wild Animals*, 134–67. On the split between preservationists (who opposed all exploitation of nature and animals) and conservationists (who supported managed use of natural resources) and the resulting demonization of hunters, see Lutts, *Nature Fakers*, 21–25.

63. Lutts, *Nature Fakers*, 15.

64. Ibid., 16.

65. George Shiras 3d, *Doe, Forest and Stream*, September 8, 1892, 203.

66. George Shiras 3d, "Still Hunting with a Camera," *Forest and Stream*, September 8, 1892, 203.

67. In his introduction to Shiras's 1935 book Edward Nelson lays out his sense of Shiras's importance as a photographic innovator: "Thus George Shiras, 3d, the original advocate of wildlife photography, was (1) the first to photograph in daytime wild animals or birds from a canoe or blind; (2) the first to get automatic daylight pictures of wild animals by their touching a string across a trail or pulling on bait attached to a string operating the shutter of a camera; (3) the first to operate the camera at a distance by a string running from a blind; (4) the first to invent a means for picturing animals from a canoe by hand flashlight; (5) the first to invent a means to obtain automatic flashlight photographs for which the animals or birds fired the flash; (6) the first to use two flashlights and two cameras, one set picturing the animal when quiescent, a second later, showing the animal in action when alarmed by the explosion of the first flashlight; and (7) the first to practice with the camera by means of a specially devised apparatus by which wild fowl and shore birds can be photographed when flying from 50 to 75 miles an hour." Edward Nelson, foreword to *Hunting Wildlife with Camera and Flashlight: A Record of Sixty-Five Years' Visits to the Woods and Wilds of North America*, by George Shiras 3d (Washington, D.C.: National Geographic Society, 1935, 1936), 2 vols., vol. 1, v–xviii, x.

68. Biographical information on Shiras is drawn from Marcia J. Belveal, "George Shiras III," *History of Photography Monograph Series* 20 (Arizona State University, 1985).

69. *Forest and Stream* was founded in 1873 and continued publishing until 1930 when it merged with *Field and Stream*.

70. George Bird Grinnell, "Rod and Gun and Camera," *Forest and Stream*, April 21, 1892, 369.

71. George Bird Grinnell, "Snap Shots," *Forest and Stream*, January 19, 1893.

72. Edward Bierstadt was the brother of the more famous Albert Bierstadt, a renowned painter of landscape imagery. He produced a number of illustrated books and numerous etchings. He trained Carlton Watkins in the Albertype process in 1873 and patented a stereoscopic viewer in 1876.

73. At the time Roosevelt had returned to politics and was a member of the U.S. Civil Service Commission.

74. Roosevelt was a friend of Grinnell's and was nationally known as an expert woodsman. Besides cofounding the Boone and Crockett Club in 1887, Roosevelt and Grinnell published several books together, including the book *American Big Game Hunting* later that same year. Theodore Roosevelt and George Bird Grinnell, *American Big Game Hunting* (New York: Forest and Stream, 1893).

75. Shiras, "Still Hunting with a Camera," 203.

76. The dates for the beginning of Shiras's practice are uncertain. Belveal claims that Shiras began his photography in 1887. Guggisberg places the beginning of his photography in 1889 following Shiras's 1936 claim in *Hunting Wildlife with Flashlight and Camera*. However, in his letter to the editor of 1892, Shiras claimed to have begun photographing in 1886. I have decided to give precedence to his earliest claim while acknowledging that the beginnings of his animal photography are uncertain. What is clear is that 1892 marked Shiras's first publication on animal photography—a letter to the editor of *Forest and Stream*.

77. The low ratio of successful images to spoiled plates is indicative of the difficulty of animal photography at the time.

78. Shiras published two more essays on camera hunting in the 1890s: George Shiras 3d, "Hunting with a Camera," *New York Sun*, August 25, 1895, 12; and George Shiras 3d, "A Harmless Sport—Hunting with the Camera," *Recreation*, March 1896. George Shiras 3d, "Hunting with a Camera," *Independent* 52 (June 7, 1900): 1364-68.

79. George Shiras 3d, "Photographing Wild Game with Flashlight and Camera," *National Geographic*, July 17, 1906, 366-423. (This issue proved so popular it had to be reprinted.) George Shiras 3d, "One Season's Gamebag with the Camera," *National Geographic*, July 19, 1908, 387-446. George Shiras 3d, "Wild Animals That Took Their Own Pictures by Day and by Night," *National Geographic*, July 24, 1913, 763-84.

80. "Dr. G. B. Grinnell, Naturalist, Dead," *New York Times*, April 12, 1938, 23.

81. George Bird Grinnell, "Hunting with a Camera," *Forest and Stream*, May 5, 1892, 427.

82. Rowland Robinson, "Hunting without a Gun," *Forest and Stream*, August 22, 1889, 82-83. Grinnell mentions the article obliquely in "Hunting with a Camera" when he writes, "The charms of 'hunting without a gun' have been dilated on in *Forest and Stream* by one of the most graceful of American writers" (427).

83. Yet, in this editorial, Grinnell did not link the tangible results produced by the camera directly with hunting trophies.

84. George Bird Grinnell, "Shooting without a Gun," *Forest and Stream*, October 6, 1892, 287.

85. George Bird Grinnell, "Snap Shots," *Forest and Stream*, November 19, 1891, 345.

86. Pigarth, "A Gun Camera," *Forest and Stream*, August 4, 1892, 92.

87. For a discussion of the history of camera guns, that is, cameras whose workings were based on those of firearms, see Marta Braun, *Picturing Time: The Work of Etienne-Jules Marey (1830-1904)* (Chicago: University of Chicago Press, 1992), 55-61. For another example of a camera gun, see Armin Tenner, "A Gun Camera," *Forest and Stream*, January 14, 1892, 28.

88. Limited biographical information is available on Mary Wallihan. Viola S. Schantz suggests that "perhaps for obvious feminine reasons her birthdate is omitted" from the biographical descriptions in their first book. Viola S. Schantz, "Mrs. Wallihan: A Pioneer Photographer of Wildlife," *Journal of Mammalogy* 26, 2 (May 1945): 133-35.

89. The Wallihans won a diploma for their photography at the Paris exposition in 1900, and a bronze medal in St. Louis in 1904.

90. Wallihan and Wallihan, *Hoofs, Claws and Antlers of the Rocky Mountains* (Denver: Thayer, 1902).

91. While the Wallihans took the majority of the photographs in the text, the book also included images taken by other photographers to round out the range of species represented.

92. Wallihan and Wallihan, *Hoofs, Claws and Antlers*, unpaginated.

93. The text of the book indicates that she learned to shoot from Mr. Wallihan and her brother. The suggestion is that her skills in the woods are more a testament to them than to her own initiative. For a discussion of Mary Wallihan's hunting and photography from an ecofeminist perspective, see Vera

Norwood, *Made from This Earth: American Women and Nature* (Chapel Hill: University of North Carolina Press, 1993), 224–25.

94. John Brisben Walker, "New Sport in the Rocky Mountains: Photographing Big Game," *The Cosmopolitan* 29, 4 (1895): 372–85. An abridged version of the article appeared as Allen Grant Wallihan, "New Sport in the Rocky Mountains: Photographing Big Game," *Review of Reviews*, August 12, 1895, 228–29.

95. Wallihan's photograph and his description of its taking appear to confirm Ryan's emphasis on the role of spatial proximity in defining the manliness of camera hunting. "Such debates thus focus on the 'sportsmanliness' of camera hunting and show how resulting photographs were judged on the genuine— or otherwise—spatial proximity between animal and camera hunter." Ryan, "Hunting with the Camera," 214.

96. Wallihan continued to refer to his animal photography as camera hunting in all of his subsequent publications.

97. For example, both Carl Mautz, *Biographies of Western Photographers* (Nevada City, Calif.: Carl Mautz Publishers, 1997), and the New York Public Library's list of photographers in its photography collection include Allen Grant Wallihan and omit Mary. www.nypl.org.

98. Theodore Roosevelt, "Camera Shots at Wild Animals: The Extraordinary Photographs by Mr. A. G. Wallihan of Cougars, Deer and Other Western Game in Their Native Haunts," *World's Work*, December 1901, 1545–49. The article is prefaced by an editor's note indicating that it "consists of an extract from the Introduction to Mr. A. G. Wallihan's forthcoming volume 'Camera Shots at Wild Animals'" (1545).

99. On Roosevelt's hunting practices and their relation to discourses of science and gender, see Donna Haraway, *Primate Visions: Gender, Race, and Nature in the World of Modern Science* (New York: Routledge, 1989), 26–58; and Alexander Nemerov, "Vanishing Americans: Abbott Thayer, Theodore Roosevelt and the Attraction of Camouflage," *American Art* 11, 2 (Summer 1997): 50–81. On Roosevelt's interests in conservation, see Lutts, *Nature Fakers;* and Reiger, *American Sportsmen.*

100. Theodore Roosevelt, *The Strenuous Life* (New York: Nelson, 1900).

101. Gary Gerstle, "Theodore Roosevelt and the Divided Character of American Nationalism," *Journal of American History* 86, 3 (December 1999): 1280–1307, 1285. On Roosevelt's racial theories, see his *The Winning of the West* (New York: G. P. Putnam's Sons, 1902–3).

102. Edward Sandys, "Our Sportsman President," *Field and Stream*, December 1901, 581–83, 582.

103. Roosevelt, *The Strenuous Life*, 5. The speech was originally delivered at the Hamilton Club in Chicago on April 10, 1899.

104. John F. Kasson, *Rudeness and Civility* (New York: Hill and Wang, 1990), 70.

105. Ibid., 112–46. Kathy Peiss, *Cheap Amusements* (Philadelphia: Temple University Press, 1986).

106. Peter Filene, "Between a Rock and a Soft Place: A Century of American Manhood," *South Atlantic Quarterly* 84, 4 (Autumn 1985): 339–55, 345.

107. Gregg Mitman, *Reel Nature: America's Romance with Wildlife on Film* (Cambridge, Mass.: Harvard University Press, 1999), 13.

108. Peiss, *Cheap Amusements*, 6.

109. The 1890s saw "a widespread cultural concern about effeminacy, overcivilization, and racial decadence." Gail Bederman, *Manliness and Civilization: A*

Cultural History of Gender and Race in the United States, 1880–1917 (Chicago: University of Chicago Press, 1995), 185.

110. Ibid., 18–19.

111. Ibid., 170–216.

112. Ibid., 176–77. See also Suzanne Clark, "Roosevelt and Hemingway: Natural History, Manliness, and the Rhetoric of the Strenuous Life," in *Hemingway and the Natural World*, ed. Robert E. Fleming (Moscow: University of Idaho Press, 1999), 55–67.

113. Bederman, *Manliness*, 214.

114. Alexander Nemerov situates Roosevelt's crusade against misrepresentations of nature in his desire to ensure American children's access to the beneficial effects of American nature. Nemerov, "Vanishing Americans," 72.

115. The original trophies were Greek war memorials erected on the field to commemorate a victory in battle. This sometimes led to each side in a battle erecting their own trophy in an attempt to claim victory.

116. Herman, *Hunting and American Imagination*.

117. Roosevelt, "Camera Shots," 1549.

118. A related argument is at work today in Greenpeace's campaigns against seal hunting.

119. Thomas Strycharz, "Trophy-Hunting as a Trope of Manhood in Ernest Hemingway's *Green Hills of Africa*," *Hemingway Review* 13, 1 (Fall 1993): 36–47, 43.

120. Their conferral of status thus operates with what Gilles Deleuze and Felix Guattari have called the logic of the pack. As Deleuze and Guattari note, "The leader of the pack or the band plays move by move, must wager everything on every hand, whereas the group or mass leader consolidates or capitalizes on past gains." Gilles Deleuze and Felix Guattari, *A Thousand Plateaus*, trans. Brian Massumi (Minneapolis: University of Minnesota Press, 1987), 33. The trophy photograph thus operates with a nonbourgeois structure of appropriation and display. It cannot be accumulated as property and must instead be continually put in play.

121. Finis Dunaway, "Hunting with the Camera: Nature Photography, Manliness, and Modern Memory, 1890–1930," *Journal of American Studies* 34, 2 (August 2000): 207–30, 214.

122. Douglas R. Nickel, *Carlton Watkins: An Art of Perception* (San Francisco: SFMOMA, 1999), 32.

123. Martin Jay, "Photo-unrealism: The Contribution of the Camera to the Crisis of Ocularcentrism," in *Vision and Textuality*, ed. Stephen Melville and Bill Readings (Durham, N.C.: Duke University Press, 1995), 344–60, 346. Hubert Damisch argues that this interpretation of photography profoundly misunderstands the relationship between perspective and humanism. Hubert Damisch, *The Origin of Perspective*, trans. John Goodman (Cambridge, Mass.: MIT Press, 1995), xv–xvii.

124. This argument is similar to Dunaway's argument that the camera hunters used photography as a technology of memory but locates it within a different practice of memorialization.

125. Krauss, "Photography's Discursive Spaces."

126. Frank Michler Chapman, "Hunting with a Camera: Its substitution of the gun—the fascination of photographing nature for scientific study and for sport—the equipment and incidental adventures of many outings," *World's Work*, June 6, 1903, 3554–60, 3552.

127. Ibid., 3552.
128. Depth of field refers to the range of the image that is in sharp focus.
129. Meiklejohn, "Adventures in Wildlife Photography," 2086-88.
130. Derek Bousé, "False Intimacy: Close-ups and Viewer Involvement in Wildlife Film," *Visual Studies* 18, 2 (Spring 2003): 123-32.
131. Magnesium was effective because the spectrum of light it produced, rich blue, corresponded to the spectrum early photographic processes were sensitive to. However, magnesium wire was expensive and burned over a period of time.
132. A jacklight is generally a hooded lantern that emits a focused ray of light.
133. William Nesbit, *How to Hunt with the Camera* (New York: E. P. Dutton and Company, 1926), 304-8. Opening the shutter and then using the flash was the standard method for flash photography in the late nineteenth century.
134. Shiras, *Hunting Wildlife with Camera and Flashlight*, vol. 1, 84-87. Shiras patented the mechanism and dedicated its use to the public. The apparatus is reproduced in Shiras, "Wild Animals That Took Their Own Pictures by Day and by Night," 772.
135. Shiras, "Photographing Wild Game with Flashlight and Camera," 378.
136. Derek Bousé argues that in contemporary wildlife film and photographs extreme close-ups inside of fight or flight distances encourage viewers to form para-proxemic relations with the animals depicted, that is, to feel an intimate connection to them. Bousé, "False Intimacy."
137. Shiras describes the image's taking in *Hunting Wildlife with Flashlight and Camera*, vol. 1, 42-44.
138. "Opening my left eye, which I had purposely closed when the blinding flash was fired, I saw the doe running up the trail, while the fawns, temporarily blinded from facing the dazzling flame, jumped about in great confusion." Ibid., 44.
139. Shiras, "Photographing Wild Game with Flashlight and Camera," 382.
140. Shiras, *Hunting Wildlife with Camera and Flashlight*, vol. 1, 44-53.
141. I am following the numbering system from *Hunting Wildlife with Camera and Flashlight*, vol. 1, 45-52.
142. Letter from anonymous French sportsman quoted in Nelson, foreword to *Hunting Wildlife with Camera and Flashlight*, by Shiras, viii.
143. The letter misspells his name as Mitbe.
144. The description of the images matches Ottomar Anschütz's pictures of roe deer discussed in chapter 1, this volume.
145. Edgar Spier Cameron, "Letter to George Shiras," June 2, 1913, in *Hunting Wildlife with Camera and Flashlight*, vol. 1, 83-84, 83.
146. "Dear Sir:
 I have had it in mind for several years to write to you to give you a bit of information which may be of interest to you. The frequent mention of your name in the reports of Colonel Roosevelt has again brought it to my mind.
 In 1900 I was a juror at the Paris Exposition in Class XII (Photography). When we visited the German Pavilion, we were shown some skilfully executed photographs of what purported to be wild animals at liberty. Professor Mitbe, the German juror, made a strong argument in their favor and most of the jury seemed impressed, when Prof. E. Wallou, one of the French jurors, directed attention to the fact that the animals were generally against snow or on rocks against the skyline, and that the edges showed the prints were made from two negatives.

Later in the day, after our work was over, he and I were walking together and he brought up this incident which he considered characteristically Tudesque. I then told him if he wished to see some real results of photography of wild animals at liberty, I would show him some by an American, adding that, unfortunately, they were not entered in our section. Then I took him to the U.S. Forestry exhibit and showed him your work. He was most enthusiastic and told me to ask my Commission if an award would be acceptable and promising to propose a silver medal (the highest award made for exhibits of work of one kind by an individual).

Through his efforts the jury was induced to visit the Forestry exhibit and a medal was awarded to you.

Hoping that this story of how you came to receive a medal from a class in which you were not an exhibitor may be of interest and new to you.

Yours very truly,

Edgar S. Cameron."

Ibid.

147. In 1901, Shiras published bromide enlargements of the *Midnight Series* as a limited edition of one thousand. Frank Michler Chapman reproduced parts of the series in his 1903 article, "Hunting with a Camera." The photographs were also exhibited at the Louisiana Purchase Exposition at St. Louis in 1904, where they won a Grand Prize. The medal is reproduced in Shiras, *Hunting Wildlife with Camera and Flashlight*, vol. 1, 27.

148. Shiras, "Photographing Wild Game with Flashlight and Camera," 366-423.

149. The photographs from the *Midnight Series* are identified in a frontispiece to the article. However, the image *Alert!* is not included in the article, and another photograph, *Doe*, is identified as belonging to the series. Ibid., 387.

150. Ibid., 389.

151. Philip J. Pauly, "The World and All That Is in It: The National Geographic Society, 1888-1918," *American Quarterly* 31, 4 (Autumn, 1979): 517-32. Gilbert M. Grosvenor, "A Hundred Years of the National Geographic Society," *Geographical Journal* 154, 1 (March 1988): 87-92.

152. Fact Sheet. National Geographic Milestones. www.nationalgeographic.com.

153. Charles McCurry, "'Let the Whole World Hear from You' The Inventor, the Architect and the Spiritual Leader," in *National Geographic Index: 1888-1898* (Washington, D.C.: National Geographic Society, 1989), 19-39, 30.

154. Pauly, "The World and All That Is in It."

155. Catherine Lutz and Jane Collins suggest that Grosvenor's editorial decisions at this time "established photographs as the mainstay and distinguishing feature of the magazine." Catherine A. Lutz and Jane L. Collins, *Reading National Geographic* (Chicago: University of Chicago Press, 1993), 27.

156. This increase was part of a broader increase in membership brought on by the populist photographic approach.

157. On *National Geographic* as a photographically illustrated magazine, see Lutz and Collins, *Reading National Geographic*; and Tamar Y. Rothenberg, *Presenting America's World: Strategies of Innocence in National Geographic Magazine, 1888-1945* (Aldershot, England: Ashgate, 2007).

158. Mark Jenkins, "The World of George Shiras: A National Geographic Miscellany." www.nationalgeographic.com.

159. Unframed copies were available from the society for fifty cents, while framed reproductions cost two dollars more.

160. George Shiras 3d, "The Wildlife of Lake Superior, Past and Present," *National Geographic* 32 (August 1921): 113-204, 136.

161. Nesbit, *How to Hunt with a Camera*, 58-61.

162. Shiras, *Hunting Wildlife with Camera and Flashlight*, vol. 1, 45-52.

163. Ibid., 42-53.

164. Jenkins, "The World of George Shiras."

165. Victor H. Cahalane, "Deer of the World," *National Geographic* 76, 10 (October 1939): 463-510, 475.

166. Andrew H. Brown, "Work-hard, Play-hard Michigan," *National Geographic* 101, 3 (March 1952): 279-320, 296.

167. The image was also reproduced in C. A. W. Guggisberg's *Early Animal Photographers* as an example of Shiras's technical innovations in nighttime photography. Guggisberg, *Early Animal Photographers*, 39.

168. The reproductions in *National Geographic* continually stressed the awards the series had won. The emphasis on the photographer's prowess became a key feature of the magazine. As Lutz and Collins argue, "The *Geographic* photographer has always been and predominately remains, both literally and symbolically, a white man. And not just any white man, but the whitest and most masculine version possible: the great hunter/adventurer." Lutz and Collins, *Reading National Geographic*, 184-85. See also Marc Manganaro, "What's Wrong with This Picture: Reflections on *Reading National Geographic*, A Review Article," *Comparative Studies in Society and History* 37, 1 (January 1995): 205-9.

169. Dunaway, "Hunting with the Camera," 230.

170. Carl G. Schillings, *Mit Blitzlicht und Büchse* (Leipzig: R. Voigtländer, 1905). On the reception of Schillings's book, see Guggisberg, *Early Wildlife Photographers*, 50.

171. Donna Haraway, "A Cyborg Manifesto: Science, Technology, and Socialist Feminism in the 1980s," *The Haraway Reader* (New York: Routledge, 2004), 7-45, 29.

172. Christian Metz, "Photography and Fetish," in *The Critical Image: Essays on Contemporary Photography*, ed. Carol Squiers (Seattle: Bay Press, 1990), 15-27, 18.

173. For one of the few readings that challenge this equation, see Paul Edwards, "Against the Photograph as *Memento Mori*," *History of Photography* 22, 4 (Winter 1998): 380-84.

174. Brian Coe and Paul Gates, *The Snapshot Photograph: The Rise of Popular Photography 1888-1939* (London: Ash and Grant, 1977), 6.

175. Beaumont Newhall, "Photography and the Development of Kinetic Visualization," *Journal of the Warburg and Courtauld Institutes* 7 (1942): 40-45, 45.

176. Shelly Rice, *Parisian Views* (Cambridge, Mass.: MIT Press, 1999).

177. Sontag, *On Photography*, 15. See also Berger, "Why Look at Animals?"

3. THE PHOTOGRAPHIC BLIND

1. Walter Benjamin, "The Work of Art in the Age of Mechanical Reproduction," in *Illuminations*, ed. Hannah Arendt, trans. Harry Zohn (New York: Schocken Books, 1988), 217-52, 233.

2. C. A. W. Guggisberg briefly discusses the blind in his *Early Wildlife Photographers* (London: David and Charles, 1977). However, his only reflection on the

blind's workings is to wonder why birds are not disturbed by the presence of "the strange canvas structure which, one would have thought, should have appeared to them as a very disturbing blot in the landscape" (31).

3. Edmund White, "Animals, Vegetables and Minerals: The Lure and Lore of Nature Photography," in *Photographing Nature* (New York: Time-Life Books, 1971), 13–16, 16.

4. Ethologists distinguish between "observing" and "watching" animals. Observation is the focused, disciplined looking done by trained professionals, while watching is the at best semi-trained activity of the general public. For an informative discussion of ethologists and their practices in blinds as they relate to scientific objectivity, see Helen MacDonald, "Covert Naturalists or How Ethologists Hunt for Objectivity," paper presented at "The Practice of Objectivity in the Natural and Social Sciences," CPNSS/Max Planck Institute for the History of Science, London School of Economics, October 8–9, 2003.

5. White's reference to hiding in fake trees and haystacks is an allusion to Cherry and Richard Kearton, whose work is discussed later in the chapter.

6. White's account parallels the description of Richard Kearton's invention of the photo blind: "Richard Kearton 'invented' the camouflage tent, which is still used by bird photographers today, in a more developed form. He discovered, that birds hardly took notice of other animals such as cows, horses or sheep. So his first camouflage tent resembled a cow. His later versions of camouflage tents were more and more abstract, until finally the realization compounded the future of bird photographers, that a camouflage tent could resemble anything and everything but the 'epitome of evolution,' the human." Fritz Pölking and Gisela Pölking, "From the Early Days of Wildlife Photography," 2004, www.poelking.com.

7. John Berger, "Why Look at Animals?" in *About Looking* (New York: Pantheon, 1980), 1–28, 14.

8. For an extended analysis of the fundamental exclusion of the human body from wildlife imagery and the erasure of entry points from which one can situate oneself in relation to the image, see Matthew Brower, "Robert Bateman's *Natural Worlds*," *Journal of Canadian Studies* 33, 2 (Summer 1998): 66–77.

9. Derek Bousé, "False Intimacy: Close-ups and Viewer Involvement in Wildlife Film," *Visual Studies* 18, 2 (Spring 2003): 123–32. Bousé's reading suggests the telephoto lens can encourage a sense of contact between the viewer and the animal that the blind discourages.

10. The logic of animal imagery discussed by Berger parallels the logic of the spectacle articulated by Guy Debord in *The Society of the Spectacle*, trans. Fredy Perlman and John Supak (Detroit: Red and Black, 1977).

11. Berger, "Why Look at Animals?" 1.

12. Ibid., 3

13. Jonathan Burt, *Animals in Film* (London: Reaktion Books, 2002), 26.

14. "Therein lies the ultimate consequence of their marginalization. The look between animal and man, which may have played a crucial role in the development of human society, and with which, in any case, all men had always lived until less than a century ago, has been extinguished." Berger, "Why Look at Animals?" 26.

15. For a discussion of engaging with representations of the animal gaze, see W. J. T. Mitchell, "Looking at Animals Looking," in *Picture Theory* (Chicago: University of Chicago Press, 1994), 329–44. For a discussion of what it is to

be looked at by animals, see Jacques Derrida, "The Animal That Therefore I Am (More to Follow)," *Critical Inquiry* 28, 2 (Winter 2001): 369–418.

16. Berger, "Why Look at Animals?" 5.

17. Joel Snyder, "Benjamin on Reproducibility and Aura: A Reading of 'The Work of Art in the Age of Its Technical Reproducibility,'" in *Benjamin: Philosophy, Aesthetics, History*, ed. Gary Smith (Chicago: University of Chicago Press, 1989), 158–74, 161.

18. Jonathan Crary, *Suspensions of Perception: Attention, Spectacle, and Modern Culture* (Cambridge, Mass.: MIT Press, 2001), 138–40.

19. Joel Snyder, "Visualization and Visibility," in *Picturing Science, Producing Art*, ed. Peter Galison and Caroline A. Jones (London: Routledge, 1998), 379–97, 394.

20. This inability to focus at high speeds is what allows us to reconstitute the individual images produced by Muybridge back into the appearance of fluid motion when the images are shown in rapid succession.

21. Crary, *Suspensions of Perception*. On the generalized phenomena of displacing the evidence of the senses for the results of the apparatus, see Bruno Latour, *We Have Never Been Modern*, trans. Catherine Porter (Cambridge, Mass.: Harvard University Press, 1997).

22. Snyder, "Visualization and Visibility," 395.

23. Cf. Beaumont Newhall, who suggests, "The evidence which instantaneous photography presented about the attitudes of men and animals in motion became assimilated by the public, through the sheer number of example presented to them." Beaumont Newhall, "Photography and the Development of Kinetic Visualization," *Journal of the Warburg and Courtauld Institutes* 7 (1944): 40–45, 45.

24. Berger insists that animals in zoos cannot really be seen, as they cannot look back at us. Berger's argument only reinforces my position that we take the "real" animal as something other than its physical body.

25. This process has been automated. Hunters can purchase electronic calling systems that digitally reproduce animal calls.

26. The two functions have now merged in the Canada Goose Recliner goose blind from Wildfowler Outfitters: the hunter lies inside a goose shell that flips open to allow them fire.

27. Hillel Schwartz, *The Culture of the Copy* (New York: Zone Books, 1996), 178.

28. *Blind* is the late-nineteenth-century term. Prior to blind the term *hide* was used, which has its roots in Middle English.

29. Cherry Kearton, *Grouse Shooter in Butt*, in Richard Kearton, *With Nature and a Camera Being the Adventures and Observations of a Field Naturalist and an Animal Photographer* (London: Cassell, 1898), 165.

30. R. Kearton, *With Nature and a Camera*. The brothers collaborated on the book, with Cherry doing the photography and Richard writing the text.

31. On the Keartons, see William R. Mitchell, *Watch the Birdie* (Settle, UK: Castleberg, 2001).

32. Richard Kearton, *British Birds' Nests—How, Where and When to Find and Identify Them*, illus. Cherry Kearton (London: Cassell, 1895).

33. The brothers achieved a good deal of renown for their efforts. Richard was a fellow of the Royal Zoological Society, and the Royal Geographical society offered the Cherry Kearton Medal for excellence in nature photography. Cherry became a pioneering wildlife filmmaker and filmed his friend Teddy

Roosevelt on safari in Africa. Cherry Kearton, *Wild Life across the World* (London: Hodder and Stoughton, c. 1920s).

34. These include Cherry Kearton, *The Island of Penguins* (London: Longmans, Green and Co., 1930); Cherry Kearton, *The Cherry Kearton Animal Book* (London: Hutchinson, 1958); Cherry Kearton, *The Lion's Roar* (London: Longmans, Green and Co., 1934); Cherry Kearton, *I Visit the Antipodes* (London: Jarrolds, 1937); Cherry Kearton, *On Safari* (London: R. Hale, 1956); Richard Kearton, *The Adventures of Cock Robin and His Mate,* illus. Cherry Kearton (London: Cassell, 1909); Cherry Kearton, *The Shifting Sands of Algeria* (London: Arrowsmith, 1924); Cherry Kearton, *In the Land of the Lion* (London: Arrowsmith, 1946).

35. The presence of the photographer outside the blind indicates that the photograph is posed.

36. Or, more accurately, is probably posed as if he were loading the gun. The first man is not firing; thus, it is unlikely that the second gun is in fact empty and in need of loading. This suggests that what we see in the image is a posed portrait illustrating the idealized mechanics of the blind. The presence of the photographer, outside the blind, strongly supports this reading.

37. On the relation between photographs and captions, see Roland Barthes, "The Photographic Message," in *Image Music Text,* trans. Stephen Heath (New York: Hill and Wang, 1998), 15–31.

38. Repeating shotguns were not in use at the time.

39. See David Quammen, "The Bear Slayer," *Atlantic Monthly* 292, 1 (July–August 2003): 45–64, on Nicolae Ceaușescu's hunting practice for a description of how luxurious blinds can become. "Another feature of the typical station is an elevated blind within eyeshot of the trough, from which the gamekeeper does his observing. In some cases this is a simple platform of planks about ten feet off the ground, like a child's tree house though not quite so graceful; in others it's an enclosed structure on sturdy pilings. If the blind is also used as a shooting position, it's known as a high seat. A high seat may be spartan or comfortable; at the comfortable extreme it's essentially a two-room cabin, furnished with cots, a wood stove, a window overlooking the target area (about fifty yards away), a firewood bin, a toilet, and maybe a bottle or two of vodka. Under such circumstances a bear hunter is not put to great inconvenience or challenge, let alone risk" (52).

40. Allen Grant Wallihan and Mary Wallihan, *Hoofs, Claws and Antlers of the Rocky Mountains* (Denver: Thayer, 1894).

41. Text for "antelope plate no 3." Ibid., unpaginated.

42. Allen Grant Wallihan also provides another description of buck fever while waiting in the blind: "Next day I was back at the blind early and several came in but not near me. Thinking I heard a splashing above me I peered over the bank and saw a few had come in there to water. They soon worked my way and aiming the camera as near right to where they would come, I waited, while my fever rose as I heard them splashing along. Imagine if you can of being within thirty feet of this most wary of game animals as I was when those walked out to where you see them. Could you control your nerves? I cannot and I have been amongst them twelve years. Nor have I seen the person who could not withstanding their boasting that they never have buck fever" (unpaginated).

43. Ibid., unpaginated.

44. Ibid., unpaginated.

45. The Wallihans' blinds were not always clearly described and were sometimes of undetermined construction.

46. Text for "Deer plate no 17." Wallihan and Wallihan, *Hoofs, Claws and Antlers,* unpaginated.

47. "If, later in the nineteenth century, cinema or photography seem to invite formal comparison with the camera obscura, it is within a social, cultural, and scientific milieu where there had already been a profound break with the conditions of vision presupposed by this device." Jonathan Crary, *Techniques of the Observer: On Vision and Modernity in the Nineteenth Century* (Cambridge, Mass.: MIT Press, 1996), 27.

48. "First of all the camera obscura performs an operation of individuation; that is, necessarily defines an observer as isolated, enclosed, and autonomous within its dark confines. It impels a kind of *askesis,* or withdrawal from the world, in order to regulate and purify one's relation to the manifold contents of the now 'exterior' world. Thus the camera obscura is inseparable from a certain metaphysics of interiority: it is a figure for both the observer who is nominally a free sovereign individual and a privatized subject confined in a quasi-domestic space, cut off from a public exterior world." Ibid., 39.

49. While the focus of this volume is on North American photography, it is essential to include the Keartons in any discussion of the history of the photographic blind. The Keartons' work is unavoidably central to the discussion. The Keartons were much mentioned in early-twentieth-century American discussions of animal photography, particularly in reference to the photographic blind.

50. The Keartons were also among the first to describe their animal photography as wildlife photography.

51. Richard Kearton, *Wild Life at Home, How to Study and Photograph It,* illus. Cherry Kearton (London: Cassell and Company, 1899), 9–10.

52. Jennifer Tucker "Photography as Witness, Detective, and Impostor: Visual Representation in Victorian Science," in *Victorian Science in Context,* ed. Bernard Lightman (Chicago: University of Chicago Press, 1997), 378–408, 380–81.

53. On the production of photographic objectivity during the late nineteenth century, see also John Tagg, *The Burden of Representation* (Amherst: University of Massachusetts Press, 1988).

54. Lorraine Daston and Peter Galison, "The Image of Objectivity," *Representations* 40 (Fall 1992): 81–128, 112. See also Peter Galison, "Judgment against Objectivity," in *Picturing Science, Producing Art,* ed. Peter Galison and Caroline A. Jones (London: Routledge, 1998), 327–59.

55. Daston and Galison, "Image of Objectivity," 112.

56. Cherry Kearton, *Photographing King Fisher,* in R. Kearton, *With Nature and a Camera,* 353.

57. In this separation from the photographer's viewpoint, the setup is similar to the set-camera photography pioneered by Shiras and discussed in the previous chapter. It differs from the set camera, though, in that the set camera, as practiced by Shiras, emphasized the contact between animal and camera even if the camera was not directly linked to the eye of the photographer.

58. R. Kearton, *Wild Life at Home.*

59. Cherry Kearton, *Artificial Rubbish Heap,* in *Wild Life at Home,* by R. Kearton, 15.

60. R. Kearton, *Wild Life at Home*, 10.

61. Cherry Kearton, *Artificial Tree Trunk Open*, in *Wild Life at Home*, by R. Kearton, 12.

62. Cherry Kearton, *Artificial Tree Trunk Closed*, in *Wild Life at Home*, by R. Kearton, 13.

63. Richard describes the tree trunk's construction in Richard Kearton, "Photographing Shy Wild Birds and Beasts at Home," *Bird-Lore* 1, 4 (August 1899): 107–12, 110.

64. For biographical information on Herrick, see Winfred George Leutner, "Francis Hobart Herrick," *Science* 92, 2391 (October 25, 1940): 371–72. Francis Hobart Herrick, *The American Lobster: A Study of Its Habits and Development* (Washington, D.C.: Bulletin of the United States Fish Commission, vol. 15, 1895).

65. Francis Hobart Herrick, *Audubon the Naturalist, A History of His Life and Time* (New York: D. Appleton and Co., 1917); Francis Hobart Herrick, *The American Eagle: A Study in Natural and Civil History* (New York: D. Appleton-Century, 1934).

66. Guggisberg, *Early Wildlife Photographers*, 31.

67. Alfred O. Gross, "History and Progress of Bird Photography in America," in *Fifty Years' Progress of American Ornithology, 1883–1933*, ed. Frank M. Chapman and Theodore S. Palmer (Lancaster, Pa.: American Ornithological Union, 1933), 159–80, 163.

68. Francis H. Herrick, "A New Method of Bird Study and Photography," *The Critic* 38 (May 1901): 425–30. The article reproduces the preface to his *The Home Life of Wild Birds* (New York: G. P. Putnam's Sons, 1901). Herrick later represented his arguments in "The Wild Bird by a New Approach," *Century Magazine* 66 (October 1903): 858–68.

69. Herrick, "Wild Bird," 860.

70. Herrick, "New Method," 425.

71. Ibid., 426.

72. Ibid., 427.

73. Ibid., 429.

74. "By nesting site is meant the nest and its immediate surroundings, such as a twig, branch, hollow trunk, stem, or whatever part of a tree the nest may occupy, a bush, stub, strip of sod, or tussock of sedge,—that is, the nest with its immediate settings. If the nest, like that of an Oriole, is fastened to the leafy branch of a tree, the nesting bough is cut off, and the whole is then carefully lowered to the ground and set up in good light, so that the branch with the nest shall occupy the same relative positions which they did before. The nest, however, is now but four instead of forty feet from the ground." Ibid., 425–26.

75. "This sudden displacement of the nesting bough is of no special importance to either old or young, provided certain precautions are taken. It is as if an apartment or living room were removed from the fourth story of some human abode to the ground floor, or in the case of the ground-building birds as if the first story were raised to a level with the second. The *immediate* surroundings of the nest remain the same in any case. The nest might indeed be taken from its bough or from the sward, but this would be inadvisable, chiefly because it would destroy the natural site or the exact conditions selected and in some measure determined by the birds themselves." Ibid., 426–27.

76. More accurately: Because the blind is thought to make our presence unobservable to the birds, the photos are taken as showing us the birds acting as if we were not there (because for us we are not).

77. On the professionalization of American ornithology, see Mark V. Barrow, *A Passion for the Birds: American Ornithology after Audubon* (Princeton, N.J.: Princeton University Press, 1998).

78. Gross, "History and Progress," 166.

79. For Daston and Galison mechanical objectivity is a moralized noninterventionism that came to characterize scientific representation in the late nineteenth century. Daston and Galison, "The Image of Objectivity," 82.

80. For biographical information on Chapman, see Robert Cushman Murray, "Frank Michler Chapman, 1864-1945," *The Auk* 67, 3 (July–September 1950): 307-15; Barrow, *A Passion for the Birds*, 103-4; Frank Michler Chapman, *Camps and Cruises of an Ornithologist* (New York: D. Appleton, 1908); Frank Michler Chapman, *Autobiography of a Bird Lover* (New York: D. Appleton, 1933).

81. Karen Wonders, *Habitat Dioramas: Illusions of Wilderness in Museums of Natural History* (Upsala: Acta Universitatis Upsaliensis, 1993).

82. Frank Michler Chapman, *Bird Studies with a Camera* (New York: D. Appleton and Company, 1900).

83. Gross, "History and Progress," 165.

84. Frank Michler Chapman, "The Fish Hawks of Gardiner's Island," *Bird-Lore* 10 (July–August 1908): 153-59.

85. Frank Michler Chapman, "The Use of a Blind in the Study of Bird-Life," *Bird-Lore* 10 (September–October 1908): 250-52, 252.

86. MacDonald, "Covert Naturalists."

87. Chapman, *Camps and Cruises*, xv.

88. Michel Foucault, *Discipline and Punish: The Birth of the Prison* (New York: Vintage Books, 1979), 202.

89. J. Maclain Boraston, "Hunting with a Camera," *Cosmopolitan* 39 (May 1905): 43.

90. *The Nation*, "Photography of the Wild," *Review of Reviews*, November 20, 1909, 484-86, 485.

4. THE APPEARANCE OF ANIMALS

1. Jonathan Burt, *Animals in Film* (London: Reaktion Books, 2002), 112.

2. For a discussion of the scientific debate surrounding Thayer's work and its relation to broader strands of biological thought, see Sharon Kingsland, "Abbott Thayer and the Protective Coloration Debate," *Journal of the History of Biology* 11, 2 (Fall 1978): 223-44; and Stephen Jay Gould, "Red Wings in the Sunset," in *Bully for Brontosaurus: Reflections in Natural History* (New York: W. W. Norton and Company, 1991), 209-28.

3. For biographical information on Thayer, see Ross Anderson, *Abbott Handerson Thayer* (Syracuse, N.Y.: Everson Museum, 1982); and Nelson C. White, *Abbott Thayer: Painter and Naturalist* (Hartford: Connecticut Printers, 1951).

4. Roy Behrens suggests Thayer began his investigations in 1890. Roy Behrens, *Art and Camouflage: Concealment and Deception in Nature, Art, and War* (Cedar Falls, Iowa: North American Review, 1981), 22.

5. Abbott H. Thayer, "The Law Which Underlies Protective Coloration," *The Auk* 13 (April 1896): 124–29. The second part of the article, published in October, added color temperature to Thayer's explanation of countershading. Abbott H. Thayer, "Further Remarks on the Law Which Underlies Protective Coloration," *The Auk* 13 (October 1896): 318–20.

6. It is unclear who photographed the images in Thayer's natural history work, as the images are uncredited. I treat the photographs in Thayer's works *as* Thayer's—not in the sense of being shaped by his personal artistic vision but in terms of their photographic approach to representing animals.

7. The photographs accompanying the article were widely circulated and were reprinted in both the Smithsonian Institution's *Annual Report* and later in Thayer's son's book *Concealing-Coloration*. The photos are reprinted as figures 22–25 and 34–35 in *Concealing-Coloration*. Abbott H. Thayer, "The Law Which Underlies Protective Coloration," *Annual Report of the Smithsonian Institution for the Year Ending June 30, 1897* (Washington, D.C.: Smithsonian, 1897), 477–82. Gerald Handerson Thayer, *Concealing-Coloration in the Animal Kingdom* (New York: MacMillan, 1909).

8. A. H. Thayer, "The Law Which Underlies Protective Coloration," 125.

9. "The accompanying diagram illustrates this statement. Animals are colored by nature as in A, the sky lights them as in B, and the two effects cancel each other as in C. The result is that their gradation of light and shade, by which opaque solids manifest themselves to the eye, is effaced *at every point,* the cancellation being as complete at one point as another, as in Fig. C of the diagram, and the spectator seems to see right through the space really occupied by an opaque animal." A. H. Thayer, "The Law Which Underlies Protective Coloration," 125–26.

10. This is, of course, the traditional artistic technique for rendering the appearance of solidity on a two-dimensional surface. The alternation of light and dark appears to us as the occupation of space. Thayer's insight into concealing-coloration stems from realizing this process can also work in reverse; eliminating the effects of shading can make a three-dimensional object appear flat and insubstantial.

11. In the interest of space I will only discuss the first sequence in detail.

12. This is a different conception of the normal animal than that propagated by the photographic blind. This normal animal is visually inaccessible by nature, not in response to human presence. Thus, the idea of the normal animal is in question in Thayer's work.

13. Donna Haraway, "Teddy Bear Patriarchy," *Social Text* 11 (Winter 1984–85): 20–64; Karen Wonders, *Habitat Dioramas: Illusions of Wilderness in Museums of Natural History* (Upsala: Acta Universitatis Upsaliensis, 1993).

14. Haraway, "Teddy Bear Patriarchy," 24

15. Jane Desmond, "Displaying Death, Animating Life: Changing Fictions of 'Liveness' From Taxidermy to Animatronics," in *Representing Animals,* ed. Nigel Rothfels (Bloomington: Indiana University Press, 2002), 159–79.

16. Alfred O. Gross, "History and Progress of Bird Photography in America," in *Fifty Years' Progress of American Ornithology, 1883-1933,* ed. Frank M. Chapman and Theodore S. Palmer (Lancaster, Pa.: American Ornithological Union, 1933), 159–80, 163.

17. James Ryan, "'Hunting with the Camera': Photography, Wildlife, and Colonialism in Africa," in *Animal Spaces, Beastly Places,* ed. Chris Philo and Chris Wilbert (London: Routledge, 2000), 203–21.

18. On the shift within scientific representation from ideal figures to typical ones, see Peter Galison, "Judgment against Objectivity," in *Picturing Science, Producing Art*, ed. Caroline A. Jones and Peter Galison (New York: Routledge, 1998), 327–59; and Lorraine Daston and Peter Galison, "Image of Objectivity," *Representations* 40 (1992): 81–128.

19. Harriet Ritvo, "Zoological Nomenclature and the Empire of Victorian Science," in *Victorian Science in Context*, ed. Bernard Lightman (Chicago: University of Chicago Press, 1997), 334–53.

20. Peter A. Fritzell, *Nature Writing and America: Essays on a Cultural Type* (Ames: Iowa State University Press, 1990).

21. A. H. Thayer, "The Law Which Underlies Protective Coloration," figure 2.

22. The standard work in biology on animal coloration argues that vertebrate eyes are the most conspicuous form in nature. "Few natural objects possess greater inherent conspicuousness than the vertebrate eye. This characteristic is due mainly to its sharply defined, rounded form. Of all shapes a round disc is the most striking and easily seen and recognized—hence the use of the 'bull's eye' for target practice." Hugh. B. Cott, *Adaptive Coloration in Animals* (London: Methuen and Co. Ltd., 1956), 82.

23. The grouse is apparently posed as in nature, yet, given that this is a stuffed animal placed by Thayer for photographing, it is unclear that this is exactly how and where a grouse might choose to position itself in life. This uncertainty becomes important as Thayer's theories become controversial.

24. This was also Étienne-Jules Marey's criticism of Eadweard Muybridge's animal photographs. For a discussion of the pains Marey took to make his photographs scientifically useful, see Marta Braun, *Picturing Time: The Work of Étienne-Jules Marey (1830–1904)* (Chicago: University of Chicago Press, 1992).

25. However, this criticism was not at all a part of the images' reception at the time.

26. The photographs indicate that countershading makes the birds inconspicuous to the camera, if not to the eye.

27. Thayer would later assert that photographs transparently revealed the truth of his demonstrations.

28. The limits of photography confronted here are different from those constraining the early street photographs that could not register movement. In those photographs the camera could not register everything the eye could see. Here the problem is showing what the eye can see and thereby capturing the field of the visible.

29. Nigel Warburton, "Varieties of Photographic Representation: Documentary, Pictorial and Quasi-documentary," *History of Photography* 15, 3 (Autumn 1991): 203–10.

30. John Tagg discusses the construction of photographs as evidence in *The Burden of Representation* (Amherst: University of Massachusetts Press, 1988).

31. See Braun *Picturing Time*; and Lisa Cartwright, *Screening the Body: Tracing Medicine's Visual Culture* (Minneapolis: University of Minnesota Press, 1995).

32. On the distinction between the photographic image as a graphical trace and as a representation of sight, see Lisa Cartwright and Brian Goldfarb, "Radiography, Cinematography, and the Decline of the Lens," in *Incorporations*, ed. Jonathan Crary and Sanford Kwinter (New York: Zone Press, 1992), 190–201.

33. For a discussion of the implications of this distinction for thinking of visual

culture, see Lisa Cartwright, "Film and the Digital in Visual Culture: Film Studies in the Era of Convergence," *Journal of Visual Culture* 1, 1 (2002): 7–23.

34. Joel Snyder, "Benjamin on Reproducibility and Aura: A Reading of 'The Work of Art in the Age of Its Technical Reproducibility,'" in *Benjamin: Philosophy, Aesthetics, History*, ed. Gary Smith (Chicago: University of Chicago Press, 1989), 158–74, 161. See also Joel Snyder, "Visualization and Visibility," in *Picturing Science, Producing Art*, ed. Caroline A. Jones and Peter Galison (New York: Routledge, 1998), 379–97.

35. Frank M. Chapman, "The Use of a Blind in the Study of Bird-Life," *Bird-Lore* 10 (September–October 1908): 250–52.

36. For a description of the reception of Thayer's work by the scientific community and its place within larger debates on evolution and animal coloration, see Kingsland, "Abbott Thayer and the Protective Coloration Debate," 223–44.

37. Thayer's demonstrations typically used decoys to show the difficulty of discerning countershaded objects. Kingsland describes Thayer's demonstrations: "In a typical experiment he placed a number of bird-sized wooden models on wire legs about six inches from the ground. Some had been countershaded from earth color above to pure white below. Others were coated with a uniform layer of earth color. At a distance of about forty yards he would point to the objects and ask the members of the audience how many they saw. Invariably they would pick out the monochrome shapes easily but miss the counter-shaded ones. It was not until Thayer brought them to within six or seven yards that the counter-shaded models would suddenly, as if by magic, leap into view." Kingsland, "Abbott Thayer and the Protective Coloration Debate," 227.

38. Joel Asaph Allen suggests that Thayer used sweet potatoes in his demonstration for the Ornithological Association. J. A. Allen, "Roosevelt's 'Revealing and Concealing Coloration in Birds and Mammals,'" *The Auk*, 28 (October 1911): 472–80.

39. Frank Michler Chapman, *Autobiography of a Bird Lover* (New York: D. Appleton-Century, 1933), 79. Quoted in Kingsland, "Abbott Thayer and the Protective Coloration Debate," 227.

40. J. A. Allen, "Roosevelt's 'Revealing and Concealing Coloration.'"

41. Thayer, "The Law Which Underlies Protective Coloration"; Thayer, "Further Remarks on the Law Which Underlies Protective Coloration"; Thayer, "The Law Which Underlies Protective Coloration"; Abbott H. Thayer, "Protective Coloration in Its Relation to Mimicry, Common Warning Colours, and Sexual Selection," *Transactions of the Entomological Society of London* 51 (1903): 553–69.

42. Edward B. Poulton, *The Colours of Animals* (London: Kegan Paul, 1890).

43. Edward B. Poulton, "The Meaning of the White Under Sides of Animals," *Nature* 65 (1902): 596. Edward B. Poulton, "A Brief Discussion of A. H. Thayer's Suggestions as to the Meaning of Colour and Pattern in Insect Bionomics," *Transactions of the Entomological Society of London* 51 (1903): 570–75. Abbott H. Thayer, "Protective Coloration in Its Relation to Mimicry."

44. This remains the basic principle behind military and hunting camouflage.

45. Gerald Handerson Thayer, *Concealing-Coloration in the Animal Kingdom* (New York: MacMillan, 1909). The book was written by Thayer's son Gerald; how-

ever, the tradition among commentators (both at the time and later) has been to treat Gerald's work as Abbott's. For example, Ross Anderson argues that *Concealing-Coloration* was "nominally written by Thayer's son Gerald, but in actuality a collaborative work in which the elder partner was the controlling sensibility." Anderson, *Abbott Handerson Thayer*, 117–19. The book was written by Gerald under Abbott's direction and is subtitled *A Summary of Abbott H. Thayer's Discoveries*. Thus, while we cannot treat Abbott Thayer as the author of concealing-coloration in the romantic sense, we can treat Thayer as the corporate author in much the same way as we can treat the images in the book (most of which were not done by Thayer) as Thayer's.

46. Figures 23 and 24, and 34 and 35 in G. H. Thayer, *Concealing-Coloration*.

47. Thayer divided defensive coloration into two classes, obliterative coloration and mimicry. Obliterative coloration aims to make animals invisible, while mimicry is deceptive visibility aiming to make the animal appear as something else. The book largely ignores mimicry, as it is confined to the lower orders. G. H. Thayer, *Concealing-Coloration*, 25.

48. Georges Bataille, *Visions of Excess: Selected Writings, 1927–1939*, ed. and trans. Allan Stoekl (Minneapolis: University of Minnesota Press, 1985); and Julia Kristeva, *Powers of Horror: An Essay on Abjection*, trans. Leon S. Roudiez (New York: Columbia University Press, 1982).

49. Improper animal photographs have reemerged in contemporary art practice. Steve Baker posits the refusal of animal form as a line of flight away from the reduction of the animal to an object of visual knowledge. For example, in contemporary photographer Britta Jaschinski's *Animal* series "the aesthetic experience is of the creatures drawing [the] power [of how they are seen] into their own dense black centres, internalizing it, incorporating it, keeping knowledge of their bodies to themselves, and refusing to be drawn on what it is that they are." Steve Baker, *The Postmodern Animal* (London: Reaktion, 2000), 147.

50. Abbott H. Thayer, "Concealing-Coloration: A Demand for Investigation of My Tests of the Effective Power of Patterns," *The Auk* 28 (October 1911): 460–64, 460–61.

51. Ross Anderson indicates that as a child Thayer studied "Audubon's *Birds of America* almost daily." Anderson, *Abbott Handerson Thayer*, 12.

52. Ann Shelby Blum, *Picturing Nature: American Nineteenth-Century Zoological Illustration* (Princeton, N.J.: Princeton University Press, 1993).

53. Ibid., 345.

54. J. A. Allen, "Thayer on Concealing Coloration in Animals," *The Auk* 27 (April 1910): 222–25, 225.

55. G. H. Thayer, *Concealing-Coloration*, figures 90–92.

56. Theodore Roosevelt, Appendix E, in *African Game Trails: An Account of the African Wanderings of an American Hunter-Naturalist* (New York: Syndicate Publishing Company, 1910), 552–68.

57. Roosevelt denied the effectiveness of countershading, arguing that white was always revealing. He posited that animals had dark backs and light bellies from the tanning action of the sun.

58. J. A. Allen, "Roosevelt's 'Revealing and Concealing Coloration in Birds and Mammals.'"

59. Roosevelt, Appendix E. Theodore Roosevelt, "Revealing and Concealing Coloration in Birds and Mammals," *Bulletin of the American Museum of Nat-*

ural History 30 (1911): 120–231. Theodore Roosevelt and Edmund Heller, *Life-Histories of African Game Animals* (New York: Charles Scribner's Sons, 1914), 54–118. Theodore Roosevelt, "Common Sense and Animal Coloration," *American Museum Journal* 18 (1918): 211–18. Thomas Barbour and John C. Phillips, "Concealing Coloration Again," *The Auk* 28 (April 1911): 179–88. Thomas Barbour, "A Different Aspect of the Case of Roosevelt vs. Thayer," *The Auk* 30 (January 1913): 81–91.

60. Kingsland, "Abbott Thayer and the Protective Coloration Debate," 235.

61. Roosevelt, "Revealing and Concealing Coloration in Birds and Mammals," 136.

62. Thayer wrote many papers in response to his critics. However, no real dialogue developed between the participants, who largely talked past each other. Abbot H. Thayer, "An Arraignment of the Theories of Mimicry and Warning Colors," *Popular Science Monthly* 75 (1909): 550–70. Abbott H. Thayer, "Concealing Coloration," *Popular Science Monthly* 75 (1911): 20–35. Abbott H. Thayer, "Concealing-Coloration: A Demand for Investigation of My Tests of the Effective Power of Patterns," *The Auk* 28 (October 1911): 460–64. Abbott H. Thayer, "Concealing Coloration, An Answer to Theodore Roosevelt," *Bulletin of the American Museum of Natural History* 31 (1912): 313–21. Abbott H. Thayer, "Naturalists and 'Concealing Coloration,'" *The Auk* 30 (October 1912): 618. Abbott H. Thayer, "Naturalists and 'Concealing Coloration,'" *The Auk* 30 (July 1913): 471. Abbot H. Thayer, "Camouflage," *Scientific Monthly* 7 (1918): 481–94.

63. Gould, "Red Wings," 222.

64. Because Thayer could always argue that the "need" was not great enough.

65. Kingsland, "Abbott Thayer and the Protective Coloration Debate," 242–23. It might also be suggested, contra Kingsland, that Thayer's opponents' antagonism to natural selection accounts for the fact that the debate did not focus on the mechanisms underlying evolution.

66. Alexander Nemerov, "Vanishing Americans: Abbot Thayer, Theodore Roosevelt, and the Attraction of Camouflage," *American Art* 11, 2 (Summer 1997): 50–81. Thayer's biographer, Nelson White, largely ignores the photographs in his published works. White, *Abbott Thayer*. Ross Anderson, the curator of a retrospective exhibition on Thayer, discusses one photograph in passing. Anderson, *Abbott Henderson Thayer*. The historians of science Sharon Kingsland, Steven Jay Gould, and Ann Shelby Blum all focus on Thayer's paintings to the exclusion of his photographs. Kingsland, "Abbott Thayer and the Concealing Coloration Debate." Gould, "Red Wings." Blum, *Picturing Nature*. The cultural historian Martha Banta discusses the natural history paintings but not the photographs that accompanied them. Martha Banta, "Masking, Camouflage, Inversions, Play," in *Imaging American Women: Idea and Ideals in Cultural History* (New York: Columbia University Press, 1987), 221–82. The historians of camouflage Roy Behrens and Richard Meryman also focus on Thayer's paintings and pay only minimal attention to his photographs. Roy R. Behrens, "The Theories of Abbott H. Thayer: Father of Camouflage," *Leonardo* 21, 3 (1988): 291–26. Behrens, *Art and Camouflage*. Richard Meryman, "A Painter of Angels Became the Father of Camouflage," *Smithsonian*, April 1999, 116–28. The critic Emily Gephardt analyzes the camouflage paintings and ignores the camouflage photographs. Emily Gephardt, "Hidden Talents: The Camouflage Paintings of Abbott Handerson Thayer," *Cabinet* 4 (Fall 2001), www.cabinetmagazine.org.

67. Nemerov, "Vanishing Americans," 56. Although Nemerov indicates that the substance of the debate is of no concern, he clearly agrees with Roosevelt that Thayer's images have little, if any, scientific value. I suggest that it is precisely this dismissal of the scientific content that allows Nemerov to bracket the content of the debate.

68. Roosevelt, Appendix E, 552.

69. Roosevelt, "Revealing and Concealing Coloration in Birds and Mammals," 210.

70. Theodore Roosevelt, "Camera Shots at Wild Animals: The Extraordinary Photographs by Mr. A. G. Wallihan of Cougars, Deer and Other Western Game in Their Native Haunts," *World's Work*, December 1901, 1545-49, 1549.

71. Ralph Lutts, *The Nature Fakers: Wildlife, Science, and Sentiment* (Golden, Colo.: Fulcrum Publishing, 1990); and Lisa Mighetto, "Science, Sentiment, Anxiety: American Nature Writing at the Turn of the Century," *Pacific Historical Review* 54 (February 1985): 33-50.

72. John Burroughs, "Real and Sham Natural History," *Atlantic Monthly* 91, 545 (March 1903): 298-309.

73. Edward B. Clark, "Roosevelt on the Nature Fakirs," *Everybody's Magazine* 16 (June 1907): 770-74.

74. Edward B. Clark, "Real Naturalists on Nature Faking," *Everybody's Magazine* 17 (September 1907): 423-27. The issue included articles from Joel A. Allen, from the American Museum of Natural History; William Hornaday, director of the New York Zoological Park; Edward W. Nelson, of the U.S. Biological Survey; Frederic Lucas, curator in chief of the Brooklyn Institute of Arts and Sciences; Dr. C. Hart Merriam, chief of the Biological Survey; the ichthyologist Barton W. Evermann; and the photographer George Shiras 3d.

75. John Burroughs, "Gay Plumes and Dull," *Atlantic Monthly* 95, 6 (June 1905): 721-37.

76. Jack London, "The Other Animals," *Collier's* 41, 24 (September 5, 1908): 10-11 and 25-26, 11.

77. "If the colors of animals were as vital a matter, and the result of the same adaptive and selective process, as their varied structures, which Darwin and Wallace teach, then it would seem to follow that those of the same habits and of the same or similar habitat would be similar or identical in color, which is not commonly the case." Burroughs, "Gay Plumes," 722.

78. Nemerov, "Vanishing Americans," 79.

79. See chapter 2, this volume; and Matthew Brower, "Trophy Shots: Early North American Nonhuman Animal Photography and the Display of Masculine Prowess," *Society and Animals* 13, 1 (2005): 13-31.

80. Kingsland, "Abbott Thayer and the Protective Coloration Debate," 238-29.

81. Francis H. Allen, "Remarks on the Case of Roosevelt *vs.* Thayer, with a few Independent Suggestions on the Concealing Coloration Question," *The Auk* 29 (October 1912): 489-507. Allen's paper provoked a response from Barbour, who sought to defend Roosevelt. Barbour, "Different Aspect of the Case of Roosevelt vs. Thayer." It also led to the editor of *The Auk* apologizing for publishing Allen's paper. Witmer Stone, "Editor's Note," *The Auk* 30 (January 1913): 146-47.

82. Frank M. Chapman, "The Scientific Value of Bird Photographs," *The Auk* 30 (January 1913): 147-49, 148.

83. Francis H. Allen, "The Concealing Coloration Question," *The Auk* 30 (1913): 311-17.

84. G. H. Thayer, *Concealing-Coloration*, 128.

85. Photography's emphasis on the links between animal and environment suggests that there was operating in animal photography what we might call a form of proto-ecological thought.

86. Witmer Stone, "Editor's Note," *The Auk* 30 (April 1913): 317.

87. Kingsland, "Abbott Thayer and the Protective Coloration Debate," 244.

88. As Gould indicates, Thayer's work on animal coloration and specifically his theory of the protective value of flamingo coloration became "the standard example used by professors in introductory courses to illustrate illogic and unreason." Gould, "Red Wings," 211.

89. Ibid., 217–18.

90. Blum, *Picturing Nature*. At this point natural selection was still not widely accepted in American science. The bias against natural selection in American science was largely the legacy of Louis Agassiz's hostility to the theory.

91. Kingsland, "Abbott Thayer and the Protective Coloration Debate," 242.

92. Nemerov, "Vanishing Americans."

93. Nemerov's argument focuses on different images than I do here. He concentrates mainly on Thayer's "Rear-End-Sky," pictures that shot stuffed deer and rabbits from below in order to demonstrate that from the point of view of a wolf (i.e., from below) the tail of the animal disappeared into the night sky. Nemerov rightly identifies that some of Thayer's paintings and photographs are of little scientific value in their complete denial of display. However, I argue that his complete dismissal of the value of all of Thayer's images is overstated.

94. Roger Caillois, "Mimicry and Legendary Psychasthenia," trans. John Shepley, *October* 31 (1984): 17–33. See also Denis Hollier, "Mimesis and Castration 1937," *October* 31 (1984): 3–15.

95. Caillois, "Mimicry," 30. Caillois saw mimicry as evidence of desire to retreat to an earlier form of existence; however, he later repudiated this aspect of his argument.

96. Ibid., 28.

97. Ibid., 30.

98. Nemerov, "Vanishing Americans," 79.

99. For a general history of the college, see Denis Hollier, *The College of Sociology (1937–39)*, trans. Betsy Wing (Minneapolis: University of Minnesota Press, 1987).

100. Roger Caillois, *Man and the Sacred*, trans. Meyer Barash (Chicago: University of Illinois Press, 2001); and Roger Caillois, *Man, Play, and Games*, trans. Meyer Barash (Chicago: University of Illinois Press, 2001).

101. However, while Lévi-Strauss has been seen as a generator of original syntheses, Caillois has been described as a talented amateur. Michel Panoff, *Les Frères Enemies: Roger Caillois et Claude Lévi-Strauss* (Paris: Éditions Payot et Rivages, 1993). Jean Dorst, "Roger Caillois Naturaliste," in *Roger Caillois*, ed. Jean-Clarence Lambert (Paris: Éditions de la Différence, 1991), 232–45. Caillois became a director of the world animal section of UNESCO and had a butterfly named after him: *d'apopasta cailloisi*.

102. According to his biographer Odile Felgine, mimicry, along with the sacred, was one of Caillois central obsessions. Odile Felgine, *Roger Caillois* (Paris: Éditions Stock, 1994).

103. Roger Caillois, *Les Jeux et Les Hommes* (Paris: Gallimard, 1958); published in English as *Man, Play, and Games*.

104. Roger Caillois, *Meduse et Cie* (Paris: Gallimard, 1960); published in English as *Mask of Medusa*, trans. George Ordish (New York: Clarkson Potter, 1964).
105. Caillois created a system "based on the nature of the aim attempted or achieved by the creature. Consequently [he made] three classes: *disguise* (fancy dress), where the creature passes itself off as belonging to another species; *camouflage* (allocryptic, homochromatic, disruptive colours, homotypes), by means of which the animal is able to blend into its background; *intimidation*, where the animal paralyses or frightens its enemy (or its prey) without this terror being justified by a corresponding danger." Ibid., 59.
106. Adolph Portmann, *Animal Camouflage*, trans. A. J. Pomerans (Ann Arbor: University of Michigan Press, 1959), 70.
107. R. W. G. Hingston, *The Meaning of Animal Colour and Adornment* (London: Edward Arnold, 1933); Cott, *Adaptive Coloration in Animals*; Wolfgang Wickler, *Mimicry in Plants and Animals*, trans. R. D. Martin (New York and Toronto: McGraw-Hill Book Company, 1968); Portmann. *Animal Camouflage*; Denis Owen, *Camouflage and Mimicry* (Chicago: University of Chicago Press, 1980); Graeme D. Ruxton, Thomas N. Sherratt, and Michael P. Speed, *Avoiding Attack: The Evolutionary Ecology of Crypsis, Warning Signals, and Mimicry* (Oxford: Oxford University Press, 2004).
108. "Only animals with a highly developed convex eye may be considered as selectors. Thus, most spiders which catch their prey by the sense of touch and animals that hunt by smell must be ignored. In fact our observations are restricted to vertebrates, since the role of the compound eye has not yet been sufficiently investigated." Portmann, *Animal Camouflage*, 100.
109. Owen, *Camouflage and Mimicry*, 115-16.
110. "The difference between pointless and useful resemblances is that in the latter cases there is presumably some other organism which notices the similarity. In addition, it must be important for the attentive organism to recognise the appearance of poisonous plants and animals, since it is advantageous to avoid them. The key figure in all such cases of mimicry is thus the organism which notices the particular character which constitutes the conspicuous similarity between different organisms. We can refer to a character of this type as a *signal*, and the organism reacting to the signal can be referred to as the *signal-receiver*. The latter is often, but not always, a predator, as will be seen from the examples provided later, so the neutral term signal-receiver is recommended." Wickler, *Mimicry in Plants and Animals*, 10.
111. The situation is different with warning colors, where the animal avoids eating something poisonous or approaching something dangerous.
112. Henry Wallace Bates, *The Naturalist on the River Amazons* (London: Murray, 1863), 2 vols.
113. "By its very nature mimicry is baffling and has therefore given rise to much controversy. The arguments, however striking and ingenious they may be, nevertheless always center around two similar questions: whether or not the disguise noted is an illusion of the human observer and whether or not it effectively protects the insect. Such problems should, in principle be capable of solution by observation and experience. In fact the reasoning and attitude of each protagonist in the argument is inevitably influenced, whether explicitly or explicitly, by the theory of natural selection. The adversaries therefore either judge the reality of the disguise by the efficiency with which it protects or, on the other hand, assume that the protection is effective if the imitation

is obvious. In other words, if a likeness is irrefutable, then it must be useful, if its usefulness is not in doubt, then it is proof of disguise. In short, naturalists can only envisage two points of view and these they share between them: (i) mimicry exists, hence it is useful (Poulton, for example); (ii) mimicry is of no use, therefore it is just an optical illusion of the observers." Caillois, *Mask of Medusa*, 65.

114. Ibid., 110.

115. Portmann also argues that mimicry falls outside strict utility. Portmann, *Animal Camouflage*. Kaja Silvermann discusses Portmann's work and its influence on Hannah Arendt in connection to Caillois in *World Spectators* (Palo Alto, Calif.: Stanford University Press, 2000), 130–40.

116. Elizabeth Grosz, *Space, Time, and Perversion* (New York: Routledge, 1995), 189.

117. Caillois, *Mask of Medusa*, 75.

118. Chris Venner, "Roger Caillois' *Mask of Medusa* (1964): New Insight into Lacanian Theory and Therapy," *Psychoanalysis and Contemporary Thought* 20, 4, (1997): 545–65, 552.

119. Katherine Arens, "From Caillois to 'The Laugh of the Medusa': Vectors of a Diagonal Science," *Textual Practice* 12, 2 (1998): 225–50, 234.

120. Although Caillois argued instead that vertebrate eyes resembled ocelli. Caillois, *Mask of Medusa*, 127. For the biological consensus on the role of ocelli, see Martin Stevens, "The Role of Eye-Spots as Anti-predator Mechanisms, Principally Demonstrated through the Lepidotera," *Biological Reviews* 80 (2005): 573–88.

121. Caillois, *Mask of Medusa*, 118–27.

122. Jacques Lacan, "Of the Gaze as Objet Petit *a,*" in *The Four Fundamental Concepts of Psycho-Analysis,* ed. Jacques Alain Miller, trans. Alan Sheridan (New York: Norton, 1978), 67–119.

123. This aspect of Lacan's work on the gaze has been very influential in feminist film theory. For an important summary of the history of this influence, which emphasizes its focus on representation and denial of corporeality, see Lisa Cartwright, *Moral Spectatorship* (Durham, N.C.: Duke University Pres, 2008), 11–50.

124. Silverman, *World Spectators*, 135.

125. Kaja Silverman, *Male Subjectivity at the Margins* (New York: Routledge, 1992), 125–56.

126. "'What determines [the subject], at the most profound level, in the visible,' remarks Lacan, 'is the gaze from the outside. It is through the gaze that [the subject enters] light and it is from the gaze that [he or she receives] its effects. Hence it comes about that the gaze is the instrument through which . . . [the subject is] *photographed.*'" Jacques Lacan, Seminar XI, as quoted in Kaja Silverman, *Male Subjectivity at the Margins,* 128.

127. For a reading that problematizes Lacan's account of the human subject's constitution through lack by raising the question of the animal subject and the impossibility of maintaining the rigorous distinction between response and reaction it is predicated on, see Jacques Derrida, "And Say the Animal Responded?" in *Zoontologies,* ed. Cary Wolfe (Minneapolis: University of Minnesota Press, 2003), 121–46. Derrida suggests that to begin to take up the question of the animal subject in Lacan, "one would have, in particular, to try to follow the path that leads, in an interesting but continuous way, to

the analyses of animal mimetism, for example, those that still work from
the perspective of the gaze precisely, of the image and the 'seeing oneself
looking,' being seen looking even by a can of sardines that does not see me."
(135). I see my engagement with the question of mimicry as contributing,
however obliquely, to that project but reconceived (as I take Derrida to be
suggesting) in terms of particular animals and not the animal in general.

128. Silverman, *Male Subjectivity*, 129. The sudden sound is Jean Paul Sartre's
classic example from *Being and Nothingness* where a sound makes the peep-
ing tom aware of his vulnerability to the look. Jean Paul Sartre, *Being and
Nothingness* (London: Routledge, 2005), 252–302.

129. Hence the disconcerting effect of portraits whose eyes seem to follow us
around the room.

130. Silverman, *Male Subjectivity*, 146.

131. Kaja Silverman, *Threshold of the Visible World* (New York: Routledge, 1996),
125–227.

132. Silverman, *World Spectators*, 127–46.

133. In his contrast of human and insect society, Caillois is following the lead
of Henri Bergson in *The Two Sources of Morality and Religion*. Bergson con-
trasted human society and insect society to argue against what he saw as the
closed system of thought at work in Durkheim's social facts. Henri Bergson,
The Two Sources of Morality and Religion, trans. R. Ashley Audra and Cloudes-
ley Brereton with W. Horsfall Carter (New York: Henry Holt and Company,
1935).

134. Caillois, *Mask of Medusa*, 120–21.

135. However, his position is not simply the late-nineteenth-century trope of
nature as "red in tooth and claw"; for Caillois, mimicry also opens a space
of play.

136. See, for example, Donna Haraway's discussion of the practice of attaching
cameras to animals in "Crittercam," in *When Species Meet* (Minneapolis: Uni-
versity of Minnesota Press, 2008), 251–63. Haraway suggests that what she
calls the haptic-optic experience of watching crittercam has the potential to
make its viewers aware of their ethical obligations to the animals involved.

137. A conversation with David Toews helped clarify this for me.

138. However, his images that tried to tie an animal's coloration to the effects of
the viewpoint of a specific predator, like his rear-end sky pictures, followed
his writing in presenting a narrower conception of animal appearance.

139. Allen, "Remarks on the Case," 492.

140. Allen, "Concealing Coloration," 314.

141. John Berger, "Why Look at Animals?" in *About Looking* (New York: Vantage,
1980), 1–28.

CONCLUSION

1. For the history of wildlife film and video, see Derek Bousé, *Wildlife Films*
(Philadelphia: University of Pennsylvania Press, 2000); Gregg Mitman, *Reel
Nature* (Cambridge, Mass.: Harvard University Press, 1999); and Cynthia
Chris, *Watching Wildlife* (Minneapolis: University of Minnesota Press, 2006).
For a general history of animal film and video, see Jonathan Burt, *Animals
in Film* (London: Reaktion, 2000).

2. Burt, *Animals in Film*, 11.

3. Chris, *Watching Wildlife*, 202.
4. Mitman, *Reel Nature*, 206.
5. Bousé, *Wildlife Films*.
6. Akira Mizuta Lippit, *Electric Animal* (Minneapolis: University of Minnesota Press, 2000).
7. Burt, *Animals in Film*, 165.
8. Derek Bousé, "False Intimacy: Close-ups and Viewer Involvement in Wildlife Film," *Visual Studies* 18, 2 (2003): 123–32.
9. Chris, *Watching Wildlife*, xiii.
10. Donna Haraway, *When Species Meet* (Minneapolis: University of Minnesota Press, 2008), 251.
11. Chris, *Watching Wildlife*, x.

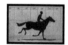

INDEX

Matthew Brower is curator of the University of Toronto Art Centre and a lecturer in museum studies in the Faculty of Information at the University of Toronto.

DATE DUE